SOME FUTURE DAY

In some future day, the world will find peace, if we carry on believing, but also get active.

Steve Howe
Rock & Roll Hall of Fame
Guitarist from Yes

SOME FUTURE DAY

HOW AI IS GOING TO CHANGE EVERYTHING

MARC BECKMAN

Skyhorse Publishing

Copyright © 2025 by Marc Beckman

All rights reserved. No part of this book may be reproduced in any manner without the express written consent of the publisher, except in the case of brief excerpts in critical reviews or articles. All inquiries should be addressed to Skyhorse Publishing, 307 West 36th Street, 11th Floor, New York, NY 10018.

Skyhorse Publishing books may be purchased in bulk at special discounts for sales promotion, corporate gifts, fund-raising, or educational purposes. Special editions can also be created to specifications. For details, contact the Special Sales Department, Skyhorse Publishing, 307 West 36th Street, 11th Floor, New York, NY 10018 or info@skyhorsepublishing.com.

Skyhorse® and Skyhorse Publishing® are registered trademarks of Skyhorse Publishing, Inc.®, a Delaware corporation.

Visit our website at www.skyhorsepublishing.com.

10 9 8 7 6 5 4 3 2 1

Library of Congress Cataloging-in-Publication Data is available on file.

Print ISBN: 978-1-64821-077-8
Ebook ISBN: 978-1-935342-18-2

Printed in the United States of America

CONTENTS

Introduction 1

Chapter One: Changes for Businesses, Creators, and Workers 9
Chapter Two: Miracles in Medicine 45
Chapter Three: Advancements in Contemporary Warfare 65
Chapter Four: Changes for Artists and Creatives 85
Chapter Five: News Media in a New World 105
Chapter Six: Banking, Finance, and Trust in an AI World 123
Chapter Seven: Meeting Humans . . . and Metahumans 145
Chapter Eight: The Revolution of Sighted AI 169
Chapter Nine: Scammers and Crime 179
Chapter Ten: A Revolution in Education 201
Chapter Eleven: The Dilemma and Possibility of Social Media 217
Chapter Twelve: Conclusions—An Accelerating World . . . Whether We Like It or Not 233

Appendix of Additional Resources 251
 The Most Influential People in AI 251
 The Most Influential Businesses in AI 262
 Twenty Key Data Analytics Tools 272
 Search Engine Optimization Tools 274
 Bonus: AI SEO Tools 275
 Thirty-Nine Performance Marketing Tools 276
 Thirty NFT Tools 279
 Twenty-One Meme Coin Ecosystem Tools, Resources, and Projects 281
 Twenty-Seven Podcast Marketing, Advertising, and Ecosystem Tools 285
 Sixty Blockchain and Cryptocurrency Tools 288

Acknowledgments 296
Index 298

In some future day, the creator economy will become the entire entertainment and media economy.

**Chris Williams
Founder & CEO,
Pocket.Watch**

INTRODUCTION

Welcome to the Age of Imagination.

You don't have to be a follower of cutting-edge technology to know we're living in times without precedent or analog; times when it feels like everything might change because of exciting new technologies.

There's an old saying that I like a lot. . . . The identity of its author is lost to history; some believe it was Vladimir Lenin, the founder of the Russian Communist Party and the leader of the Bolshevik Revolution. But anyhow, the saying is: "Nothing can happen in decades, and then decades can happen in weeks."

For me, that sums up what it feels like today when it comes to new technology. We're living in a world in which technology's advance can sometimes seem slow or even stagnant—or that we simply *won't* see any further advance in certain areas—but then you blink and realize that we have suddenly progressed by leaps and bounds. A major new advance has taken place, and it felt like it happened overnight!

I believe that one of the reasons for these lightning-quick

advances are the synergies that are created by existing technologies "meeting" one another and unlocking their true collective potentials.

The purpose of this book is to provide a guide to how and why Artificial Intelligence (AI) is going to solidify itself as the final (and the most powerful) synergistic component that unlocks this potential and allows us to enter an astounding new age—one which I call the Age of Imagination—in which existing technologies are suddenly superpowered, and achievements that we imagined were generations away will materialize seemingly overnight.

Not everything in this age will change, but some things *definitely* will. The good news is that most of the changes will be profoundly positive ones. They will allow tasks to be accomplished more quickly, and with greater accuracy. They will allow us to notice trends over large sets of data to uncover important breakthroughs we might have otherwise missed (or taken many decades to notice). They will open new doors in science and technology, sure, but also in art and creativity. They will prevent errors, accidents, and oversights. And perhaps most importantly, they will manifest a "leveling effect" that will allow for greater competition and greater inclusiveness—all over the world—in just about every field there is.

AI is going to be a powerful catalyst. It's going to be the spark that sets these transformative changes in motion across disciplines. And to do this, it will leverage the technologies and platforms that have already been built up over the last few decades. AI is like the final ingredient in a recipe that makes all the prior ingredients work together—and then transforms the dish into something wholly new and wonderful.

Specifically, I believe that there are three important "foundational ingredients" that are waiting to be unleashed by AI.

Introduction

The first foundational ingredient arrived at the dawn of what historians now call the Digital Age or the Information Age. Following the technologies of the Industrial Revolution, the Digital Age saw the introduction of the first personal computers and digital devices. This began with the work of pioneers like Alan Turing and John von Naumann, who charted the path to digital computation. Though the exact moment "computers existed" is hard to pin down, throughout the 1940s, 1950s, and 1960s we saw the gradual, accretive development of programmable digital equipment that performed computations. In the seventies and eighties, these "computers" were then significantly enhanced via Internet connectivity. The eighties saw the growth of personal home computing, and the nineties the introduction of the World Wide Web and web browsing. By the turn of the millennium, computers were being used in virtually every industry, and at nearly every echelon of society. This brought forth an era in which great swaths of our economy became based on the sharing of information—quickly, accurately, and in large quantities. Stocks were traded digitally, newspapers were deployed digitally, and even the most important (or the most mundane) communications could be sent by email instead of hard copy. In a single generation, everything had changed.

The next foundational ingredient was the development of virtual realities and the metaverse. From early video games to contemporary social networks, computer technology allowed for the creation of immersive, interconnected digital worlds. At first they could be very simple—even crude—and certainly not something that could be mistaken for authentic reality. Early video games, for example, were little more than moving dots on a screen. Yet with the exponential growth of processing technology, computers began to render worlds that could soon be mistaken for footage of "the real thing." These worlds generally served specific

functions, even if that function was just entertainment. They were not "worse" or "better" than the actual world, just different. And in these new worlds, people could connect in new ways. They could make friends, start businesses, create art, or just socialize. And as the technology grew, people found that they could both spend and make money in these digital worlds—with some of the money being as artificial as the world itself, but some of it being *very* real.

And that brings me to the final foundational ingredient. Who says which money is "real" and which isn't? The advent of blockchain technology and cryptocurrency compelled us to examine this question through a new lens. A blockchain is a digital public record of all prior transactions involving a specific digital token. Blockchains are made up of linked "blocks" of data maintained across connected computers in a peer-to-peer network. In addition to letting users track and record physical assets—like houses, cars, luxury goods, or even land—blockchain also allowed for the production of cryptocurrency. Cryptocurrency (or just "crypto") refers to tokens of digital money that are maintained in a decentralized digital blockchain network. Bitcoin is the most prominent example. Cryptocurrency is not backed by a central issuing authority, like a government or a reserve bank, and this means it can function effectively while being completely unregulated by authorities (though some governments, like China, are now issuing their own cryptocurrency in the form of a Central Bank Digital Currency [CBDC]). Furthermore, because crypto is minted to the blockchain, it is more secure than almost all fiat money (and counterfeiting it is, by definition, impossible).

Digital Technology.
The Metaverse.
Blockchain and Cryptocurrency.

Introduction

By themselves, these are all immensely powerful, game-changing tools. However, when combined with AI—which they are now going to be—their impacts are likewise compounded, and the upshot is that we'll no longer be living in the same world. The Digital Age will become the Age of Imagination.

What will change in this new age?

I believe an accurate answer is "practically everything," but that's also too broad of a response to be satisfying. So this entire book is about where and how things will be changed in the coming age. But if I had to give a single answer for what was going to happen next, I might say "acceleration."

AI accelerates everything. Full stop.

In a world integrated with AI technology, news travels more quickly. Medical tests and engineering trials are run at vastly accelerated speeds, giving us answers and solutions more quickly than ever before. Virtual renderings—like architects' conceptions of skyscrapers based on nothing more than sketches, or fashion models wearing newly-designed outfits (that were only just sketched on a napkin), or artwork slated to be incorporated into advertising campaigns—will be available with unimagined immediacy. Creatives will be able to make and sell their work faster than ever before. Financial transactions—including everything from being paid for a sale, to getting a loan from a lender—will become speedier and more seamless. Services that keep us safe—from private security systems all the way up to the armies that patrol a nation's borders—will be able to assess and neutralize threats more effectively. And perhaps most exciting of all, AI is going to accelerate the ways that humans can connect to other humans. People will be able to form relationships more quickly, and these relationships will be higher quality. They'll be deeper. Trust will come faster. Shared interests will be easier to see. And everyone will be more confident about exactly where they stand.

From education, to health care, to sustainability, the fast and accurate modeling made possible by AI is going to change everything.

I call this new world the Age of Imagination because almost anything you want to imagine is going to be possible. In so many industries, people are still asking: "I wonder what X would look like?" In an Age of Imagination powered by AI, you won't have to wonder. AI will instantly and accurately show you.

That's the difference.

That's what it's going to be like in the Age of Imagination.

Will AI bring challenges and dilemmas, too? Yes, a few—and this book will consider these as well. However, challenges arise with *any* new groundbreaking technology—and, as humans have time and time again throughout history, we will find ways to overcome these challenges and mitigate any negative "side effects" that may accompany the rise of AI.

Finally, in terms of opportunity and equity, I'm most excited of all about the level playing field that AI is going to create for everyone, everywhere. Anybody who is able to imagine something—or come up with the next great idea—is going to be able to visualize, deploy, and ultimately monetize it, no matter who they are, where they live, or what their ethnic, cultural, educational, or religious background might be. A good idea will be a good idea—and a profitable idea—no matter who has it, or where they are in the world.

We're about to enter the Age of Imagination, and it's going to change *everything*.

Hold on tight. . . .

In some future day, the First Amendment will be a rallying point for humanity, a definitional point for all human beings to embrace what they have in common. A common article of faith, not just in free speech, but in each other.

**Professor Jonathan Turley
Bestselling Author and
Constitutional Law Expert**

CHAPTER ONE
=========

CHANGES FOR BUSINESSES, CREATORS, AND WORKERS

The Age of Imagination is going to be powered by connectivity. When many people hear that word—"connectivity"—they think of devices interfacing with one another. To some extent that's an accurate way to visualize it, and it's also something we already have. People can email one another, play cooperative online games, and do business face-to-face on a Zoom or Teams call. All of these activities involve devices interfacing. But in the Age of Imagination, this kind of interfacing is going to become *supercharged*. It will accelerate. It will become seamless and automatic. After a while, we're going to lose the sense that we're interfacing and connecting through devices. We'll simply feel connected, period.

There are several critical components that will allow this new level of connection to become possible. They are existing

technologies that will be leveraged and transformed into something new as we move forward. They include (but are not limited to):

- Cloud computing technology
- Social media
- Mobile devices
- "The Internet of Things"
- Blockchain technology
- The metaverse
- Augmented reality
- Virtual reality
- Drone technology
- Autonomous vehicle technology

All of the above are going to be connected, empowered, and improved by AI. You can also think of these elements as tools, and AI as the force that is going to allow almost anyone, anywhere, to use these tools.

This chapter is about how businesses, creators and makers, and the people who are employed at businesses are going to be impacted by the changes ahead. For existing businesses and creators, the transition to AI—and the integration of AI into the above elements—will be both empowering and disruptive at the same time. The good news is that it is going to create a level playing field that allows businesses of all sizes to compete as never before. However, it will also change the location(s) of the playing field, and will compel existing brands to attune themselves to customers in entirely new ways.

Now the question everyone in the boardroom is asking: Will consumers be ready for these changes?

The answer is: Yes. In fact, consumers will be *demanding* them. It is the consumers who will drive the coming change.

Changes for Businesses, Creators, and Workers

Every Fortune 1000 executive and C-suite leader is now aware of the coming rise of artificial intelligence, the metaverse, and blockchain technology. Yet very few of these leaders regard themselves as experts or pioneers in the field. Most are outsourcing decisions around AI to subject matter experts. Some leaders are even ambivalent about—or actively *resistant to*—the potential impacts of these technologies.

"*Some* industries are going to be impacted by AI, sure," many of these executives will allow. "But *mine?*"

(I'll let you imagine the skeptical tone in which the above line is often delivered.)

Of course, virtually *all* industries are going to be profoundly impacted by the technological changes AI will bring. It's not just me who thinks this. Whoever they are, and whatever they like to shop for, consumers are excited about purchasing products and services in an AI-driven virtual reality. In 2023, McKinsey and Company estimated that the global metaverse and virtual shopping market is expected to eventually grow to $5 trillion. They also estimated that corporations, venture capitalists, and private equity firms invested around $120 billion in the metaverse in 2022—and that this investment has been increasing at a rate of 110 percent year-over-year. In my industry—branding, advertising, and representation, with a concentration on fashion lifestyle categories—we regularly see projections that the market for digital fashion is going to grow to a multibillion-dollar market by the end of the decade. Ultimately, digital fashion and metaverse clothing is expected to grow into the mid-ten-figures and stay there.

Whatever you sell, market, or create, the coming changes are going to powerfully *and permanently* change the ways consumers shop. Just as looking up a product or service in the phone book was long ago supplanted by searching on the Internet, so will our

current online shopping landscape soon be supplanted by the rise of artificial intelligence and the metaverse.

Innovation is already accelerating digital change in the marketplace. Think of the diminished rate of cash transactions we've seen in just the past few years. Now add to that consumers who want to use new digital financial tools—such as digital wallets containing cryptocurrency—to pay for whatever goods or services they purchase. Customers increasingly prefer shopping in a digital environment. This can mean taking an avatar into a virtual store in the metaverse and making a purchase that will be delivered to them in the "real world"—sure!—but it can also mean the customer might want to have their analog, in-person shopping experiences enhanced by digital elements. Consumers want immersive and persistent digital enhancements—and they want them everywhere they go.

For example, imagine it's the near future, and I walk into a physical clothing store to browse. Because I have made my digital and metaverse profile accessible to the store, they can immediately understand what kind of customer I am the moment I walk inside. They can access information about my personality and preferences, and then tailor my shopping experience accordingly. Maybe I've made it clear that I care deeply about environmental sustainability. In that case, the real or digital assistant can begin by telling me about the circular economy and upcycled features of the item I am considering buying. What if I care about activism or a political movement? The store can lead with how their brand connects with me ideologically. What if I care about supporting philanthropy? Immediately, I can learn how a portion of my purchase will be used to help fund a cause I'm passionate about. Finally, let's say I have *no* ideological underpinnings to my buying habits; I'm just somebody who likes a good deal! The business can know *that* about me too, and simply

Changes for Businesses, Creators, and Workers

let me know why right now is the time to buy if I want to save money.

Whatever you sell, however you sell it, your customers are going to want to make purchases in ways that align with their digital identities. Identity is important, and it's only going to get more important as we move deeper into the twenty-first century. The lines between an online identity and an in-person identity are going to blur. Successful businesses will need to understand this, and to harness the awesome power of AI to use this "identity first" environment to drive sales. No business can afford to fall behind.

As a scholar of fashion technology, there are important historical inflection points that have allowed my industry to make leaps forward. My industry has not been a stranger to sudden impacts. In 1811, 66 percent of all the clothing in the United States was still made in people's homes. But in 1830, the sewing machine was invented in France, and the consequences of this would be massive and global. (I should note that the Singer sewing machine that so many Americans are familiar with did not actually debut until 1851.) The 1840s saw the beginning of the mass manufacture of garments (mostly in the Northern states) and the farming of cotton—which it must be noted, rode on the backs of enslaved people—in the Southern states. In the 1860s, standardized paper patterns—with standardized sizes—were created; suddenly, clothing makers everywhere adopted them. In the 1920s, we saw the rise of department stores. In the 1940s, synthetic fibers like nylon, polyester, and acrylic were invented for use in the Second World War, and soon over 40 percent of fibers used in clothing in the United States would be synthetic. In the 1980s, we saw the rise of robotics and automation in the production and distribution of clothing. Almost overnight, every task that could be done by a robot *was* done by a robot.

All of these inflection points were inextricably connected to changes in culture and technology. While all of these have been important, I believe they are going to pale in comparison to the impact that AI is going to have. If we can get the mix right, then humans, tech, and capitalism are going to combine in wonderful ways. And the time is already here for the next leap forward. In fact, the time was yesterday.

In my industry of advertising with a concentration in the lifestyle industries, including fashion, art, music, sports, and entertainment, surveys consistently show us that over half of Gen Z are now comfortable getting fashion inspiration from nonhuman avatars. (That number is going to be even higher for Gen Alpha.) The market for "virtual fitting rooms" is forecasted to grow from $3 billion today to $30 billion by 2028. And globally, over 25 percent of consumers consistently indicate that they are interested in pursuing clothing shopping experiences virtually.

For any business, the growth of brand avatars in the form of metahumans—which we'll discuss in greater depth in a subsequent chapter—is going to forge new, more personalized connections with customers. These brand avatars can do things like host exclusive virtual events for your product, or become the customizable star of a product demo. You'll be able to configure these brand avatars for every segment of the market. Do you want your avatar to have a Southern accent when you make a pitch in the South? Boom! It's done. This technology will allow a business's brand messaging to have greater impact with consumers.

And just imagine how AI will be able to help you out when it comes to customer service. Everyone knows how much people detest dealing with automated customer service over the phone. But that will change when the AI-powered customer service agent can speak to the consumer in a personalized way, in the language they speak, and with a seamless and instant knowledge of the

Changes for Businesses, Creators, and Workers

customer's needs and issues. Digital customer service is going to go from being a liability to being *preferred* by many consumers.

Or consider sales. Digital sales representatives are going to be able to interact with customers knowledgably, and to anticipate and answer their questions. Their knowledge of the customer will be superior to human sales reps. And if for any reason a customer prefers a human salesperson, they can always make that hand-off. Imagine a store where a digital salesperson can allow customers to purchase products, make appointments (in my industry, that might be an appointment for a custom fitting), and deal with annoying issues like returns. And that digital salesperson will have a knowledge of the customer's purchase history, preferences, and passions.

What's more, all of these digital, AI-powered interactions with customers are going to allow businesses to capture valuable data and analytic feedback in real time. It will be a world where C-suite executives can make data-driven decisions without the need for a data analyst, or without a multi-day wait while data is manually examined to generate the answers they need.

The coupling of AI with blockchain technology shifts the power away from centralized production ventures and back to the individual creators. As never before, we're going to see a level business playing field that allows for true competition. The barriers of geography, language, and income are going to break down. A sixteen-year-old fashion designer from the Bronx will be able to design her products using AI, generate interest for them using social media, and then compete directly with major fashion houses. Tech innovators in any location will be able to design, build, and launch programs. Most important of all will be the ability of creators to produce digital assets—and deploy them—from any location. These "assets" will include images, book or movie trailers, art, music, and so on. All of it can be created

quickly and easily using AI. The creators will be able to monetize it and protect it on the blockchain. (More about how this works in subsequent chapters.) Suffice it to say, it will be a one-stop-shop. Everything you'll want to do, you'll be able to do it using AI.

In my agency, we already have designers who are using AI to mock-up products, create the primary packaging, create the secondary packaging, create full ad campaigns, and then presell the product to get money for cash flow. They can then build based upon those initial orders. And they're protecting their intellectual products through the use of smart contracts embedded on the blockchain.

This is a disruption, but it is a *good* disruption. The playing field is being leveled. Massive fashion companies like PVH (formerly known as the Phillips-Van Heusen Corporation) and LVMH (Moët Hennessy Louis Vuitton) need to pay attention to what is going on. Now, individual creators, who couldn't compete with large fashion houses just a few years ago, can work out of their apartments and challenge these industry giants.

Another area where AI is going to change everything for creators—and for businesses that sell content—is collaboration. Specifically, it will enable new and exciting collaborations, the likes of which the world has never seen. To give an example, few American photographers have been able to conjure a personal style like the great New York City-based photographer Richard Avedon, who passed away in 2004. The professional tennis player Coco Gauff was *born* in 2004, and she has become a mainstay of sportswear company advertisements and has been featured in fashion magazines like *Vogue*. What if Gauff could have been photographed *by* Avedon? But alas, it was not to be. They were from different eras, and their lives just didn't line up . . . so we'll never know.

Changes for Businesses, Creators, and Workers

Or will we?

Artificial intelligence allowed my agency to create *stunning* visual images of what a photoshoot of Gauff might have looked like if Avedon had been around to shoot it. These images are remarkably accurate-feeling. (When I show them to people, I always have to reiterate that they were *not* actually shot by Avedon.) We've done the same thing with Robert Mapplethorpe, imagining how he might shoot Timothée Chalamet. In this case too, it's pretty remarkable how realistic the final product looks. At my agency, we've been able to create AI renders of how *many* great photographers who have passed away might shoot subjects who lived (or are now living) at a different time. And all of them were created using AI.

Businesses and creators are going to be able to use this technology to show potential customers real visualizations of how their products and services could be used. Where does that land in terms of ethics or copyright? For me, that connects to the idea of needing to "do the right thing"—a theme I'll return to throughout this book. When a new technology allows us to do something new, there will always be both ethical and less-than-ethical ways to implement it. It was true when the manipulation of still images became possible due to technology like Photoshop, and it's true now with AI. People will need to do the right thing. The right thing and the *legal* thing are not always identical.

I have a law degree, I was admitted to the bar in New York, New Jersey, and DC, *and* I sit on the board of the New York State Bar Taskforce for Cryptocurrency and Digital Assets. Which is just to say: I know whereof I speak! I think that the United States Supreme Court will ultimately find that using the kinds of digital AI renders I've described above—e.g.: imagine subject X photographed by photographer Y—does *not* qualify as copyright infringement on the estate of a deceased photographer. There are

standards in current copyright law for something called "transformative use." This is a relatively recent copyright standard; it was solidified by the courts in 1994, and is a subset of "fair use." (Fair use allows limited portions of copyrighted material to be used by someone who is not the copyright holder, but only in certain limited circumstances. Fair use includes things like a reviewer quoting a few passages from the book they are reviewing, or a teacher or scholar excerpting part of a work in their classroom lessons.) Transformative use occurs when someone takes an existing work and adds something new that gives the work an entirely new perspective or position. Examples of transformative use are things like sampling a musical work to create a parody that makes fun of the original, or using a number of copyrighted pictures in a large collage that forms an entirely new image when viewed from a distance.

The transformative use standard is going to be vitally important for businesses and creators. If you adequately transform something, then you're not infringing on copyright. When my company creates an image of a new pair of Nike shoes as though they were designed by Dale Chihuly—for example—I believe that it does *not* create copyright infringement and is sufficiently covered by transformative use. I'm careful to say "I believe" because I feel dead certain that as use of AI in business and creative work expands, we're going to see a lot of these cases run all the way up to the US Supreme Court.

Whatever the law ultimately allows—or doesn't—in the Age of Imagination, companies are going to want to err on the side of embracing collaborators and those who transform their products in exciting ways . . . rather than suing them for copyright infringement. To get a hint of what that future might be like, I think we can look at something Nike is already promoting. They have done a tremendous job of building out a community vertical

Changes for Businesses, Creators, and Workers

using emerging technologies, specifically blockchain. There's a platform called dot-SWOOSH that I'd encourage you to look up online. Using this platform, Nike is taking their very, very important and iconic intellectual property—the swoosh and some of their sneaker designs—and allowing designers to create new versions of their products that both the designer and Nike can monetize together.

I think as the success of this sort of thing becomes more widespread, we're going to see more and more brands get comfortable with allowing creators to engage with their products and create new cooperative collabs. Everyone will be able to monetize in new and different ways. However, it's important for me to point out that we are still feeling our way forward when it comes to the standards of proper behavior in the world of AI. Right now, the standard that the patent office uses are that if something is machine generated, it won't enjoy the same protections as if a human had created it. You can't protect something that's machine generated to the same degree as something drawn by hand. But, if that's the case, then what protections do IP-holders deserve? Can they protect *subsequent* people from using those images in AI art? To what threshold? If I make a copyrighted hand drawing, can someone else use AI to tweak or enhance it and sell that result?

If you're a brand owner in a lifestyle category, part of your marketing arsenal is collaborations. Should you use AI to collaborate with a protected IP? How far can you take it and still remain within the law? How do brands—luxury brands who may have built their intellectual property over hundreds of years—deal with unauthorized collaboration when it happens and is shared on social media? You could have user-generated content that totally upends your centuries-old brand standard. If it's shareable (or already shared) and popular, then how do you react to that?

I'm asking all of these questions precisely because I can't tell

you the answers, and that's because the answers will be different for everyone. However, I do know one thing: these are the sort of questions that *all* businesses and creators will have to answer in the years ahead!

Another thing I'm going to talk about repeatedly in this book is the ongoing tension between those who are in favor of accelerating this technology quickly and those who believe doing so would be unwise. In industry and business, we must be allowed to compete. I believe that taking an intentionally slow and hampered approach when it comes to the implementation of AI will necessarily, by definition, be a ruinous path for businesses (and their employees) as well as creators. However, I also believe it is possible—and, indeed, is incumbent upon us—to ensure that AI evolves quickly *and morally* at the same time. I am confident that this can be done, because it *must* be done.

Business leaders need to take an optimistic approach that incentivizes growth. We need to be aggressively and unapologetically pro-tech. If we get this right, we'll not only get a new set of powerful tools for use in business and commerce; we'll also give capitalism and free markets a way to inexorably expand into new places all over the world. The people who want to decelerate the evolution and adoption of AI have scary slogans they sometimes use, like "Decelerate or die!" They aren't saying we need to stop the evolution of AI completely, but they are *certainly* saying that we need to regulate the hell out of it, and put imagined problems ahead of existing, real-world applications. When they want to sound less extreme, they'll use other slogans like "Build safe!" (What reasonable person could be against safety, right?) But we can't let those who are afraid of artificial intelligence drive the conversation for a couple of simple reasons.

One reason is that they're *simply wrong* about the dangers

Changes for Businesses, Creators, and Workers

purportedly presented by AI. Look, AI is *not* going to spontaneously launch nuclear weapons for no reason, and/or enslave humanity. I think a lot of the mythology around this concern comes from works of fiction that many of us grew up with. For example, in 1983, at the height of the Cold War standoff between the United States and the Soviet Union, the Matthew Broderick film *WarGames* introduced a generation to a scenario in which a supercomputer becomes "self-aware" and threatens to launch nuclear weapons and start World War Three. Likewise, the award-winning, incredibly famous science fiction story "I Have No Mouth, and I Must Scream" by Harlan Ellison captivated a generation of readers by suggesting that AI supercomputers might eventually talk to one another, decide collectively that they prefer artificial beings to organic ones, and then use technology to murder and enslave the human race.

These scenarios are not going to happen because artificial intelligence has *no motivation* for doing any of these things. Because artificial intelligence is just that—artificial—it simply doesn't have the motivations that could conceivably drive an evil human to take steps to bring about a horrific, world-ending scenario. AI has no drive. It has no desire. It does not prefer existing to not existing. Today, Generative AI is algebra. Math will not kill us.

Could AI be *used* by a person with bad intentions? Sure. Safeguards must be taken against that, and I've devoted a subsequent chapter to how we must all work to prevent nefarious uses of AI. But AI cannot and will not cause a disaster to occur simply of its own volition. The concern here is like being afraid that after you invent a gun, the gun is going to go around town on a shooting spree *by itself.* That's not going to happen. Such scenarios will always remain in the world of science fiction.

The second reason why we can't let those who are afraid of AI drive the conversation—and this is just as important—is that the

only thing adopting an intentionally slow pace will accomplish is to give hostile nations an edge over us . . . as *they* are all going to be embracing AI with open arms! We know that countries like Russia and China are already using AI to sow disharmony in the United States and Western nations. And it's not just the dispersal of targeted propaganda. Hostile nations can use AI to gain access to information meant to be confidential. It can be used to steal patents and inventions. It can download products and processes that may have taken American companies many millions of dollars to invent and develop, and reproduce them in a competing economy. The most troubling uses of AI by hostile nations may be the ones we haven't even considered. But there are some things we do know for sure. The most conservative projections show that Russia and China are likely to invest tens of billions of dollars into AI by the end of this decade. They're not doing that for no reason at all.

Western capitalism succeeds because it's the best system for honest businesspeople and creators. It lets them take their skills and talents and use them to build something big and remarkable, and then to enjoy the resulting rewards. If we allow any other nation or culture to outpace us when it comes to incorporating AI into our business and creative cultures, we risk losing everything that gives us an edge!

So when we talk about the development of AI—whether it will be used in business, art, or elsewhere—what exactly do we mean? At this juncture in AI's journey, we're mostly seeing the development of Large Language Models, or LLMs for short. If you're not familiar, an LLM is a type of AI that can generate text, respond to text input conversationally (much like a human could), and

Changes for Businesses, Creators, and Workers

sometimes create things like images or video renderings. The most famous LLM is probably OpenAI's ChatGPT. However, companies like X, Amazon, Meta, Microsoft, and many others are all currently working on (or have already created) competing LLMs.

Every field is going to be impacted by how these LLMs are grown. Importantly, this growth does not happen in a vacuum; LLMs need to be taught and trained, just like humans do. Right now, most LLMs are being trained on publicly available data. That is to say, information from all over the world—and most of it on the Internet. The LLMs read this text data and learn to understand the relationship between the words. They learn how things are connected, and they can eventually use their learnings to speak to things within this collection of data just like a human could. (The recall ability of an LLM greatly exceeds that of most humans.)

Are all LLMs trained with the *same* data? No, and this is key.

LLMs are built and curated differently. The big tech companies also have different resources for capturing the data that LLMs are built from. For example, Google can draw on information from Google searches to train an LLM on what data people look for and find useful. Meta is going to have access to information that people share on the social media platforms that it owns (Elon Musk is already doing this with Grok and "X"). Will these translate into substantive differences in AI functionality? It is entirely possible. These tech companies will be able to train their models however they like.

These are the kinds of calls that people in the tech industry are going to have to make. What we know is that if we want AI to help in difficult situations, we're going to have to do the "hard work" on training it on difficult topics. If we don't, we'll end up with something nobody's happy with.

Notoriously, in the mid-2010s, Microsoft launched an AI chatbot named Tay that infamously trained itself using social media

posts. However, in doing so, it "learned" to repeat sexist and racist ideas. (To Microsoft's credit, when this happened, Tay was quickly taken down.) Now, the "easy" solution to this would be to train LLMs to entirely avoid things that could be interpreted as racist or sexist. However, that's not the world we live in. One must occasionally encounter objectionable content or ideas. If Microsoft or any other company wants to give us an LLM product that is truly helpful—in business or elsewhere—they will need to build LLMs that recognize sexist and racist terms (and other objectionable things), but also understand that they are offensive and hurtful.

There are challenging nuances here that are worth noting. Someone using a slur on social media in 2025 is a pretty clear-cut case of what we *don't* want a contemporary LLM to emulate. But what about when an LLM is given a canonical literary text to "learn from" that was written in a time of outdated ideas about women, people of color, and LGBTQ people? Here again, we are going to have to work to ensure that these tech companies know what they are doing. Some of that will be done by the free market. *Businesses that adopt these AI models are going to have to make sure that the values of the LLM they are using comport with their own values and represent their business in the way they want to be seen by their customers!*

There are different *kinds* of bias that businesses and creators will have to learn to navigate in a world of AI.

First, there is overt bias, which companies are doing a good job of taking care of. In a case of overt bias, an LLM may have been intentionally trained to use an inappropriate word, slur, or thought paradigm. But there's also i*mplicit bias*, which is trickier. In my opinion, we may be able to root out overt bias completely—for example, ensuring an AI never uses certain slurs or rude words—but implicit bias is going to be more challenging to correct. It may be an

Changes for Businesses, Creators, and Workers

ongoing concern we have to address indefinitely. I say this because AI learns from humans, and human history contains implicit bias in many, many areas. Those who wrote great works of literature, or conducted great scientific experiments, or who founded the United States of America, may have nonetheless been impacted by the implicit bias of their day. Large language models are trained on the corpus of history, and what people throughout history thought and wrote and did. Some ideas—and some people—were excluded from historical conversations because of these biases.

AI will also never have perfect information. That's because people don't have perfect information, and the sources of information we give AI to learn from are necessarily going to be flawed in certain ways. But—another theme I'm going to repeat throughout this book—something doesn't need to be perfect in order to be tremendously valuable.

This, however, does bring me to an important point about LLMs, which is that, as good as they get—and, believe me, they're going to get amazing—it will always be important to check their work when something important is at stake. As the saying goes, we must learn to trust but verify.

How is this done? It's less mysterious than you might imagine.

First, if you are using an LLM that links to sources (or just cites them), check those sources personally before accepting anything the LLM has provided as gospel truth. Make sure the LLM has summarized the content correctly, and that it has included everything relevant.

Next, do your own web search using a search engine and attempt to verify the information the LLM has provided to you. (You may also wish to use the "SIFT" method: *Stop, Investigate* the source, *Find* better coverage, and *Trace* claims to the original context.)

Finally, you may want to use a model that links to its sources,

like Perplexity or Copilot. This makes things easier to fact-check (though Perplexity and Copilot aren't foolproof yet—so beware).

And I'll say one more thing on this topic. Branding matters. I'm an ad guy, so I think a lot about how products are positioned and what (and how) they are named. The people at Microsoft elected to call their LLM Copilot for a reason. It's not as advanced and reliable as we might ideally like it to be. They know that, and that's why they didn't name it Autopilot. (Maybe one day it will be rebranded when it advances far enough, but for now the name is apt.) For the moment, the work of LLMs has to be checked. It is designed to be checked.

Personally, whenever I use LLMs, I always go back and check the results. When I'm provided information or answers with no sources cited, I simply ask it: "Can you cite a source for that?" If it can, great. If it can't, I know I need to keep looking. I also will sometimes tell my LLMs: "Only provide me with answers that can be verified by X or Y resources." That often works well, too. (Sometimes it feels like LLMs are children who have to be given very, very specific instructions in order to ensure they do a task the right way.)

And look, despite following these steps, I still occasionally find issues with the responses LLMs provide. They're not perfect, and they're not designed to be—at least not in their current incarnations. What they *are*, however, is an indispensable tool for business (and beyond) that will only become *more* indispensable in the years ahead.

At the core of AI in business will be data. At my company, we've already built an AI-based tool called "Fashion AI" that looks at the entire customer journey—from before she knows that she

Changes for Businesses, Creators, and Workers

wants to buy the product, all the way through to post-product acquisition and returns. We're now using Fashion AI to create a system where brands can access their data and analyze it in real time, making real-time changes. In plain English, that means the CEO, CFO, or CMO of a fashion company can ask questions like: "How is my spend on this social media campaign working?" And can instantly see: "TikTok's not working very well, so let's move our ad spend over to a different platform." Or they can notice: "This one black turtleneck is being returned at a very high rate. Why? Let's investigate and see if we need to fix something."

In the Age of Imagination, businesses will be able to make changes very much "in the moment" because of their access to data. But not every company is here yet. It's my understanding that LVMH, the world's leading luxury conglomerate, currently has about five or six data sets. It can take from thirty to forty-five days for them to analyze this data and then react. That sort of lag time is going to go out the window in the Age of Imagination.

What fashion companies are going to be able to do in an AI-driven future is identify problems quickly, and solve them just as quickly. This can mean quickly addressing changes on the back end—where the customers can't see—but it can also mean quickly and effectively designing new products when the existing ones cease to function effectively. In the Age of Imagination, *your* imagination really is the only limit. Everybody needs to realize that . . . or else cease to be a competitive force.

I have a client at my agency who has 2,000 points of sale in the United States. Their CMO recently said to me: "Marc, it used to be sufficient for me to have six new images per season to use in marketing and branding. Now I need two thousand per month. What are we going to do?"

The answer is—and it's what we've been doing—ramping up a program for them that preserves the core integrity of their creative

team, but uses AI to create additional content while respecting the history and vision of the brand. Two thousand new images a month might once have been unthinkable. Now it's just January.

As creators, we have a responsibility to respect the previous creators who came before us, and to respect the history of vision of the brands we represent. (If we didn't do that at my company, this CMO wouldn't want to work with us!) It all goes back to "do the right thing." Even if the Supreme Court says we *can* do something, we always have to ask if it is right. We need to respect artists, and I'm confident we can do that while still using the awesome new tools AI gives us. Many people involved in the conversation around AI seem to be taking the position that humans will *not* do the right thing in the Age of Imagination unless they're compelled to by the government (or some similarly powerful entity). I just don't believe that that's the case. Most humans are comfortable doing the right thing without the government identifying approved "right things" and distributing a list of them to us. Humans have—and have always had—a strong, innate sense of right and wrong. We won't suddenly lose our moral compass with the advent of AI.

I believe that businesses and creators might gain access to certain leeway with the advent of AI that they don't currently have. Yet it will be up to each and every creator to adopt a moral approach. We will police ourselves, and also police one another. There may be situations where the justice system would find that your use of AI is not criminal or copyright infringement, but it could still be the wrong thing to do; your creative peers might find that it is still a dishonorable use of the AI technology. If they don't believe you're doing the right thing—and/or if your potential customers don't believe you're doing the right thing—you're not going to have a positive outcome from a business point of view.

Changes for Businesses, Creators, and Workers

But what's so exciting is that while we're seeing very little in the way of the negative, we're already seeing AI make tremendous strides in solving problems for businesses. The capability is no longer theoretical. In my own industry, we're looking at the future of retail and the future of shopping. There are three very specific challenges in my industry right now, and AI is helping us to address them.

The first problem is that the biggest area of growth is not in the primary market, but in the secondary one. That is, it's in the market for resale and pre-owned fashion. What's the solution? Brands can use AI to create their own platforms for used goods, and move seamlessly into the space. Brands can introduce their own peer-to-peer platforms to enable their brand's base to engage with these "authorized resellers." (This is already happening. In 2023, Rolex purchased Bucherer, which is one of the largest global retailers of new and used watches. Most industry observers align on the fact that Rolex did this to get into the resale market for pre-owned Rolexes, which has seen explosive growth.)

The second problem my industry faces is returns. About 30 percent of all retail purchases are returned. This incurs significant costs for brands, as many are expected to offer free returns. The AI-driven solution to this issue is "virtual try on" (or VTO) technology. By using AI to give customers a much more realistic impression of how clothing will look on their bodies, we can greatly reduce returns and eliminate this unwanted expense.

The final challenge is how to accommodate the tastes of a group of consumers who are increasingly not homogenous. America is getting increasingly diverse. The first "majority minority" group in the United States—that is to say, the cohort in which white people will no longer be the majority—is now thirteen years old. How can we accommodate this demographic shift? The answer is

that we can use AI to amplify the variety of designs offered, and invest in innovation. We can use AI to diversity and tailor our communication-styles to different communities, and tailor our branding to specific groups.

My examples are from fashion, but in any industry, I firmly believe there's almost no challenge that AI won't be able to assist us with—making things better for the consumer and for businesses at the same time.

AI is also going to improve the ways *all of us* do business because of the contribution it will make to *predictability.* That's something businesses of all types are solely in need of in the twenty-first century.

With the rise of climate change, significant weather events are coming more frequently, and in ways we've never seen before. These events impact many areas of our lives. Safety is probably people's number-one concern when something like a tornado or hurricane happens. But even if you successfully take shelter during a major weather event, the impact on one's livelihood can be calamitous. Crops can be ruined, and facilities can be destroyed. The insurance business is finding it can no longer profitably insure businesses—and private homes—in states like Florida, Louisiana, and California where weather events have become particularly severe. The impacts of this are far-reaching. Construction companies don't know where they will be able to build new homes. This means construction workers don't get hired, and that a national housing shortage continues to go unaddressed. Investors are afraid to greenlight new projects because things have become so unpredictable.

Are these major weather events going to plateau? Get worse? Recede?

What businesses—of all types—desire above all is a predictable

Changes for Businesses, Creators, and Workers

landscape. They need to know what is going to happen next so they can make predictions accordingly.

In addition to the accretive effects of climate change, we know from recent events that major world events in other areas can also make it difficult for businesses to predict the future. Global pandemics like COVID-19 can shut down commerce all over the world. Giant container ships can get stuck in shipping canals, blocking any other ships from getting through and putting global shipments weeks behind schedule. And countries that seemed to have mended their aggressive ways can suddenly start wars against European democracies. Not only are major events like these difficult to predict, but so too are their impacts.

But whether you're attempting to forecast the weather or geopolitical events, AI can help.

AI will bring remarkably superior climate modeling and weather prediction. (Tomorrow.io is already leading the way.) In the small scale, you'll feel this impact by seeing your nightly weather report become much, much more accurate. Meteorologists will be able to make accurate weather predictions much further in advance. But on a macro-level, this technology is going to allow for modeling that can predict the chances of major weather events year-to-year. The impacts of climate change, human-caused pollution, and changing weather patterns can all be taken into account by AI. And as time goes by, AI is going to be able to look across multiple years of data to make new discoveries that will allow us to understand how weather events are connected. AI will be able to track the behavior of wildlife populations, and learn from them when a weather change may be imminent.

The ability to more-accurately predict major weather events—and to do so much further in advance—will allow industries like insurance and real estate to manage risk appropriately. Things

will no longer seem so unpredictable that many businesspeople simply decide to "get out of the game."

Farmers will benefit not only from a superior understanding of weather patterns, but also from AI's ability to analyze soil health, water requirements, and the need for soil rotation. All of these will allow farmers to plant crops in a more targeted way than ever before. AI will also be able to monitor threats in the form of pests and diseases that can kill crops. Disease spreads can be predicted and tracked with much greater accuracy.

But what if the thing destroying your crop isn't an army of wheat mites or aphids? What if it's an army of T-34 tanks sent rolling over your wheat field by a hostile nation? The good news here is that AI holds significant promise for being able to predict major geopolitical events and what their impacts may be for businesspeople and supply chains.

AI can be trained to use predictive modeling to take existing historical data and use it to accurately forecast the impacts of events ranging from trade sanctions all the way up to major ground invasions. It can run simulations that can help businesspeople gauge the outcomes of ongoing scenarios, and make educated guesses about what might happen next. Every war will involve risk, but AI can help businesses understand those risks better than ever before, and take steps to mitigate the ways in which they might be impacted. (I'll talk more later in this book about the need for AI to be objective and neutral, but there are few better examples than this kind of scenario. If Country A goes to war with Country B—and an AI based in Country A is used by businesspeople to help understand what their risks are from this conflict—it will be useless to them if Country A compels its AIs to "patriotically" forecast nothing but swift victories over Country B. AI must be allowed to give bad news. Given the complexity of geopolitical events, we can't make accurate predictions if we are

Changes for Businesses, Creators, and Workers

stymied by irrational investments in who the winner of a conflict will be. AI needs to be transparent about what its basis is for making a prediction, and nationalism and patriotism can't factor in.)

How does our world tend to act? How do we—the humans in the world—tend to act? If we can know these things with some degree of reliability, it's easy for us to do business. If we can't make any predictions at all in these areas, then it probably isn't even worth coming in to work.

By providing businesses with targeted content that brings up better predictions about potential disruptions—and more accurate info about how those disruptions will impact us personally—businesses will be able to not only survive but thrive in an increasingly complicated and volatile world. AI will make it possible.

So I've given my thoughts around how I think AI is going to impact businesses, creatives, and business owners like me . . . but what about the vast majority of people who participate in the economy who neither own nor run businesses? Will artificial intelligence be able to help the rest of us who just go to work at a company each day?

In theory at least, the answer is yes.

Let's start with the first part of employment—finding the job itself.

By leveraging the capabilities of AI, job seekers ought to be able to have an easier time of navigating the job market. They should be able to approach finding jobs more strategically, and learn if there are (or aren't) any appropriate open positions more quickly.

AI will help those who post jobs and those who may be candidates for those jobs to match their skills better than ever before. Job sites and networking sites like LinkedIn will want to employ

the best skill-matching AI capability they can because it will result in a better user experience, and better and faster outcomes for both employees and potential employers.

AI may also be able to notice trends and make predictions based on information in profiles and résumés. These predictions may be less overt, and may be subtle to the point of being practically subliminal. That is because a large job-posting site will be able to use AI to quickly reference large swaths of user data from across the site, and compare that to information about job outcomes. For example, it can look at people who describe themselves as "a real go-getter" on their résumé. It might notice that when people using that description go into sales jobs, they generally have good outcomes and stay at the employer who hires them for at least ten years. However, it might also find that candidates using that term have poor outcomes when they are hired for a marketing position, and tend to stay in their job for a year or less. Noticing this trend, the AI can configure its algorithm to steer "go-getters" to sales over marketing. Everybody wins.

When it comes to choosing those descriptive terms, AI programs can help job-seekers write their résumés to optimize their impact. It can also help with ensuring that résumés look professional and are easy to read. If there are gaps in someone's employment, AI can help suggest the right way to explain them. And if someone's résumé would be very strong if they *just* had one particular class or certification, the AI can notice that too, and can recommend investing in a new course or credential.

AI will also help with the tricky, in-person challenges that are also part of the process. For example, AI powered platforms will be able to generate metahuman avatars (more on these in a later chapter) who can talk to the job-seeker and conduct mock interviews. They can provide feedback on the candidate's answers, make suggestions for improvement, and even conjecture as to

whether they would (or would not) have been moved forward to the next round. Not only is much of this technology already available, but leading-edge AI programs like ChatGPT 4o can view the interview subject, and make in-depth suggestions around presentation skills. It can make constructive comments around a job-seeker's tone of voice, posture, and even choice of interview clothing. It can remind them to make eye contact, sit up straight, and so forth.

In addition to interview assistance, AI can help candidates succeed via networking opportunities. It can do all the same kind of assessment for a mock job interview, but around a rehearsal networking session. It can also proactively make suggestions for which networking events will be the best use of a candidate's time. (For example, it could scan postings to look for events near the candidate, in the candidate's industry, and featuring alumni from the candidate's college and/or from their previous places of employment.)

One exciting potential use for AI in the job hunt is "sentiment analysis." This involves using information about the candidate to find a workplace with the right cultural fit. Beyond an employer's need for someone who will know how to do the "nuts and bolts" tasks involved in a job, employers want workers who will fit in with the company culture. Workers who find that the environment at a company "feels right" are more likely to work hard, and to feel satisfied with the work they do. Some employees want a company that's casual, while others do best amid rigid formality. Other employees will want to work for an entity that has a powerful mission statement, and which professes to serve ideals that are bigger than itself. Others still might simply want a job that pays a good salary, or allows the employees to goof off and have fun from time to time. By helping job seekers find workplaces that align with their values and preferences, they're more likely

to find a satisfying fit where they're likely to stay long-term, and employers are more likely to get satisfied workers.

So, anyhow . . . that's how it's *supposed* to work. But—in a trend we'll see in subsequent chapters—there may currently be a gulf between the potential of AI and how it is being used right now.

For example, when it comes to the contemporary hiring market, some job-seekers aren't using technology to apply for the targeted positions for which they're most suited. Rather, they're using AI to "auto apply" to as many jobs as they possibly can, and/or using it to tweak their résumés to each job (whether or not that change is indicative of any real skill set). The results of this kind of behavior are bad for everybody. For one, the candidates themselves get demoralized. They may think: "I'm sending out a hundred résumés a day and still not getting hired. What's wrong with me?" The catch, of course, is that maybe ninety-nine of the hundred are jobs not really suited to the candidate. Yet the negative impact on their self-esteem is the same.

And employers in this situation face a deluge of résumés from people who may not necessarily be qualified for the posted job, but are simply employing a "spray and pray" approach to job hunting. This situation has led HR departments—perhaps necessarily—to use technology to screen for experience-related keywords before they have actual employees devote time to reading résumés. This contributes to a further "gamification" of the process; applicants are trying to guess the "right" words that will be screened for, as opposed to honestly and thoughtfully describing their skill sets and the reasons why they think they'd be right for the job. Too many job applicants are simply plugging buzzwords into AI programs, and directing the AI to write their résumé and/or work samples. Employers are then using programs to sort through these resumes to look for AI.

Changes for Businesses, Creators, and Workers

Because AI is new, I think American workers (and employers) are struggling to find the right ways to use it when it comes to job-seeking. Obviously, there are many areas where it can provide legitimate, useful help, and create efficiencies for everyone involved. However, job-seekers who choose to sacrifice quality for quantity—and to try to make up the difference by letting AI "do all the work"—are necessarily going to be disappointed in the results. My hope is that as time goes on, we realize the appropriate ways that AI can help both employers and applicants, and that it becomes clear that wasteful and excessive use of it in the job-seeking process serves nobody.

So, we've looked at the job-hunting process, but what about when office workers are doing their actual work?

Here, the coming benefits of AI seem to be entirely positive. Mostly, they're going to make routine tasks easier to complete (and to complete accurately) so that workers can be freed for projects requiring more thoughtfulness and critical thinking.

With the help of AI, many job responsibilities and tasks will be "nearly-automated." Workers will be able to describe tasks to their AI using conversational language, and most of the time AI will know what to do and execute the request accurately. This doesn't mean that the worker isn't working or "doing the task themselves"; it just means that the worker can perform the task with greater efficiency, accuracy, and speed. For example, a worker could tell an AI: "Take the names from the 'Master Project' document, put them into a spreadsheet, and alphabetize them by last name." What might have once taken a data entry clerk several hours of typing and/or copying and pasting will be performed almost instantaneously. This kind of speed will also be possible for scheduling, making and moving appointments, and inviting colleagues to meetings. Or what about image manipulation? A worker might simply be able to tell a program like Photoshop:

"Remove the sweat stains from the bank president's armpits in his new publicity photo." The AI will listen and use the tools at its disposal to adjust the image accordingly.

AI will also be used to take notes, summarize documents or email threads. In live meetings, an AI can listen-in live or to a recording, and produce a summary of any desired length with important points emphasized.

Depending on how comfortable companies become giving AI programs access to their stored information—which I have a feeling will be "very, very comfortable"—AI is also going to be able to answer questions that workers may have about the status and history of projects, which will make many aspects of a company run much more efficiently. For example, when faced with recurring projects or issues, workers are going to be able to ask AI: "How did we solve this last time? What were the steps? How many drafts of the document did it take? Who signed off?" All of these items will be immediately retrievable. And for any ongoing project, a worker would be able to query: "Who has looked at the source material? Who has opened the document itself? Does anybody have any meetings scheduled to work on this?" This can help an employee to quickly understand the status of a project, and where it needs to go next.

Workplaces can also draw upon AI to search its files for archival and storytelling purposes. The histories of important accomplishments will be easy to find and catalog. A veteran employee being acknowledged at their retirement could be presented with a list of every project they ever worked on! (Overall, AI will be incredibly helpful with document retrieval. It will be less likely that anything important is ever lost. Workers will be able to ask an AI "Where are the drafts of the document where we dealt with the X issue?" or "Where is the email thread in which my team discussed the X initiative?")

Changes for Businesses, Creators, and Workers

AI will also be able to make personalized suggestions for employees when it comes to professional development at their organization. If there's something an employee wants to understand better—or a skill set the employee needs in order to get promoted—the AI could recommend classes or tutorials. If an employee is experiencing frustration in the workplace, the AI would be able to look at how other workers have solved that problem in the past, and make suggestions accordingly.

In something that impacts both hiring *and* on-the-job tasks, AI will be able to provide services like immediate, multi-language translation. This will bolster the ability of companies to hire broadly, and to take the most-qualified candidate regardless of language proficiency. It will also facilitate international collaboration.

AI will free up office employees to think more strategically, but it will always be available for things like brainstorming and information-gathering, which can help inform strategy. For example, if a worker would like to have information about trends in an industry over time, or insights that have been noticed over large sections of data, an AI would be able to provide those things. An AI can make suggestions for jumping-off points, and can point out subtle things that may not have initially been noticed.

All of these AI-based enhancements are going to give workers—whatever their roles may be, and whatever place they occupy on the company org chart—the ability to do their jobs more quickly and more efficiently. Employers of all sizes are going to embrace these tools for their employees because it will become necessary to do so in order to stay competitive. AI will make workers happier, will make tasks less laborious, and give everyone more time to focus on strategy and efficiency. It's going to be a win-win.

In conclusion: Businesses, creators, and workers are going to use AI to make remarkable things possible—for themselves, for their brands, and for their customers. Designers will be able to bring just-imagined products to vibrant life immediately, giving companies new ways of exploring possibilities and showing their products to the marketplace. Because AI tools will be available on just about any device, smaller brands—and even tiny startups operating out of apartments—are going to be able to compete for attention and sales in the marketplace. Large, legacy brands don't need to feel threatened by this as long as they remain willing to undergo a paradigm shift themselves, so that they too can move nimbly, deploy content quickly across many channels, and react swiftly to changes in the marketplace. I forecast that so-called "decelerationists" will remain part of the conversation for a few years to come, but businesses and creators who listen to them now will find later that it was a bad idea. No matter what, AI technology impacting the business world is going to evolve swiftly. The good news is that we can insist upon curating it—as it evolves—so that it is morally, legally, and ethically appropriate.

And that's not just talk. If we take the right steps in a collective, thoughtful way, it is eminently achievable. Although I personally favor a free, open marketplace devoid of over-regulation and government intrusion, the following concepts should be explored in coming months and years.

Business communities in Western nations can use their powerful influence to insist on the establishment of ethical guidelines for developers to follow. The guidelines won't have to be developed from scratch; frameworks like the IEEE Global Initiative on Ethics of Autonomous and Intelligent Systems and the European Union's "Guidelines for Trustworthy AI" are already extant. By

making these the kinds of safeguards that any reputable developer would follow, we can create industry-wide safeguards.

We can also work to ensure that the development of ethical AI is incentivized through how projects are funded, grants are given, and investment capital is deployed. We can make it normal for anyone seeking funding for the development of an AI project to feel they need to state explicitly how their work will fall within accepted ethical guidelines. The media can make a point to report on the ethics involved in (or NOT involved in) the development of specific AI projects. Governments and universities can give awards and citations to those who demonstrate excellence in AI ethics. (And then can withhold funding and tenure from those who don't.) We can also insist on "algorithmic transparency" when it comes to the development of AI. Certainly, in a capitalist system with a level playing field, tech companies must be allowed to preserve the "secret sauce" that makes their AI, LLM, or image generator superior to the competition. However, that doesn't mean they cannot be compelled to provide the public (or regulators) with some basic information around how their product makes decisions and decides what requests are appropriate. Competing food and beverage companies can maintain the confidentiality of their recipes while still listing the basic ingredients, nutrition, and calorie counts on the label. So too can we insist that tech companies provide basic information around the mechanisms being used by their AI.

Finally, we can design societal practices and safeguards that allow us to identify and report ethical problems with AI so they can be remedied. A theme you'll notice throughout this book is that I've got a healthy amount of skepticism around the ability of governments or the legal system to effectively regulate AI. I believe a system for allowing problematic AI use to be reported

and remedied is within our grasp without government intervention. The Age of Imagination will make that possible. When proof of an unethical AI system is made public, it can be immediately shared in both traditional media and social media. An educated public will demand that businesses self-correct, and repair any ethical lapses related to their AI development. We've already seen examples of the public refusing to accept AI image generators when they show factually or historically inaccurate pictures. This is heartening. I believe we can look forward to a bright future as long as the public continues to demand content that is accurate and true.

In the future, the marketplace of customers, the marketplace of ideas, and one's creative and corporate peers will demand that legacy and propriety are respected whenever AI is used. I have every confidence that our society will align to insist that this is made possible.

Changes for Businesses, Creators, and Workers

Changes for Businesses and Creators will benefit your:

- *Career: Businesses will have more ways to sell, and more ways to connect with customers. The physical barrier that might have kept someone out of a career, or kept them from building their own business, will fall away. Everything will be accelerated.*
- *Community: The creator community will be empowered in new, unheard-of ways by AI. There will be new ways to create, monetize, and connect with fans.*
- *Family: In an AI-driven future, your family will have better access to goods and services on every platform, and your relationship with creators will explode into exciting new dimensions of connection.*

Where and how to engage with this technology now:

- *AI for use in business is the most competitive space. Learn more by checking out some of the biggest players like OpenAI, Google Cloud AI, Microsoft Azure, IBM Watson, and Amazon Web Services AI.*
- *Take a look at services like Figma, Creatopy, and Uizard which are helping designers and creators make digital mock-ups.*
- *To see a cool hands-on workplace application, check out Chipotle's design lab, where Chippy the Robot is using AI to help its employees make tortilla chips more quickly than ever before!*

In some future day, American fashion will transform by a combination of two disparate things. One is digitization, like, AI. But with digitization, as it becomes hyper tech, human beings will crave what is uniquely human, what makes us human, and so that real personification, the real personal touch will pull us back. Or both things will need to exist simultaneously and that will transform fashion.

**Constance White
Senior Executive Director
of the Social Justice Center,
Fashion Institute of Technology,
and Author of *How to Slay***

CHAPTER TWO

MIRACLES IN MEDICINE

The field of medicine will be accelerated, augmented, and transformed by AI. Humans will live longer, have fewer health problems, and will enjoy their lives more . . . all because of the efficiencies that AI-augmented health care and wellness will provide. AI is positioned to help with all aspects of medicine, from the mundane—making an appointment to see a provider, taking notes during a routine physical—to some of the most complicated and harrowing scenarios faced by providers and practitioners.

As we all know, medicine often involves literal life-or-death decisions that must be made quickly; some of the greatest stakes we can face. It is also a discipline where preparation is key, and where the more information you have, the more empowered you'll be. Health-care providers are charged with assessing a situation, gauging what the challenges and problems are, and then taking decisive action to solve those problems. From surgeons

to physician's assistants, all practitioners stand to benefit from anything that can help them quickly make accurate "if/then" predictions. This is exactly what AI is going to provide.

Yet it's important for me to note that the integration of AI into medicine is going to create situations in which most people will want to ensure a "human element" is still guiding the process and confirming any diagnoses. I think most patients will be comfortable going for a doctor's visit and seeing a physician who is working *in tandem* with an AI. However, very few patients will be entirely comfortable having "a robot" making unaided and unchecked decisions about their health care. For a variety of reasons, it will still be important to have a living, breathing human physician in the room.

At the same time, it's not hard to imagine a situation—perhaps in a remote area, or an under-resourced, developing nation—in which a human physician might not be present to provide care firsthand. In these cases, should an AI be used in place of a human physician? Should this "medical AI" be allowed to prescribe medication? To perform surgery? Here, if there's truly no other option, I think most people will say yes.

Something is always better than nothing when it comes to health care, and there are going to be many situations where an AI can be that "something."

But let's begin at the beginning.

At a high level, in the years ahead AI will mostly assist physicians by providing increased diagnostic accuracy and speed in the examining room. While "doctors"—generally speaking—will never be replaced by AI, it is conceivable that, in the Age of Imagination, a "visit to the doctor" might involve both an AI and a human physician working together. The doctor will be able to use the AI to confirm the accuracy of diagnostic results and imaging, to put symptoms and abnormalities into context, and to

suggest things to the human physician. This combining of wits is likely to lead to better patient outcomes, and also a better patient experience.

With the aid of an AI, a physician can help a patient to better visualize what is happening inside of their body, from a broken bone to white blood cells fighting off a virus. Whether projected as a hologram or shown on a television screen, an AI in the exam room will be used to deploy illustrations to help patients to understand their conditions . . . which is often a first step to effective treatment.

AI will also improve patient outcomes by assisting with the development of new treatments and medicines. The medical field has already amassed copious amounts of patient data (and is compiling more all the time). One of the challenges of assessing the effectiveness of a medical treatment has historically been finding the (human) bandwidth to comb through all of that data. But what if an AI could comb through the data . . . and do it instantly? Not only would cures and treatments emerge more quickly—along with any side effects or risks—but entirely new trends and uses for medications could be discovered. This would allow medical and pharmaceutical companies to identify potential uses for drugs much more efficiently. Ultimately, that will not only reduce costs (with fewer human-led hours of research needed) but more importantly bring effective medications to consumers much more quickly.

In the hospital industry, our current era will be remembered as a time of consolidation and closure. Many independent hospitals and health centers are finding they can no longer remain financially viable, and so they're allowing themselves to be purchased by large hospital systems. Hospitals serving rural populations are being hit the hardest. According to the 2023 *Becker's* "Hospital CFO Report," between 2005 and 2023, 104

rural hospitals in the United States closed. Of the rural hospitals remaining, about 30 percent say that they are at risk of closing in the near future. One of the many regrettable results of this trend is that Americans living outside of urban areas have to travel farther to receive adequate care. AI and the metaverse will provide some of the best solutions for mitigating this situation.

Telemedicine using AI will allow patients to "visit" physicians in the metaverse. Improved video technology and rendering—enhanced with the assistance of AI—will allow doctors to make more accurate diagnoses over video. Physicians will also be able to keep an eye on patients as though they are physically in the room. That's because AI-powered medical devices—which patients can wear or keep in their homes—can accurately track health symptoms and alert health-care providers to any changes, as well as provide a live video feed. This will allow for early interventions for rural patients with chronic or worsening symptoms, and help them know when it's time to take a trip to get in-person treatment.

For both rural *and* urban patients, AI will help healthcare providers make strides when it comes to patient engagement and education. All too often, when patients are advised to learn about steps they can take to better their own health, or about the details of a new diagnosis, their ability to access further information is limited. Sometimes educational materials handed out at clinics are not in the language a patient speaks. Some patients might lack access to neighborhood libraries where they could—electronically or via hard copy—obtain more information about their condition. Some patients simply don't know where to begin and will require hand-holding that has historically been beyond the scope of what hospitals or doctors can provide. Enter AI. In the Age of Imagination, hospitals will be able to deploy AI-powered virtual assistants (sort of like

animated chatbots, but with a breadth of expertise, and with a human charisma that far surpasses anything currently on the market). These virtual assistants will be able to interact with patients from any device—including from things like public computer terminals at a library—and can find engaging ways to answer questions and educate patients about their health-care journey. (Google has already developed a medical chatbot called Articulate Medical Intelligence Explorer, or AMIE, that uses real data from medical consultations to learn how to ask questions, interpret responses, and form differential diagnoses.)

Is the patient new to this condition, or are they already somewhat knowledgeable about it? Are they a "nervous patient" who might need help being brave when it's time for follow-up appointment? The AI will be nuanced enough to adjust for that as well. It will also be "with" the patient at all times, able to answer a question or allay a concern, 24/7. This will enhance patient engagement, improve compliance with treatment plans, and help patients feel empowered to take the right steps when it comes to protecting their health.

At the "macro level," AI is going to help hospitals and health-care systems of all sizes become more efficient. AI will optimize hospital workflows and resource allocations by analyzing patient flow, staffing patterns, and determining what time of day there's most demand for certain medical equipment and devices. Obviously, there are few other industries where staffing is a more sensitive or contentious issue. Nursing care is at the very center of things. Every study shows that when hospitals spread nurses too thinly among too many patients, patients don't get the best care and have poorer outcomes. Yet when hospitals err on the side of overstaffing nurses, some nurses are left with nothing to do and it can create a serious financial strain on the institution. (For a hospital that's already in financial trouble, overstaffing can be

literally ruinous.) With AI able to provide real-time information about when nurses and other health-care providers are likely to be most needed, hospitals won't have to guess. This will help to streamline operations, improve efficiency, and cut costs without sacrificing patient care. (AI monitoring can also help tweak staffing to reduce ER/ED wait times.)

There is also hope that AI can help to somewhat soothe—though probably not entirely eliminate—the tensions between physicians and insurance companies when it comes to authorizing and covering treatments. Insurance companies often require doctors to get prior authorization for certain tests and treatments to avoid overprescribing and prevent physicians from running up an unnecessary bill. In order to keep treatments in check, the insurance companies often require copious written explanations from physicians making a case for why the treatment is needed. Physicians, as should surprise nobody, deeply resent and dislike having to write these explanations. However, there's hope! On their side, doctors are already using LLMs to quickly create these write-ups and check them for accuracy. And on the side of the insurance companies, AI can review the requests for authorization more quickly. Insurers can also use AI to review physician treatment patterns to detect the specific physicians who are authorizing too many unnecessary tests; if they can locate the "bad behavior" by select doctors in this way, it may make written requests for prior authorization less necessary.

In an AI-driven world, health care will be more effective, able to reach more patients in more locations, and will give physicians tools to help make better diagnoses and avoid errors. In short, the industry will be able to do all the things it already does, but just do them better. And AI is going to continue assisting in the medical field—and continue getting better—as long as we humans allow it to train itself on us. I can easily imagine a near-future

Miracles in Medicine

scenario in which we sign a waiver before a doctor's appointment that agrees to allow the AI present to record and learn from our interaction with the physician (while keeping our identity anonymous, of course). I'm willing to bet that AIs will learn superlative bedside manners, and will help ensure that both patients and physicians stay calm and relaxed, and ensure that patients feel heard.

Research is the key driver that makes improvements in medicine possible. Much of the advancement we see in medicine happens behind the scenes, in laboratories and research facilities. Here too, we are going to see AI making incredible advancements possible.

AI has the ability to look at large reams of medical data and spot patterns that human researchers might have missed (or might not spot for years or decades in the course of manual review). AI is going to speed up this data analysis in a way that achieves staggering results. For example, AI tools will be able to review genomic data at scale, identifying differences and mutations in genes that can impact patient wellness. Researchers and physicians will then create courses of treatment that are customized based on a patient's genes, making medicine even more personalized and effective. AI will also be able to study proteomics and metabolomics across large population data sets. (Proteomics is the study of dynamic protein product interactions, and metabolomics is the study of how small metabolite molecules behave within cells). Taken together, AI-aided research in this area is going to result in the identification of new biomarkers and the creation of new therapeutics.

The physical laboratories conducting experiments and generating new treatments are also going to improve. When the robots mixing chemicals are driven by AI, the kind of human error that can mar medical trials is entirely eliminated. AI-driven medical

robots are also able to scan for medical anomalies—such as disease markers or unexplained medical phenomena—and identify them more quickly than humans could. Using algorithms, AI will be able to spot potential drug reactions more quickly. Do humans with certain traits tend to have an unexpected negative (or positive) reaction to a certain drug? This information will help scientists to develop superior candidates for experimentation, and help researchers safely and effectively design human trials for new medicines. AI can help with patient recruitment by analyzing large swaths of health records and figuring out whom to target. And during the medical trial itself, AI can monitor patient data to immediately detect any harmful reactions and/or positive effects. The biases that can color the data in human-led trials will also be eliminated.

In addition, AI will be better at predicting if and when a trial has provided all of the useful data that can be gleaned. For example, in some cases, trials will be able to conclude more quickly—making things easier for both subjects and researchers—because AI can tell there's nothing further to be learned. But if a trial is producing results that are not yet conclusive, the AI can recommend that a trial be lengthened if it believes that doing so will produce a more medically useful result. The quality control throughout medical trials will also be greatly increased. Equipment can be seamlessly monitored by an ever-attentive AI eye. The smooth operation of instruments will be guaranteed, and the quality of large processes and individual instances of data collection will be more carefully scrutinized.

Discoveries on the back end are going to come much more quickly in a world where AI is allowed to do what it does best. That will ultimately translate to better medicine, and better outcomes for patients. Medicine can become more tailored to a patient's unique needs, down to their very genes and proteins. Physicians

will be armed with a much greater knowledge of the best treatment options available to patients, including how medicines and medical treatments are likely to impact each patient.

AI is also going to help the technicians who assist physicians in making diagnoses. In fact, virtually *all* medical professionals who work "behind the scenes" are going to find significant enhancements that become available through the powers of AI.

When it comes to imaging analysis—from an ER doctor looking at an X-ray to try and spot a hairline fracture, to a radiologist looking at a scan for a sign of cancer—AI is going to be able to detect anomalies and medical issues that human eyes would miss. This means catching diseases and cancers more quickly. (I should note that this is already beginning to happen. In June 2024, the journal *Nature Communications* published a joint study conducted by physicians at my own institution—New York University—and by the University of Glasgow in Scotland regarding the use of AI in diagnosing lung cancers in patient tissue samples. The study found that AI could identify the correct type of cancer 99 percent of the time. But more than that, the AI predicted with 72 percent accuracy when patient tumors would recur after treatment, while a sample of human physicians tasked with making the same predictions was only 64 percent accurate. That's an example of an 8 percent bump in accuracy that doctors in the future might enjoy thanks to assistance from AI!)

In this way, the process of image analysis will be not totally automated, but instead, augmented; doctors can take the first look, and AI will be there to do a follow-up check and help eliminate the chances that anything is being missed.

AI will also help improve the already-automated processes involved in sample testing. For example, AI can assist diagnostic processes in the analysis of blood samples that may contain ctDNA, which are small portions of tumors that can be leaked into

the bloodstream in DNA form. Finding these bits of ctDNA can lead to very early detection of cancers, which can greatly improve patient outcomes. However, the sheer bandwidth of processing power necessary to perform this analysis often makes it difficult. Using AI, this sort of analysis will become routine.

And what about after a patient has passed away?

Part of keeping a population healthy is looking at what is causing deaths in a community, and taking the appropriate actions at a macro level. When medical examiners examine the body of a deceased person, their determinations make it possible to spot disease or medical condition trends across communities. For this reason, it's important that their final determinations be as accurate as possible. Here, AI can help as well.

With its supernaturally sharp eye, AI can help detect anomalies in postmortem images that a human physician might miss. This will make it easier to determine the cause of death, whether it be from a disease or from a hard-to-spot cause such as fractures or internal bleeding.

AI can also help medical examiners to determine if or when they need to involve law enforcement. When was an injury caused by a fall, and when by a blow? By immediately comparing wounds on a corpse to those in a database, the AI can look for clues to indicate if a homicide may have occurred. AI can also quickly screen the contents of a stomach—or a bloodstream—for any chemicals that may be associated with causes of death. If any chemicals found are not naturally occurring, then the AI is going to point that out. AI can also help medical examiners more accurately determine times of death. When fed such information as environmental conditions, biological markers, and other information about the deceased, AI can use this to provide much more precise estimations of when a person may have passed.

Or what about cases in which a body arrives at the medical

Miracles in Medicine

examiner's office in a state of decomposition, and without fingerprints or a DNA database match? Here, AI can assist in determining the identity of someone who has passed away. AI-based facial reconstruction technology can help to create visual representations of what someone may have looked like. These can then be compared with images in databases of missing persons. If the recovered body still has teeth, AI can use dental records to quickly compare dental structures in databases looking for a match.

Some of the most interesting uses for AI in the autopsy room involve "educated-guess" scenarios. An AI can look at a deceased person's health risk factors and other information that typically informs unexplained deaths—including drug use—and use this to help an examiner make a best guess. The AI can draw on hyper-local trends for this. For example, if there is local pollution in the area where the decedent lived, or a trend of illegal drug use in the area, the AI can notice and incorporate that information.

AI is not only going to assist physicians in the examining room and the research lab, but also make advancements even after life has ended, creating a rich body of institutional knowledge that physicians can draw on to help living patients in the future. By enhancing the capabilities of medical examiners to make accurate diagnoses, identify the deceased, and understand causes of death, AI is going to help doctors better understand health risks at the micro and macro levels. In doing so, physicians in the community will be able to take more steps to help keep patients healthy and living long lives.

I've talked about how AI is going to help target our improvements in physical health, but I've not said anything about mental health specifically. I should remedy that forthwith, because AI has the potential to *significantly* assist therapists, psychologists, and psychiatrists provide better mental health care!

For example, just as AI is going to be able to look at patient data and medical history to help physicians diagnose a heart problem, so too will AI help mental health practitioners to diagnose mental health conditions. AI can facilitate screening tools and tests to catch common mental health issues like depression and anxiety. It can also look through DNA and family data to look for inherited conditions like chronic depression. If patients need extra screening for certain inherited conditions, the AI can identify this.

Now what about the "third rail" of AI in mental health: virtual therapy metahumans or digital doubles? Look, no matter how advanced AI becomes, there will always be important ways in which a human therapist remains inimitable. There is something powerful about a real, human-to-human connection. Human empathy can be mimicked by an AI, but never completely replicated. When all things are equal, it's probably never going to be the case that AI chatbots become preferred to human therapists.

But with all that said, I think it's clear that AI therapists will still have a role to play.

AI-based virtual therapists can be available, day or night, when a patient needs them most. And while some human therapists do remain "on call" and available to their patients outside of sessions, no therapists can literally be available to all patients at the same time. AI therapists will be a good option for patients who need a therapist they can interact with at 3:00 a.m., who they're certain will be there. (For many therapy patients, access is of the utmost importance.) Virtual therapists will also be a good option for patients who need to see a therapist more frequently than a typical one hour per week session. And patients who may not be able to afford to see a human therapist—or who might be in a living arrangement where access to a human therapist is not possible—will find an AI therapist can be the best option.

Just like humans, AI therapists can help humans cope with

difficult events, provide coaching and education, and deploy cognitive-behavioral techniques. The patient will know that they're not dealing with a human therapist, but there may still be some ways in which the patients will find the experience very satisfying. A patient will understand that a virtual therapist is providing data-driven insights, and is likely drawing on experiences and datasets from multiple patients. It is possible for an AI therapist to "see" many more patients concurrently than a human mental health practitioner could. And that AI is learning all the time, and getting a sense of what forms of assistance are most helpful. The AI can then draw on this experience to develop personalized plans for current patients. An AI can also track progress over time, looking for feedback that may indicate whether or not the therapy is helping the patient reach desired goals; if the therapy is not proving effective, the chatbot can implement changes that may lead to a better outcome.

As the world becomes more comfortable with AI therapists—there are already several companies offering them such as Earkick, Mindspa, and Youper—human therapists may begin to integrate AI therapists into their treatment programs. It may even evolve into a sort of "tag team" approach. For example, an AI therapy metahuman could listen-in to weekly sessions between a human therapist and a patient (held either in-person or over Zoom). Then that AI chatbot therapist could be available to "fill in" for the human therapist if the patient needed support between sessions. The AI would be able to draw on content captured during sessions with the human therapist, and reference it as needed. (From the therapist's perspective, the AI could also have advantages. If the therapist wanted a quick reminder of what had been discussed in last week's session, the AI could easily provide that summary. And if the therapist wanted to get the AI's suggestions for diagnoses and treatment plans, the AI could provide

that advice as well. The AI also might be able to capture nonverbal cues that would give the human therapist clues to a patient's emotional state.)

Another way that AI could be helpful to human therapists is in practice and training. An AI can create realistic simulations of patients with particular mental needs and issues. The therapist can then practice on this patient—whenever and wherever it's convenient to do so—in a controlled environment with low stakes. These AI simulation patients will be constantly tweaked and updated as new research about mental health becomes available. These innovations can be used to optimize the chatbots for optimal development. When AI is allowed to capture the particulars of patient sessions—with the patient's consent, of course—then therapists can "practice" providing therapy to specific individuals and not conglomerate AI constructions combining many patient experiences. If a therapist says: "I'd like to practice providing therapy to someone with borderline personality disorder" the AI will be able to generate that experience seamlessly and quickly.

Finally, one of the most important ways that AI will be able to help mental health practitioners is when it comes to outcome analysis. Given access, AI can collect health data on patients after their time in therapy has ended to give practitioners a sense of how they're doing. Are their symptoms controlled? Are they reporting good mental health? Or have they relapsed and needed to seek more treatment elsewhere? By gauging treatment efficiency, AI can help mental health practitioners to understand where therapy and other treatments have been effective over the long term. This information can also help human therapists and patients arrive at a mutual place of harmony when it comes to ending or suspending treatment. When a physician is helping a patient heal from something like an infection or a broken leg,

it's easy for everyone to see when a treatment has run its desired course. The antibiotics have stopped the infection, or the leg has healed back into pace. But it can be more difficult to know when a patient is in a good mental place to conclude a course of therapy, and/or when a patient might be terminating therapy prematurely for other reasons. By drawing on past patient information and using predictive models, AI can assist mental health practitioners in identifying when conditions are likely indicating that a patient is ready to conclude therapy and move on. And on the other side of the coin, an AI can tell a therapist when it suspects further treatment is still needed.

From personalizing treatment to providing improved diagnostic accuracy, it's clear that AI health care will have much to contribute to AI mental health care. Mental health-care practitioners will have more options, better training, and will know more about patients. Outcomes will be better studied and more effective. And patients themselves will have more options than ever before, even in situations where interaction with human providers may not be available.

In conclusion, it is no exaggeration to say that because of the powerful additions AI is going to make, we are now poised to enter a Golden Age of medicine and longevity. Our ability to detect and diagnose diseases is going to be significantly bolstered by AI predictive analysis. The more historical data AI can absorb, the more accurate its predictions can be. And when symptoms *do* appear, AI will help physicians identify the best possible treatments. Because of the boost given to technicians like radiologists, we are going to be able to read medical imaging much more accurately for earlier diagnoses. AI will use

predictive technologies to aid in the development of drugs and treatments. People with chronic conditions will be able to live better and longer lives because AI will help them with monitoring. Things like blood pressure and glucose levels can be continuously reviewed, and AI will be canny enough to understand from context when a spike in either could be cause for concern, or when it's more likely to be no big deal. Even for people who haven't yet developed chronic conditions, AI wearables can help anybody who wants to keep an eye on their health factors and make changes when any warning signs crop up. AI will be able to help patients gauge their risk of developing certain health conditions based on lifestyle and genetic factors. People will have access to key metrics themselves, and can monitor them at home if they like. But then, armed with that information, AI working in tandem with human physicians can help motivate people to make the exercise, nutrition, and other lifestyle changes to minimize risk and maximize chances for a good outcome. And for those who prefer an AI option, AI-driven mental health practitioners—curated by real psychologists and psychiatrists—can help people make the right choices by providing mental health support, counseling, and motivational training to anybody who needs it. This can reduce stress and anxiety, which are chief risk factors for poor health. All of this can work in tandem to give people new and better options for maintaining their physical well-being. This synergy has the potential to be life-changing, and to extend human life. As the downturn in human life expectancy that has lingered after the COVID pandemic tells us, many factors play into health and longevity. We must avoid "deaths of despair" just as much as deaths from preventable diseases. That's why keeping people motivated is key. By leveraging the efficiencies

of AI, we can move to this Golden Age in which people live longer, healthier lives, and also happier lives.

The companies that work on medical breakthroughs are going to have much-improved access to general data over large populations, and this will allow us to gauge the effectiveness of treatments—as well as spot any health issues potentially impacting large groups—much more quickly. Data around health trends will become an extremely valuable commodity. Because of ethical concerns, protecting these data will be key. (A question in this connection to which I *don't* have an answer: How will a greatly improved ability to predict patients' potential health issues impact the health insurance industry? Will this be the final straw that breaks the camel's back and compels the United States to switch to a single-payer form of universal health care? Or will health insurance companies find a way to remain profitable and still provide wide coverage in this changing landscape? It will be interesting to see what happens!)

I want to end this chapter by quoting a friend of mine who passed away recently. She was an outstanding person, and her family has become very close to mine. When she was diagnosed with brain cancer at a tragically young age, she began sharing with me her thoughts around living with a terminal diagnosis. She would often use the analogy of "broken crayons." She once said to me—and this is verbatim—"I want people to know that I may be a broken crayon, but I can still color vividly." I thought these words were profound because they so aptly express the way that people who may be living with a serious or incurable condition still have so much to give to the world. They still have so much to share with us. And they are still able to experience so much on a personal level.

When I think about the potential of AI to help people like my

friend "color vividly" despite suffering from a serious medical condition, I'm filled with a renewed sense of purpose. The advances made possible by AI in medicine are going to make the world better for so many, and those advances will allow people—even people near the ends of their lives—to make the most of all the time they have left.

These coming miracles in medicine will benefit your:

- Career: Anyone choosing a laudable career in medicine will have powerful tools that will let them perform their job far better than their historical counterparts in the pre-AI world. Yet despite very rapid technological advances, a "human touch" will always be required.
- Community: Communities will be safer in a world where AI guides the hands of physicians. Medical technology will use the benefits of AI to greatly extend our lives. When a health problem potentially impacting an entire community pops up, AI will be quick to spot it.
- Family: Families everywhere will enjoy greater safety and security, faster responses to medical emergencies, and improved access to effective medicines and treatments.

Where and how to engage with this technology now:

- For broad, high-level overviews of how AI is likely to impact the field of medicine, look for resources on the websites of Harvard Medical School and the National Institutes of Health (NIH); they are regularly updated.
- The NIH, the Food and Drug Administration (FDA), and the American Medical Association also have updated resources around how AI will be used to revolutionize and improve the development of drugs, medicines, and medical treatments.
- Those interested in receiving therapy via an AI can already pursue that with a private company like Earkick, Mindspa, or Youper. (Those who would prefer to pursue online therapy with a human therapist—who may simply be guided by AI—can access providers like BetterHelp and Talkspace.)

In some future day, this younger generation will use these technologies to unify against the forces of evil worldwide.

Amy Myers Jaffe
Author of *Energy's Digital Future:*
Harnessing Innovation for American
***Resilience and National Security* and**
Director of the Energy, Climate Justice, and
Sustainability Lab of New York University

CHAPTER THREE

ADVANCEMENTS IN CONTEMPORARY WARFARE

AI is going to revolutionize warfare, making things easier for the good guys, minimizing unnecessary expenditures of materiel, and most importantly minimizing loss of life.

One of the most interesting things about technology in warfare is that it seems to be the area in which the general public is *most* concerned when it comes to the growth of AI in our lives. Mainstream newspaper columnists—often with no expertise in either warfare or AI—imagine scenarios in which an AI is given access to nuclear weapons and uses them to destroy humanity. What's amusing to me about these examples is not just the fact that they're so completely off base. Rather, it's the fact that warfare is one of the areas where AI—or something close to it—is *already* used, and has been used for a very long time.

So, to try to dispel some of these concerns, I'm going to start

by outlining some of the ways we already rely on artificial (or at least automated) intelligence in warfare, and then I'll explore some of the specific AI-based advances we're going to see in the very near future.

You see, since ancient times, warfare has always been about intelligence. The side with the best information is going to win the battle. More general adoption of AI in combat is only going to prove this axiom true. Intelligence matters. It always has. Contemporary military commanders rely on nonhuman intelligence gathering to aid in their strategic planning and decision making. When looking to obtain accurate situational awareness of battlefield conditions, militaries across time have relied on radar, sonar, and satellite imaging. All of these have been crucial to obtaining information on the strength and size of opposing forces, and also such factors as terrain conditions, weather conditions, and movements of civilian noncombatants. AI is only going to make these existing ways of accessing knowledge more effective. Whether the commander on the field is looking to be proactive or defensive, they can use this information to ensure that any actions they take are optimized, and that they allocate their resources and troops in the best way possible.

Militaries also already rely on intelligence to enable them to identify and distinguish threats. Early radar from World War II could only detect when "something" was flying through the air toward them. Yet as technology improved, radar was able to distinguish planes from missiles, and then types of planes from other types of planes. Even before the general integration of AI into the battlefield, soldiers at all levels were relying on artificial electronic determinations to dictate a next course of action. Should a surface-to-air missile shoot down an approaching plane, or let it approach? These decisions have to be made almost instantaneously to prevent disaster, and the soldiers and airmen

Advancements in Contemporary Warfare

involved are relying on machines to give them information about an approaching vessel more quickly than a human eye could possibly discern.

This is all to say that we already trust nonhuman assistants to help us make some of the most important determinations in warfare. Adding AI to the mix is only going to increase their effectiveness.

AI-enhanced combat systems will help militaries make predictions and recommendations on the battlefield more quickly and accurately than ever before. AI is going to significantly enhance current capabilities by providing additional information to decision-makers, ensuring nothing is forgotten or overlooked, and by helping to guide a course of action (while leaving the literal or figurative decision to "pull the trigger" up to a human professional).

How to engage the enemy—or whether the enemy should even be engaged at all—is always a situationally-dependent question. Because AI can quickly correlate data related to a battlefield situation, it will be invaluable for military leaders trying to make a decision about an engagement. AI on the battlefield may be able to suggest new strategies in-the-moment, and give commanders more opportunities and options. An enemy's weakness may be hidden on the surface, but could be detectable in patterns or behaviors that AI will notice. AI will also be able to see symptoms of a friendly unit doing well or struggling. It can access the physiological state of friendly soldiers. It can tell a commander if troops are feeling calm, afraid, motivated to attack, and more. All of these traits can help leadership make crucial decisions on the battlefield.

In baseball, the axiom about hitting is "See the ball; hit the ball." In warfare, it might as well be: "See the enemy; shoot the enemy." But that's often easier said than done. Through near-instantaneous video analysis, AI will make it easier to detect

enemies who may be intentionally concealing themselves. It will also make it easier to identify "friend from foe" and help reduce incidents of friendly fire. AI can also help identify the most vulnerable points at which an enemy should be struck; that is, which points of attack are likeliest to be most deadly. In other words, in a future battlefield augmented by AI, it is going to be harder to hide, and it is going to be harder to survive if you are attacked. (The fog of war is going to get a lot less foggy thanks to AI!)

Many people still have the notion that the future of AI warfare is that everything will be fought by fully robotic combatants. (I suspect they picture something from the *Terminator* film series.) Humanoid metal foot soldiers are still a long way off—and will probably never be practical—but there *are* several ways in which unmanned robots can have a part to play. For example, reconnaissance vehicles—of every sort—that used to require a human pilot will soon be able to gather intelligence under their own power, and without the risk of losing a human life if they are shot down. Specialized battlefield robots will probably also take over the most dangerous tasks like unexploded bomb disposal. When it comes to offensive capability, AI will create entirely new possibilities for existing technologies—with the biggest being drones. Most of us are aware of how drones are currently used on the battlefield. A lone human operator drives a drone into enemy territory for the purpose of 1) gathering video intelligence about enemy troop positions, or 2) to drop a very limited ordnance—like a single grenade—onto the enemy. However, military futurists are already honing in on the capability of drones to be bolstered to a staggering degree when AI is introduced into the mix. The most talked-about possibility is the theoretical ability of large groups of drones to create "drone swarms." These very large groups of drones would be able to launch coordinated attacks that could overwhelm enemy defenses. Because they are

Advancements in Contemporary Warfare

small and maneuverable, it would be challenging to fight back against them. (Picture someone throwing a rock at a swarm of birds, and you'll get some idea of what it might be like.) Because they are so small, these drones would be able to pass through openings too small for a human, and they could be tuned to carry a variety of payloads—from explosives, to poison gas, to guns. They are also faster than humans, with most military drones able to cruise at or near fifty miles per hour. A thick enough swarm could be used as a "living" cover to conceal troops or vehicles, or to overwhelm an infantry position.

I want to note that the use of AI in military situations like those involving drones is also liable to have a "leveling effect" in warfare. That is to say, some of the factors that have prevented smaller, less-advanced countries from effectively engaging militarily with larger ones may fade away. (Will this be a good thing or a bad thing? That answer may depend on whom you ask, and which countries' agendas you support.) Traditionally, larger nations and larger armies had built-in advantages that made it difficult for smaller forces to engage them. Physically big nations could put a lot of land between their enemies and any potential targets. To hit a target deep in enemy territory usually required a large expenditure of time and manpower—in the case of a major tactical incursion—or of money and technology in the case of a laser-guided missile. Drones fitted with AI stand ready to upend this model. Drones can travel great distances—often literally "under the radar"—to deliver a deadly payload to a target. (The conflict in Ukraine has already seen effective drone attacks on Moscow, which is over 280 miles from the Ukrainian border.) Drones are also less costly to deploy than a rocket or missile, and often just as accurate. Unlike a missile or rocket, an AI drone dispatched to deliver a payload to a target is going to be able to "think" and make adjustments as it proceeds. Is there a changing

weather pattern that could conceal a target, or change its trajectory? The AI drone is going to be able to account for that and make adjustments. Does the battlefield suddenly present an opportunity for concealment or subterfuge, such as flying through smoke or clouds? The AI drone can always take advantage of that. If a primary target is destroyed by something else before the drone has reached it, that drone can immediately locate a second-choice or third-choice target, and so on. This reduces the chance that materiel will be wasted. Or what if an attack needs to be called off completely? It's much easier to recall (and preserve) a drone and its payload than it is to self-destruct a hypersonic missile at long distance.

The ability to engage enemies in a targeted way, from great distances, and with minimal financial or manpower investment, is going to substantially change the cost/benefit analysis of military engagements for nations of all sizes. Quite frankly, it is going to eliminate some of the natural safeguards that have so far insulated larger nations and armies from attack. When wars happen in an AI-driven world, I have no doubt that we're going to see some remarkable David versus Goliath scenarios where the outcome is far from guaranteed.

Now let's take a moment to think about how AI is going to help with military operations when they occur *off* the battlefield.

In 1944, British intelligence seriously considered greenlighting a plan to assassinate Adolf Hitler. Codenamed "Operation Foxley," the plan would have involved assassins gunning down Hitler while he took his regular morning stroll around the grounds of the Berghof, his headquarters in the Bavarian Alps. However—though hotly debated internally—the plan was never carried out.

Why?

Advancements in Contemporary Warfare

There were several reasons. One was that the British wished to avoid making Hitler into a martyr-like figure. Another was to avoid giving the impression that the Allies had only been able to win through treachery and "dirty tricks." However, probably the most compelling reason the British had for calling off the assassination was that, by 1944, they *understood* Hitler very well.

Since the start of the war, the greatest military psychologists and psychiatrists had been working nonstop to put together psychological profiles of Hitler. Because of this, the Allies had developed great acumen when it came to predicting what Hitler was going to do next, and how he might react to certain information. Hitler was also not a master tactician; he'd just gotten lucky with a few surprise attacks early in the war. And the British knew that if Hitler was successfully assassinated, the war would not immediately end; the Nazis might select a new top leader whom the Allies did not know so well. (And indeed, being able to successfully anticipate Hitler proved one of the keys to concluding the war quickly in its final months.)

This is obviously a pre-AI example. However, it shows how getting to know one's enemy is a vital part of victory. In this connection, one of the ways that AI is going to give commanders an upper hand on the battlefield will be to enable them to "know" their opponents—both collectively and individually—in every sense of the word. When it comes to anticipating the moves of an opposing commander, AI will enable the military to quickly and accurately construct a psychological profile of them using multiple sources. Are there recordings of video or audio interviews with the opposing commander? Have they written books, articles, or social media posts? What activities do they participate in—or not participate in—on social media? Are there indicators that they could tend toward having a psychological condition like anxiety, depression, or susceptibility to stress?

SOME FUTURE DAY

All of this can be used by AI to help build a predictive psychological profile that speaks to how this opposing commander is likely to react to conditions on the ground.

If you are up against an experienced foe, there will be records of decisions they've made in previous combat situations and battles. When have they historically held their ground, attacked, or retreated? Here too, AI can analyze past behaviors to construct probability models to help anticipate what an opponent is likely to do next.

Do you have "eyes on your enemy?" Perhaps you have access to a camera system that can show you the face of the enemy commander during the battle. If so, AI will be able to use facial expression and micro-expression analysis to provide real-time feedback of your opponent's psychological state. Even if you can only see your foe at a great distance—through a long-distance camera, for example—AI can interpret gestures, posture, and other aspects of body language to tell you how he or she is likely reacting to the situation on the battlefield. Do they seem stressed-out? Are they hesitating before giving orders, as if they're unsure? An AI is going to be able to spot all of these things from a distance.

Other uses of AI are going to give armies a psychological advantage by helping them to understand their foes on a macro-level. The collective personality traits of an enemy can be used to cultivate an approach to combat that gives a tactical advantage to one side.

In 200 BC, ancient Mongolian armies would go into battle with throat singers at the fore of their formation; the unnerving sound could strike fear in the enemy and fed into rumors that the Mongolians had demons fighting on their side.

The ancient Romans built arches and monuments to their own victories in conquered lands as a way of making the local populace feel demoralized and as though rising up would be futile. ("If

Advancements in Contemporary Warfare

the Romans can build a magnificent arch—that we don't even have the technology to build—how can we ever hope to defeat them in a guerilla war?")

In early modern warfare, generals from Napoleon Bonaparte to Robert E. Lee relied on rumor and misdirection to exaggerate the size of their armies and strike fear into opponents (who mistakenly thought they faced a numerically superior force).

And in the First and Second World Wars, countries on every side produced propaganda that portrayed soldiers from enemy nations as inhuman and monstrous. This propaganda was designed to dehumanize the enemy, evoke disgust, and make soldiers lose any compunction they might have around killing the enemy.

I cite these examples to illustrate that military commanders have long been aware of the need to engage the enemy on a psychological level, as well as on the physical battlefield. As we entered the Age of Information and began to see nascent versions of AI-like capabilities, digital warfare became a key element in combat. Psychological operations that once would have been executed in analog fashion—such as leaflet drops—were now executed in cyberspace. Cyber specialists spread disinformation online to create confusion and manipulate perception. (This can be done by dispersing memes that will hopefully be spread online among the populace—or by enemy troops specifically—or it can be done more directly; for example, in May 2024, the security services of Ukraine hacked Russian television and broadcast with what it said were accurate statistics of the number of Russian soldiers killed and wounded since the start of the war. Whether or not the Ukrainian numbers were necessarily accurate, the hack had the effect of sowing the seeds of doubt in the Russian psyche.)

However, going forward, AI is set to transform the intelligence and psychological components of warfare in ways that will make hacking a TV broadcast seem absolutely quaint.

SOME FUTURE DAY

In the Age of Imagination, any military offensive is going to be coupled with malware attacks that immediately disrupt enemy communication wherever possible, and intentionally spread confusion and doubt. Even if only *some* of the enemy's equipment can be disrupted, that's going to make the enemy doubt what they see and hear.

And, I mean, armies are going to get creative with it! What about deploying a deepfake video from the enemy Supreme Leader informing soldiers that their general is a traitor and should not be trusted . . . right before that general leads their forces in an attack? What about deploying false email messages and alerts from genuine spoofed email addresses claiming that the attack has been called off, or that there are a significant number of traitors among the army's own ranks? What about fake phone calls to field commanders from an AI impersonating the general's voice, telling them to surrender? Anything that creates fear, doubt, and uncertainty is going to hurt the enemy in the very moment they want to be psychologically strongest.

In the runup to combat, AI will also be very useful when it comes to data mining. That is, AI will be able to capture and process information about enemy targets (be they machines or people), and uncover otherwise hidden connections that can then be correlated. Who talks to whom? In which directions down the chain of command are orders broadcast, and exactly how? By understanding connections between military entities, enemy forces can be disrupted and demoralized in the very moments when they are counting on clear and orderly communication.

However, it is important for me to note that some critics of AI have forecasted that the introduction of AI into warfare—especially into psychological warfare—is likely to create something sometimes referred to as "the dual use dilemma." This just means that if two opposing forces (who are more or less equally

Advancements in Contemporary Warfare

matched in terms of AI) both use the tactics at the same time, the result will be a kind of AI-arms race. And this race will result in a situation where AI systems on both sides are vulnerable to attack. Each side's own assets could conceivably be used against themselves by the enemy.

I think the correct response to this concern is: "Well, duh."

Obviously, warfare is going to find new verticals when it spreads to the ways we use AI to curate, receive, and deploy information. AI will be just another front, and we'll have to get used to that. Just as the development of aircraft took warfare into the skies, so will AI take it into the cybersphere.

The good news is that the good guys are ahead of the game—and that's true whether you're using AI for psychological warfare, or to actually make moves on the battlefield.

Because the United States and NATO-member nations are literally the most attractive on earth—which is to say, they attract people; humans from everywhere want to move there—we have the best and brightest in the cyber-field to make sure we stay ahead of the game with battlefield AI. Militaries in these nations collaborate closely with the tech sector, and the latest innovations that can make a difference in combat.

Western countries are home to the top, cutting-edge research labs where AI is being (and will be) curated for combat purposes. In the wars of the future, the ability to develop AI-weaponry "in house" by the nations who will be using it will be of paramount importance. AI weapons developed by leading, first world nations can be sold to developing nations for use in regional conflicts, but the leading nations with the largest economies are not going to want to buy their AI capabilities secondhand. In order to be competitive, every country is going to need to work to stay on the leading edge. Major nations like the United States and other NATO countries—as well as Russia and China—will have the

sophisticated cyber infrastructure that will allow them to stay on the leading edge of carrying out sophisticated cyber operations.

The Western world's "attractiveness" will also figure in crucially when it comes to obtaining and keeping the highly skilled employees that will be needed to maintain AI dominance. The militaries of developed nations will be able to attract top talent from the world's top universities with the top computer science programs. Pull any global ranking of universities and take a look at where the schools are located. (The most recent *U.S. News and World Report* ranking of top global universities is from 2023. But in this ranking, twenty-four of the top twenty-five universities are located in NATO-member countries. One of the top twenty-five global universities is located in China. With this kind of lop-sidedness expected to continue for a while, there is every reason to believe that friendly Western nations will stay on the leading edge of advanced AI cyber tactics. However you might feel about the politics and culture of the United States and England, they still have nearly all of the top schools for developing leaders in this industry. It also doesn't hurt that these Western nations are—broadly speaking—wealthy and capitalist. People who study in these nations are going to want to stay in these nations because doing so increases the chance they'll do well for themselves financially.)

But there's more good news!

The United States is also going to have a great advantage when it comes to integrating AI with traditional military capabilities . . . because it has such tremendous military assets to start with. The United States spends over $900 billion on its military each year. That's more than the next six nations (China, Russia, India, Saudia Arabia, the United Kingdom, and Germany) *combined.* And much of this spending goes into developing and purchasing the best technology on the face of the earth. (It should be noted that two

Advancements in Contemporary Warfare

nations—China and India—have a larger number of total active duty troops than the United States. But you have to ask yourself: Is there really a big advantage to having more soldiers in the field if those soldiers have second-rate or third-rate equipment, and they can't trust their own cyber intelligence?)

There are already excellent examples of Western militaries leveraging AI and cyberwarfare to provide advantages in the field—and, in some cases, to win victories in ways that remove the need for bloodshed entirely. For example, consider the 2010 Stuxnet cyberattack on the computers involved in Iran's nuclear program. Generally agreed to have been an initiative of the United States and Israeli militaries, this attack involved sending a cyber virus that infected the software of over a dozen industrial sites in Iran that were tied to its uranium enrichment program. Experts agree that the Stuxnet attack first relayed information about Iran's nuclear program back to the friendly nations, allowing them to see how far along the Iranians had gotten, and then literally took control of the centrifuges involved in enriching the uranium, causing them to spin in a way that they destroyed themselves. Now, could the air forces of the United States and Israel have launched a bombing raid instead? Could they have used leading-edge fighter planes to breach Iran's air defenses and destroy the enrichment sites with missiles and bombs? Almost certainly! However, that approach would also have involved a risk to the friendly pilots flying the mission, as well as to Iranians on the ground. (Even if the attack were carried out late at night to minimize the loss of human life, it's likely that there would still be security guards and maintenance workers on-site.) But more than helping to ensure humans would not be killed, the Stuxnet attack also gave the US and Israel plausible deniability. It's harder to say you weren't involved when planes from your air force are flying over the enemy and dropping bombs. It's another

thing entirely when your enemy arrives at the uranium enrichment lab one morning to find that all of the centrifuges are spinning themselves apart, and none of the controls are working. Iran could make a pretty strong guess as to what was happening and who was behind it, but that's very different than having definitive proof of who destroyed your nuclear program.

In this way, the use of AI and cyber warfare will bring a kind of subtlety to international military operations. Armies will be able to disrupt their foe's civilian or military infrastructures in such a way that it may not be immediately clear that an attack is happening. When is a plane's radar malfunctioning organically, and when it is doing so because it has been hacked? (In a "mine and countermine" scenario like out of World War I, nations will have to develop AI-based anomaly detection systems that can quickly and accurately diagnose whether a malfunction comes from without or within. Only leading, first world nations will have the capability to do this well.)

Going forward, all militaries are going to understand that AI and cyber are critical elements of warfare, and that they must be integrated into every strategy. A military as large, leading edge, and well-funded as that of the United States of America has the best chance of maintaining global dominance and integrated operations.

It's worth noting that I am conjecturing about known entities and military operations. Necessarily, almost every first world government has intelligence agencies and services that flow beneath the surface and are unknown to most people. Even so, these agencies have extensive capabilities that are going to be supercharged by AI. They will be able to monitor global communications and—most importantly—use AI to *detect trends* developing across that information.

Imagine that a country's intelligence services are so advanced

Advancements in Contemporary Warfare

that they can record every phone call made anywhere in the world, and read every email that is sent. That would be great, right? Your country's intelligence services could know everything. But would you? Estimates vary, but most experts think around 13 billion phone calls are placed each day, and anywhere from 300-400 billion emails are sent each day around the globe. Who would have time to sift through all of that? What's the point of having all of these data if you don't have enough hours in the day to review it all? This is where AI comes in. AI is going to be able to "read" and "listen to" source material at an incredibly fast rate that will dwarf the capabilities of any team of humans. AI will be trained to sift through everything it reads and pull out the gems of intelligence information (military or otherwise) that may be useful to the home nation and its allies.

AI will be able to look for specific threats and actionable information—such as emails that say "I'm going to kill the president" or "We'll begin the attack next Tuesday at dawn," but AI will also be able to use historical data to detect more subtle trends. Even when militaries or terrorist cells may be communicating in code, AI will be able to look at things like traffic patterns to determine when an attack may be imminent. Do certain groups cease communication abruptly in a way that's suspicious? Does a pattern of communication match previous patterns that have preceded a military or terroristic action? AI is going to be able to catch all of this.

The robust advantages AI is going to provide will save lives. Terrorist attacks are going to be stopped. Surprise attacks are going to be discovered ahead of time and neutralized before damage can be done. Threats will be shared between allies—who may be using different kinds of AI—and the benefits of sharing information will be key. Collaborative defense efforts will compound the positive impacts of this technology. Best practices can be

shared between allied nations, and they can coordinate on joint cyber operations.

In both defense and offense, leading edge AI is going to give militaries a significant advantage in the wares of the near future. AI is going to predict, detect, and help militaries respond to threats in ways that minimize casualties and result in wins for the good guys. AI will (in some cases) automate and (in almost all cases) optimize offensive military operations to make victories more likely, minimize wasted personnel power and resources, and reduce the chances of noncombatants ever coming to harm. I think that when militaries and civilians alike see the results of AI when it comes to allowing Western nations to achieve "peace through strength," it will become generally accepted that AI is a necessary component of countering threats and preserving peace.

I'd like to close by acknowledging that no matter what we do, AI is going to create situations in which most people will want to ensure a "human element" is guiding the AI and confirming its recommendations—especially in the theater of war. Imagine that a friendly army has trained its AI to identify and classify certain vehicles as enemy tanks, and other vehicles as noncombatant civilian personal cars. But now imagine that in the course of cyberwarfare, the enemy hacks into the friendly AI, and reverses these classifications. Now the AI is seeing "enemy tank" when it should see "civilian in a car" and vice versa. The friendly army can still prevent a potential disaster—and also notice that a hack has occurred—as long as there is a procedure in place to ensure that a human reviews the call that the AI has made (this could mean looking at a screen, or looking through a viewfinder) before the call to launch a missile is made. Put more succinctly, whenever possible, we're going to want humans to "check the work" of AI before a launch button is pushed.

Advancements in Contemporary Warfare

Despite our best efforts, we're going to encounter unanticipated, emergency circumstances that will sometimes require us to make tough choices in these areas. There may be combat situations in which a human operator is not available to verify the target determinations of an offensive weapon that is being powered by AI. In these cases, should the AI-weapon be able to act (and fire) autonomously, until a connection to a human operator can be restored? What if the weapon is defending a population of vulnerable civilians? What if it will mean winning or losing the entire battle?

Warfare can involve the taking or preserving of life. Accordingly, it is among the most serious and controversial areas where AI will be applied. However, because of the tremendous benefits AI can bring, for the overall good of humanity, we will have to embrace it. AI will help us to diagnose situations and recommend corresponding courses of action, and we'll be able to receive these recommendations more quickly, and draw on a greater amount of historical data, than has ever been possible before.

Personally, I have a feeling that when we start seeing AIs helping the good guys win on the battlefield—in a way that minimizes the loss of life for everybody involved—we're all going to get a whole lot more comfortable with allowing it to be our guide.

Advancements in contemporary warfare will benefit your:

- *Career: Future careers in defense will involve the nexus of technology and humanity. AI will endow militaries with grand new powers, and soldiers fighting on the front lines will be kept safer than ever.*
- *Community: Enhanced defense capabilities among Western nations will increase everyone's safety, prosperity, and freedom. The free world will never be freer!*
- *Family: Your family will be safe, secure, and informed far in advance of any threats thanks to the magnificent efficiencies AI will grant to Western militaries.*

Where and how to engage with this technology now:

- *For cutting edge news in this field, you can consult contemporary publications that cover the military, aerospace, robotics, and defense contracting.*
- *The investment in AI at leading military contractors is already strong, and that's for good reason. To learn more, follow the work in this space of companies like General Dynamics, Boeing, Lockheed Martin, RTX, and Northrop Grumman.*
- *The military is already recruiting heavily from leading computer science programs at top universities across the country. Learning more about AI at the college level will inevitably make clear the applications for defense ... and give you some clues as to where the industry is going.*

In some future day, the role of the chief marketing officer will be a pathway to the CEO . . . the role of the CMO is so incredibly important to setting the vision for the company . . . they're the voice of humanity and the empathy from a consumer perspective and corporation.

**Kristin Patrick
Chief Marketing Officer
of Marc Jacobs, and
Former Chief Marketing
Officer of Claire's**

CHAPTER FOUR

CHANGES FOR ARTISTS AND CREATIVES

With the rise of DALL-E and other platforms that can generate visual artwork based on written descriptions, people are once again asking big questions about art and artists. What is art? What is an artist? If a human describes a painting to an AI, and then the AI renders a painting of that description, who is "the artist"—is it either, neither, or both? In these earliest days of AI, some art galleries have confirmed that they will "capital-n Never" display art that has been created by AI. Other galleries, such as the Dead End Gallery in the Netherlands, have opened in order to *exclusively* display artwork created by AI.

What is important for me to clarify right off is that AI is going to help artists make better art, but it will never replace the artists themselves. Like a writer using a thesaurus to quickly find the right word, what AI will do is allow artists of all types to

experiment with creating artistic renderings from different viewpoints—and in different styles—quickly and efficiently. The ability to do this is not going to make art less valuable, or put "real artists" out of business. Instead, it is going to create a democratization of creativity, and give more artists access to the same tools.

The celebrated (and extremely financially successful) artist Jeff Koons famously employs a workshop staffed by dozens of artists producing work that is all ostensibly "by Jeff Koons." These "helper artists" produce examples and variations of ideas that Koons may have explained or described to them, and they help him hit upon just the right design for a sculpture or painting. The works they assist Koons with are then fabricated in Koons's massive workshop.

How can a young, emerging artist—with limited means and no paid staff—possibly compete?

The answer is AI. AI and the metaverse can help an emerging artist to clearly visualize possibilities before she ever sets them to canvas. Art created digitally—or scanned into the digital world—can be manipulated, replicated, and tweaked however she wishes. Three-D printing and digital printers can introduce a final product into the physical world without the need for assistants.

The Age of Imagination will empower artists and creators to disrupt the legacy creative fields, and this is just one example. AI will disrupt not just visual art, but also publishing, music, film, and fashion. The entire world will feel the impact of this change. We'll see more art from more viewpoints, and a democratization of viewpoints. The result will be that *the person who has the power is going to change.*

In the past, we've envisioned the arbiters of art and creativity—i.e., those who can create and deploy the highest-quality content—as being Hollywood film studios, major publishing

Changes for Artists and Creatives

houses, big record labels, massive art workshops, and large fashion companies.

In the Age of Imagination, our arbiters of art and culture can be an eighteen-year-old girl with a creative spark in India, a thirteen-year-old Minecraft fashion designer in Nigeria, or a twenty-year-old hip-hop artist in Harlem. In this new age, we're going to see entirely new revenue streams become possible for creators. Consider the evolution of the recording industry. In the 1970s, musicians who wanted to make an album still needed to purchase expensive studio time in order to record their music onto physical reels of analog tape. The move to the Digital Age slowly replaced the need for recording tape, and digital recording technology soon made home computers the equivalent in quality to professional studios. An enormous mixing and mastering board could be replicated on a laptop. But just when the technology had reached a point that many considered "fully evolved and accessible"—after all, how could something possibly become smaller, faster, or easier than making an album on your laptop?—AI is opening yet more possibilities. Just as it can compose an image or a video, AI can be prompted to create music. Musicians will use this capability to explore how their songs might be adjusted. They will use it to brainstorm and to be inspired. AI will allow composers to immediately hear how a song might sound if the lead instrument were changed from a guitar to a piccolo or a cello. And AI will be able to do this immediately and accurately. Artists will be able to sell not only compositions they have created, but their own signature styles of playing, and even their voices. For example, a singer will be able to sell or license his or her digital voice to other creators. Then secondary creators can create "digital duets" with the original singer, and the original singer can collect royalties. Entirely new revenue streams for artists are going to result from this, and the historic "middlemen"—who

have run creative industries behind the scenes for so long—will be rendered unnecessary.

But wait a moment, I hear you saying. If AI is so good at copying things, what's to stop it from engaging in inappropriate impersonation? If Mick Jagger licenses his voice for use by AI, how will consumers know they're getting the "real" Mick Jagger voice? The answer is the blockchain. Unfortunately, we all know that AI can make deepfakes possible, and deepfakes can indeed succeed in deceiving people in the short term. But the blockchain will eliminate impersonation and help to ensure that authenticity is preserved. Cameras are already able to mint an authentic image to the blockchain the moment a photo is taken, and this will be possible with an audio sample as well. How do I know if the AI Mick Jagger I'd like to license to sing a duet with is the genuine one (and not some dark web knockoff)? I will be able to look that up on the blockchain!

And there are examples of this already happening without the need for licensing. In 2013, the renowned country western music star Randy Travis suffered a stroke that took away his ability to sing. At the time, many assumed his recording career might be over. However, in the spring of 2024, Travis surprised almost everyone by releasing new music that featured him singing. The vocals in the new music were created using AI. Engineers took vocal samples from throughout his career, and the AI was able to employ those samples to replicate the way in which Travis would have sung the new songs. In this case, Travis himself was able to help curate the process, and help both the human engineers and the AI to understand what tweaks were needed to faithfully replicate his signature vocal style.

It is worth noting that this is not the first time replication of someone's existing voice had been attempted. When famed film critic Roger Ebert lost his voice in the course of cancer treatment

Changes for Artists and Creatives

in the 2000s, the Scottish tech company CereProc used existing recordings of Ebert's voice to create a text-to-speech program that actually sounded like Ebert.

In the cases of Travis and Ebert, there was a large amount of source material for the voice replicating technology to pull from—Travis's many vocal recordings, and Ebert's televised movie reviews. But as technology improves, the ability of AI to accurately replicate someone's talking or singing voice won't be limited to only those with a deep catalog from which to sample. Going forward, AI will be able to replicate a voice with uncanny accuracy after "hearing" just a few words.

The Age of Imagination is also going to make it possible for creatives and artists to deploy their work into the virtual world personally, without the need for outside assistance. Because of AI, the digital gatekeepers will soon be gone. A designer who makes clothing in the flesh-and-blood world will be able to sell digital versions for avatars to wear in the metaverse, just by taking a picture of the original garment and letting AI do the rest. Creating physical goods will now mean creating digital assets at the same time. Products that were once shipped direct to customer can now also be deployed "direct to avatar." Fans of a creator are going to be able to engage with his or her work in both the metaverse and the physical world. (To be clear, the difference between the two is not going to change. People will know which is the metaverse and which is the "real world." What's going to change is that the "wall" between the two will become infinitely more porous. With AI renders of photographs, something built in the physical world can be quickly imported into the digital world. And with 3D printing, a product of the digital world can swiftly become physically real.)

If I find an awesome new shirt that I love wearing, and I want my avatar in the metaverse to be able to wear it, too, that should

be able to happen. In the Age of Imagination, it will. And the artist will get paid twice!

Now let's look at narrative art. "Storytelling" is a big-tent term that can encompass creative endeavors like movies, novels, TV shows, operas, video games, comic books, and more. It's who we are, and what we do. Humans are animals that understand themselves and their history through stories. Stories inspire us to imagine what is possible for the future, and help us understand our past. Any fundamental change to storytelling would—obviously—mean a massive cultural shift. This is precisely what AI is about to cause.

There's a movie from the 1980s that has become something of a cultural touchstone—*The NeverEnding Story*. (Despite its title, the film runs just over 90 minutes.) I think of it now because AI's impact on storytelling means that we actually will begin to see narratives that can theoretically extend forever. It will be possible to create tales that literally have no ending. When AI is unleashed in storytelling, creators harnessing its power are going to be able to extend stories as long as they want to. This is already happening with video games and DLC (downloadable content). A game studio may initially design a game with a fixed beginning and end, set within a finite world. In its initial form, it's possible for players to explore every part of the game-world, and to reach barriers past which they cannot proceed. But if the game is popular and appetite remains, the game companies can release DLC "expansions" to the original game. By purchasing these expansions, players can add new locations to the game-world, literally expanding the parameters of the maps, and can continue exploring. The DLC can also change other things within the digital game-world, fixing bugs, or giving players new costumes, tools, moves, and so on. However, with current technologies, DLC content must

Changes for Artists and Creatives

be created by game developers. This means the game companies must make a cost-benefit decision. Namely, will it be more profitable to have their developers create DLC for an existing title, or would they make more money moving on and designing an entirely new game? In most cases, even the most beloved game franchises eventually reach a point of diminishing returns, and the developer makes the decision to move on to a new game. Fans of the original game are then left in a world that—however much it may have been expanded—will now remain finite forever.

But what if that didn't have to be the case? What if the expansions to the game never had to end?

AI will soon make it possible for game studios to quickly and inexpensively create endless downloadable content. This content can continue to be sold to diehard fans of any title that the studio has produced. It will no longer be a "this or that" decision. Using AI as a creative tool, game companies can continue to (quickly and inexpensively) design and deploy high quality DLC that gamers will love, while still creating new titles, too.

But videogames are only one form of storytelling.

Consider the potential for the creation of AI-generated content in movies. For most of history, filmmakers have been confronted by creative restraints that went beyond mere budgetary restrictions when it comes to making sequels. For example, beloved actors in a franchise could grow old or die, or they could engage in problematic on-set behavior that made them impossible to cast. Filming locations could change or be destroyed by natural disasters. Laws allowing filmmakers to shoot in certain settings could be changed.

With the aid of AI, these boundaries can be overcome. Using AI as a creative tool, filmmakers will be able to create sequels to beloved movies and shows for as long as audiences desire. Each year, AI-generated moviemaking gets better and better. Before

long, something generated by an AI-assisted computer is going to be downright seamless.

AI has already eliminated the need for many reshoots in Hollywood. For example, if an actor gives an otherwise perfect take but flubs a single word, that fix can be made retroactively. When AI learns an actor's appearance and voice, it can go in and render perfect what was captured flawed. This opens up entirely new territory for how films can be shot. Say that a screenwriter comes up with a better line for a character to say. . . the day after that scene has finished filming. Using AI and CGI, the filmmakers can go back and change the dialogue to match the new line. Or what about overdubbing? For years, viewers had to choose between watching foreign films with subtitles and the original audio, or with overdubbed voices that did not match the actors' mouths on screen. But with AI, a film can be automatically "ported" from one language to another. For example, a film shot in Spanish can be altered so that their characters are now speaking English—and this is done with the original actors' voices, leaving many characteristics of a performance preserved, and with CGI compelling the actors' mouths to match the changed dialogue. (Just imagine what this is going to do for making films more accessible globally. A film shot in a language that has relatively few speakers can now have a powerful performance seen at box offices around the world. This technology goes way, way beyond making things better for "people who don't like subtitles," though they will certainly be beneficiaries as well!)

Is there the potential for danger or misuse here? I understand why some might be tempted to think so. In the popular science fiction TV show *Black Mirror*, there's a memorable episode titled "Joan is Awful" starring Annie Murphy and Salma Hayek. In this story, a woman's likeness—and life story—is used without her consent by a streaming service. Could such a thing actually

Changes for Artists and Creatives

happen in real life? Maybe it already has, at least a bit. In 2024, OpenAI released a digital voice assistant that sounded very close to the actress Scarlett Johansson's voicing of a digital assistant in the movie *Her*. When the OpenAI product was released, Johansson expressed great displeasure and revealed in interviews that she had initially been approached by OpenAI about voicing their new assistant and turned the project down. This led most industry observers to conclude that OpenAI had simply moved ahead with an imitation of Johansson's voice without her permission. (OpenAI's reputation was not helped when its CEO, Sam Altman, tweeted the word "Her" upon the product's release.) Most legal experts agree that Johansson has extremely solid grounds on which to sue OpenAI. However, apart from any lawsuit, the damage to OpenAI's reputation was already done. The business community, the tech community, and the general public all sided with Johansson.

Technically speaking, yes, AI technology will make it possible for an unsavory production company to steal someone's image or voice and replicate it in a work of fiction without permission. However, such a theft could not be accomplished secretly, and the public has already shown that it will not stand for it. Whether large or small, inappropriate and exploitative use of AI technology in moviemaking is not acceptable.

With the aid of AI, filmed entertainments are going to reach dazzling new heights. Computers are going to make breathtaking visions into reality for creators. The limitations of the analog world are going to fall away, and things that once seemed to be self-evidently impossible will begin to happen. Cinema is going to enter a new Golden Age in which the only limits are what creators can imagine.

SOME FUTURE DAY

So I've talked about storytelling in video games and movies, but what about storytelling that goes beyond a single format? You see, most storytelling currently takes place "in a box." Let me explain what I mean by that. . . . The "box" in question can be the four sides of a movie screen, TV screen, or computer monitor, or it can be the boundaries of a tablet or physical book. It can be the boxy panels of a comic or graphic novel. It can be the frame enclosing an epic painting.

Almost everywhere we currently look at stories, they're in a box.

But in the Age of Imagination, creative entertainments are going to transcend their formats. They will refuse to be "boxed in" and will find homes throughout every wired aspect of our lives. This will take the form of seeing a story move from a film screen to the screens of our mobile devices, to AI headsets, to the sound systems in our cars, and to our experiences in the metaverse. The first step will be incorporating our preferences into the entertainment.

Many contemporary video games already begin by asking players to indicate certain preferences: What do they want the main character to look like? What should the difficulty-setting be? Do they prefer a more story-driven experience, or more running and shooting? When gameplay begins, the game remembers these preferences and curates the gameplay experience accordingly.

Movies and television are going to function this way in the Age of Imagination, but there won't be prompts to indicate our preferences. The AI will know all about you, and will automatically tailor a film to meet your predilections. (You can already see a crude version of this—*with* prompts—on many streaming services. After you watch a movie or show, you might be met with a quick survey in which you'll be asked to select between: "I didn't like this. I liked this. I *REALLY* liked this.") Whether you prefer

Changes for Artists and Creatives

action sequences or not . . . Whether you like horror films that are a little spooky, or downright terrifying . . . Whether you like your romantic sequences PG or extra-explicit . . . All of these preferences are going to be immediately known by the device upon which you're watching a movie or show. Not only will entertainment services tailor suggestions to meet these preferences. They will tailor *the content itself* to conform to what you like . . . and this will happen automatically.

The Age of Imagination will create filmed entertainment that feels like it was literally "made for you." Whatever film you're watching, AI will work to help ensure that you're seeing more of your favorite things, and less of what you don't like.

And of course, it's also important to note that use of AI in entertainment will never be compulsory. Avant-garde *artistes* can continue to make films that are *never* tailored for the preferences of audiences. (In 1995, filmmakers Lars von Trier and Thomas Vinterberg launched the Dogme 95 filmmaking certification. This certification told audiences that the film in question had been shot without the use of special effects, animation, or similar augmentations. Likewise, Age of Imagination filmmakers wanting to certify their work as "AI Free" to meet an artistic vision will always be able to do so.)

Yet filmmakers who *do* embrace AI storytelling will find that they are able to weave tales that take place "outside of the box" in more than one sense. What if you could watch a movie in a theater, but then continue the story on related devices? There are already examples of a story beginning as a ninety-minute movie, and the tale continuing as episodes of a subsequent television show. But imagine if the movie continued on your smartphone, in the metaverse, and/or in a digitally enhanced virtual reality. With the aid of AI, characters in a film you enjoyed might show up as friendly NPCs in your next video game. They might

use your smartphone to tell the next chapter of their tale. Your Kindle reader might populate with written stories of the subsequent adventures of your favorite characters.

And all this would happen quickly and seamlessly.

Now let's go back to *The NeverEnding Story*. If you were a fan of that franchise—and let your AI-augmented devices know it—the tale really *could* continue and become theoretically endless. But let's say that over time, you decide that you don't like dragons anymore. You're done with dragons. They're played out. Does that mean you have to be done with *The NeverEnding Story*? Not at all! This is because, through AI, the story can evolve with you as your preferences evolve. Falkor the dragon can suddenly get "written off the show" if you decide dragons are annoying now, but the rest of the tale can continue.

Stories will become not only never-ending, but ever-evolving. They will be able to change so they can keep up with you.

In addition to viewing, listening to, and reading stories, consumers will be able to interact with stories in entirely new ways.

Returning to the critic Roger Ebert, in 2010 he caused a kerfuffle by declaring that video games could never qualify as "art" because of the way that players are trying to "beat" or "win" them. As you can imagine, he received serious pushback for this position. His readers pointed to games like *Shadow of the Colossus* as a counterpoint.

AI is going to come close to rendering the entire question moot, because it's going to blur the line between where the movie ends and the video game adaptation begins. In the Age of Imagination, video games are going to be able to detect and match users preferences, just like movies. As preferences change, the game will change right along with them. But the revolution in storytelling will come with the interplay between these two narrative formats.

Imagine a consumer who has a favorite entertainment franchise

Changes for Artists and Creatives

about a heroic knight. The consumer initially watches a recurring streaming show about the knight, but eventually decides to play the video game. The video game can pick up the story just where they stopped watching the show. And if the consumer then switches back from the video game to the show, the unique actions and choices made during gameplay will be immediately reflected in the show. Did the knight pick up a silver sword in the video game? Now the actor in the show has a silver sword. Did the knight choose the golden sword instead? Then the sword in the show will be golden instead.

This interactivity will also blur lines between the fictional world and the real world of the consumer. When the consumer can see their unique choices automatically reflected in the future manifestations of the show—movies, TV series, comics, novelizations, and so on—it's going to foster a stunning new level of attachment and loyalty of consumers to the franchise. Imagine that the consumer makes a choice, that that choice is reflected in the franchise, and that the consumer can then purchase a physical 3D-printed product that arose from their choices.

AI will make all of this possible. It will also give us a more competitive landscape for entertainment businesses. Smaller game companies will be able to compete against the bandwidth of larger studios because game design companies are going to have access to the same tools operating at the same speeds. This means that the edge in the marketplace will not come from scale or technological dominance. Rather, it will be decided by who can formulate the best storytelling and design. This will create a truly free marketplace in which consumers will benefit by getting the best games possible.

We're already seeing the first signs of the integration of storytelling and art between formats. Musical artists currently hold virtual concerts in games like *Fortnite*, where digital versions of

their shows are integrated into the game map and become part of gameplay. The artists perform in avatar form. Thereafter, the artist's songs are featured in the game and become part of its universe.

But this is the snowball just starting to roll.

In the near future, AI will see that physical products and experiences are also able to be debuted—and sold directly to consumers—as part of a gameplay experience. Gamers are already comfortable using real and virtual currency to make in-game purchases. Soon, a gamer encountering an in-game concert might have the option of purchasing tickets to a live show in the "real world" when that artist comes to town. Someone purchasing a virtual item of clothing for their avatar might be asked if they'd like to purchase the same garment for themselves from a fashion brand. Or what if a gamer is experimenting in a "sandbox" environment, and they design a totally unique in-game item. Depending on the materials used for construction, the gamer may be able to have that custom-designed item sewn/fabricated/welded (or etc.) and overnighted to their home (my agency is doing this now with a super fan vertical we built named "Spatial Nation").

We already know that Millennials have "broken the seal" when it comes to comfort with digital transactions. Even Gen X is mostly comfortable shopping and designing digitally. That genie is out of the bottle. What's coming next will be the desire for ownership of digital assets, and that is where Gen Z and Gen Alpha are going to take us. Digital assets can be unique when they're made part of the blockchain. NFTs have made multiple generations comfortable with that idea. Gen Z and Gen Alpha will want to create, purchase, and trade digital creative work. This preference will mean a further leveling for creatives. Because AI will make the design and deployment process easy, designers of any age (or in any

Changes for Artists and Creatives

socio-economic circumstance) will be able to go up against the "big guys" and sell digital items they design to gamers, and to anyone operating in the metaverse. The only limits will be design skill and imagination, which will be a boon for consumers who want to collect the best possible digital items.

I see these elements of the Age of Imagination coming together in a "triangle" for artists and creatives. One point of the triangle is content creation; one point is content distribution; and one point is monetization.

Each point is important, and each point is made exponentially more powerful with AI.

Once they are armed with the creative power of AI-based tools, we're going to see a democratization of the creative process. There will be almost no institutional barriers to creating high-quality content. From AI-driven platforms like DeepArt and Runway ML, to more fundamental tools, everything from text, to music, to art is going to be generated beautifully and easily. The limit will genuinely only be the creator's imaginations. It will be easy for artists to focus on making art . . . not finding a way to afford better and more expensive tools.

The next two points—and both of these will be explored in more depth in a later chapter—are connected to getting art in front of consumers and getting paid for it in a fair and equitable way.

Content distribution for artists will become more powerful with AI, especially on social media platforms. AI algorithms will allow social media to gauge interest and engagement patterns to immediately connect users with creative content they're likely to enjoy (and purchase). AI-driven analytics tools will also give

creators valuable information about who is engaging with their art—and how—which will allow them to refine their own content strategies. Because of the way social media works, we're not going to have a small group of arbiters—be they physical art galleries or art websites—but rather a dynamic and dazzling multiplicity of ways to notice and access creative content that lets people forge new connections with the creators of all their favorite stuff.

The final point of the triangle will be the integration of cryptocurrency into artists' compensation models to offer new opportunities for creatives to monetize their work, and to keep more of what they earn. Artists will be able to access these resources from anywhere—whether or not they live in a country with a stable government and/or a stable currency. They'll be able to bypass traditional payment gateways and will lose a much smaller portion of their earnings to fees and middlemen. They'll also enjoy transparency around the sale of their work because of the connection to payment on the blockchain. Provenance-related questions about who purchased a work of art will become a thing of the past. Copyright infringement will be much easier to prove. Recordkeeping will be fast and easy. And as new ways of monetizing work become available—such as licensing for commercial purposes, or creating NFTs—online platforms will make it easy for creators to take advantage of them. Creators will also be protected in their creative expression via the shift from decentralized finance. For example, a repressive government that wants to censor and prevent the sale of a revolutionary artist's art might easily be able to do so in the local currency, but will face challenges repressing a creator who deals in crypto.

This "powerful triangle" is going to be one of the most visible ways that we see the elements that began during the Information Age transformed with AI in the Age of Imagination to directly

Changes for Artists and Creatives

empower a group. The synergy that will be created between creative tools, distribution pathways for works of art, and monetization minted to the blockchain is going to make it easier than ever to have a successful career as a creator. Thriving fan communities will come together, and artists who are monetizing their work directly—and worrying less about breaking down the institutional doors—will find that they suddenly have more hours in the day to focus solely on creative expression.

In conclusion, AI is going to mean a revolution for members of the creative class—and for creativity itself! Whatever you make or design can be quickly visualized and realized, and can just as quickly be taken to market. There will also be infinite exchange between virtual and real worlds. The hatmaker who sews hats in her workshop can easily scan and offer copies of her hats for digital avatars to wear. And a digital designer who makes hats for characters in video games and the metaverse can soon have those same hats available for sale to people in the real world. The ways we tell stories will also change. We will be able to tell them on multiple devices, interact with them and alter them (if we want to), and continue them indefinitely. From musicians, to filmmakers, to graphic designers, new revenue streams will open up as AI makes previously unimaginable collaborations possible.

The imaginations of our creative citizens will be the only limit.

Changes for Artists and Creatives will benefit your:

- *Career: Artists from anywhere will be able to make, curate, and sell their work anywhere and everywhere. Storytellers can tell stories on virtually any device.*
- *Community: The "artistic community" need no longer be a physical place. Anyone from any location will be able to share their work, get feedback, make sales, and become part of a conversation.*
- *Family: Working as an artist will become possible for anyone. No family member will need to "move away" to attend art school or have a career in the art world. Family members of any age will have access to the finest art from all over the world.*

Where and how to engage with this technology now:

- *Designers can explore rendering their work digitally with contemporary software services like Centric, Vmake, and Lectra.*
- *Explore platforms like Charisma AI and Story.com to see how interactive storytelling and virtual worlds are already allowing creators to tell stories in new ways!*
- *From Squarespace to Etsy to Redbubble to Amazon, the field is wide open for artists and creators looking to monetize their work. Educate yourself on the platforms available now, and keep an eye out for developing platforms that may expand the power of creators in the future!*

In some future day, New York State's children will use technology to build tomorrow.

Clyde Vanel
New York State
Assemblyman

CHAPTER FIVE

NEWS MEDIA IN A NEW WORLD

Who do we trust and why?

This question has become central to how Americans interface with news reporting and coverage in the twenty-first century. We now find ourselves with more news sources (and news commentary) than ever before, but the sheer amount of choice this presents us with can be paralyzing. Who is dedicated to reporting the true facts as they happened, and who might have an agenda to their news broadcasts? Where can we turn for the authentic facts, and where would be given "alternative facts"?

AI and the Age of Imagination will most assuredly assist with this dilemma—helping us to answer these questions and get closer to the truth. As the use of AI grows, I believe that for a short period, things are going to get "worse" when it comes to our ability to determine authentic news reporting . . . but then, in the longer term they're going to get much, *much* better.

SOME FUTURE DAY

I'll explain how this will work, but first, a little context . . .

The potential for news reportage—in any form—to be manipulated for propagandistic purposes has been a concern for as long as news-gathering has existed. When photographic images were first made possible in the 1800s, it seemed for a moment that a new technology had given us access to a foolproof way to see what had "actually happened." If there was a photograph of it, then it was definitely real, right? But almost immediately, the ability of photographs to be altered or manipulated became common knowledge. A photograph showed something that *might* have actually happened, but it wasn't ever a sure thing.

Then film and video recordings emerged as a new way to create a true accounting of things. These methods were superior to still photography, and more difficult to manipulate . . . but not impossible. "Special effects" started slowly, but gained ground every year. The move to digital video and digital animation signaled the death knell for the innate veracity of film. Now, AI deepfakes have become the final nail in the coffin.

Today, we live in a world permeated by news—or just as often "news"—which is spread over social media. Major television networks still produce nightly news broadcasts—and some stations like CNN, MSNBC, and Fox News provide twenty-four-hour news cycles—but these formats are glacially slow compared to looking up what's trending on X/Twitter. But, because of the potential for manipulation, when a video suddenly goes viral of, say, a politician taking a bribe, savvy consumers of media are forced to take it all with a grain of salt. It shows something that *might* have happened, yes, but even video is no longer solid proof of something. Only in the subsequent hours and days will it be revealed if the video has been digitally manipulated, staged, or edited. Things that once could have been immediate evidence of something being true now contain merely the *possibility* of it being true.

News Media in a New World

In the early days of AI, we are already seeing notable examples of these manipulations. The pop singer Taylor Swift was the subject of several sexually-explicit deepfake images that were posted on Twitter/X and viewed millions of times before the account posting them was taken down. While most of her fans were able to use context clues to deduce that the images were not genuine, many people were still disturbed by the pictures.

In this way, photographs and hi-res 4K ultra-HD video clips have—astonishingly!—been relegated to the same status as a written account published in a newspaper. The news consumers are still forced to ask themselves: "Does this account come from a trustable source? Has this news outlet reported things accurately and in an unbiased way in the past? Is there any reason for them to be less-than-honest in this instance?"

Some cultural critics have looked at our situation and declared that we're entering a "post trust" period. For example, a Gallup poll conducted in 2022 found that only 34 percent of Americans have confidence that the mainstream media reports the news in a fair, unbiased way. These were some of the lowest figures since Gallup began polling Americans on this topic.

What is the consequence of this lack of trust? In a word: tribalism.

Everyone across the ideological spectrum seems to agree that America's news outlets—just like Americans themselves—are more politically polarized than ever before. Members of a political party and/or ideology seek out news reporting that connects with what they already believe. There are multiple reasons for this. Certain political ideologies might find certain issues more important or compelling, for example. But there can be no denying that a very large part of this tribalism comes from questions of trust. Viewers are asking, "Can I trust that a news outlet will tell me the whole story? Can I trust that I will be told the truth?"

And they're more likely to trust an outlet that feels in sync within their own tribe.

Because we are living in times of great technological capability—when news footage can be so effectively manipulated—many Americans have been tempted to retreat back into the world of tribalism. (For their parts, the news networks will be happy to provide that tribalism—and to stoke the idea that "the other side" is not telling you the whole story—as long as it remains profitable to do so.) I recently spoke with a former editor-in-chief of the *Wall Street Journal*. He, like me, is the kind of guy who generally sees the world through a lens that is fiscally conservative but socially liberal. He also is very invested in the integrity of journalism, and ensuring that the changes brought by the coming revolutions in technology allow the ethics of good journalism to stay firmly in place. This *WSJ* editor told me that—by and large—the public no longer trusts the media because individual journalists are given the burden of ensuring that whatever they report lines up with a preexisting narrative.

This is part of tribalism.

Do you ever get the feeling when you turn on, say, Fox News or MSNBC that you "already know what they're going to say" about a news development? That's because you do. Humans are pattern-recognition machines, and we learn to recognize the patterns of how news is filtered through a certain narrative. According to my *WSJ* editor friend, a majority of journalists now think it is their job to create narrative, not to simply report the facts. They're pressured to do this because facts reported within a narrative—and reported quickly—get more clicks and more eyeballs. (We're already seeing how early-stage AI can be misused to these ends. A large language model like ChatGPT can be told to rewrite a statement of the facts for an audience that is "pro-Second Amendment" or "anti-Second Amendment" or in any other

way that is likely to appeal to certain demographics. This will not have a positive impact on our right to know what is going on, or—in this example—on the Second Amendment itself.)

We're also living in a world where different media formats may lend themselves to certain narratives, and that creates further tribalism. For example, at the time of this writing, the world remains embroiled in the Israel-Hamas War. More and more journalists on platforms like TikTok have moved away from reporting the facts of the narrative, and simply reporting from a pro-Hamas perspective. One reason they are doing this is that the aftermath of a bomb in Gaza is easy to display—quickly and vividly—in the TikTok format. But these videos will always fail to capture the truth and nuances of this conflict because the full story is impossible to tell in an ultra-condensed time frame. And yet, Gen Z remains deeply influenced by TikTok, and so now we see more and more anti-Semitic sentiment within that generation. If we flood the marketplace of ideas from only one perspective, we will not have the kind of careful and complete telling of the facts that will be needed to see the full picture behind complicated world events.

We are also living in times when reporters themselves can simply "become" news outlets. Consider the recent transformations of Joe Rogan or Tucker Carlson. The line between the person and the outlet is virtually nonexistent, but the reach is still a long one. And what will the global impact of that be? When Rogan or Carlson release a video clip that can be immediately translated and captioned, it is shared all over the globe. Does this format have any checks for journalistic integrity? You'll recall that journalism is not a field like law or medicine in which society has agreed one ought to have special certifications in order to practice it.

And continued tribalism will only leave us in a political rut, making Americans who respectfully disagree on a minor point

feel as though an impassable ideological gulf separates them from those on the other side of the issue. Indeed, this tribalism perpetuates the tendency of Americans to "other" those they disagree with. To perpetuate a language of "us and them," when in fact we are all Americans. Everyone agrees political polarization is making the country worse, not better.

But what if it didn't need to be that way?

They might not always be able to agree on everything, but what if Americans could at least find a way to align on whether or not certain things had actually happened? Whether or not they were *actually real*?

Not to get too dramatic about it, but for our country—for *any* country—to endure and function effectively, most people need to be able to agree on a core set of facts. If we can't achieve this, our tribalism will only get worse. About half the country will only trust left-wing news, and about half the country will only trust right-wing news. Anyone simply trying to be an informed citizen and make up their minds after learning the situation will have virtually no place to turn.

We can avoid this fate if we use the tools provided by the Age of Imagination.

How?

Let's start with news photography.

As I noted, photos were the first instrument for providing an unbiased, true rendering of what had happened, and then the first to fall victim to manipulation. It's mostly run under the radar, but for a couple of years already, services have existed that *can mint an image to the blockchain the very moment it is taken*. This essentially creates a "certificate of authenticity" for an image. Anyone can check the blockchain to see when and where the image was photographed, and whether it has been altered or not. The potential of this technology to give confidence to consumers of media

journalism is astounding. (I'm frankly puzzled that it is not already in wider use.)

Because of the importance of this capability, I'd like to take a moment here to explain how it works.

The blockchain is an immutable ledger that keeps an accurate record of information on blocks. Once information is written to one of these blocks, that information is there forever. For example, a block could contain information about who originally mined a Bitcoin, whom they sold the Bitcoin to, and who owns it now. The permanence of something being written to a block means it's tamper-proof, and all edits to the block are available for the public to view.

But how would they actually do that?

A simple program called a "block explorer" (or sometimes "blockchain explorer") is all that is needed. A block explorer is an online browsing tool that users can employ to find the specific information they seek. Most are free to use. Right now, many of the main block explorers are targeted to finding things on the blockchain that users are most interested in verifying—such as cryptos like Bitcoin and Ethereum. (For example, popular block explorers for Bitcoin include blockexplorer.com, blockcypher.com, and btc.com.) Block explorers tend to be designed so users can find the most sought-after information first, which, for crypto, includes when a block was mined, and when a block was involved in a transaction. Many block explorers allow users to generate a "Merkle tree" of the block if they want to, which will provide complete, in-depth information about the block, such as who was involved in any transaction involving the block, which addresses sold the block, which addresses received it, and where those involved were located.

In the Age of Imagination, block explorers will be used to verify much more than crypto transactions. People will want to know

about the authenticity/veracity of images they see in the news, and I have a feeling that the next wave of block explorers will be designed precisely with that functionality in mind.

When image- or video-verification block explorers are commonplace, the process to find desired information will be relatively easy.

First, a user will have to search for the desired digital asset. (Such as an embarrassing photo of the president of the United States; they want to know if it's real or created by AI.) The user will be able to find the digital asset by searching for its unique digital identifier (if they have it), which as a token ID or smart contract address. However, search functions within the block explorer will let users search for the image using conversational phrasing ("photo of the president of the United States taking a bribe while his pants fall down") and a search function within the block explorer will help the user eventually locate it.

Once the image is located, the first thing the user can check are the details of the image's minting. That will include answering questions like:

- To what blockchain platform was the image minted?
 - What time was it minted?
 - In what physical location was the device it was minted from?
- What smart contract was used to mint the image to the blockchain?

These details will provide powerful context clues for establishing authenticity. The circumstances of the minting should match the expected information about the creation of the digital asset (which could be a photo, video clip, or something else). If an image purports to show the president taking a bribe in Geneva in

2025, but the image was minted to the blockchain from Warsaw in 2026, there is good reason to doubt its authenticity.

After they verify the minting details, users of the block explorer will also want to check the image's history and provenance. That is, they will want to know the history of ownership and custodianship relating to the asset. Users will be able to see if the asset has been transferred, sold, or had other changes in ownership. They'll also—in the case of a photograph—be able to look up the camera it was taken with. They'll be able to see if the image has been uploaded to an intermediary device before it was minted to the blockchain. (For example, between being taken on a digital camera and minted to the blockchain, was the photo uploaded to a laptop where it could be digitally altered?)

Finally, while it won't be many folks, those who wish to obtain a granular level of information about a digital asset would also be able to use the block explorer to review the smart contract and ensure it's legitimate. Smart contracts are programs running within a blockchain network that automatically execute agreements when certain things happen and/or certain conditions are met. The term can sound overly-technical and intimidating, but a smart contract is really just an if/then proposition that's automatically executed. If I set up an alert in my online banking such that "*IF* my credit card balance goes over $1,000, *THEN* the bank sends me a text to let me know," I am using a smart contract. In other words, a smart contract is just a digital agreement that's automated so some things will happen if conditions are right. So again, I don't expect many users of block explorers will decide they need to do so, but they *could* peruse the code and documentation used to create the smart contract involved in minting the asset, and verify that all is in order.

By taking the above steps, it will be easy for users in any location—as long as they have access to the Internet—to use block

explorers to discover the circumstances under which an image or video clip was created. They'll be able to do this for important, historic images reproduced in major news outlets, yes—but, if they like, they can also use it to look up casual, fun images that might have been shared on social media. Hopefully, verification of this sort can become as easy and commonplace as stopping to Google something.

As the use of blockchain technology grows, we're already seeing new block explorers being launched for the purpose of verifying NFTs. Being visual art, NFTs are only a hop, skip, and a jump away from being photographic images. I think we are very close to block explorers for photographs and videos.

I can already foresee that services are likely to come into existence because consumers who regularly view media images may find it tiresome to look up all the images they have questions or doubts about. Thus, verification services will likely become commonplace. A news outlet like the *New York Times* could contract with one of these services, which would guarantee that any photo published in the *Times* has been verified via a block explorer by the service. I expect publications will be likely to brand or watermark images to make clear that this verification has taken place.

The effect of this technology on leveling the journalistic playing field is going to be astounding.

If all that a consumer can count on to support the authenticity of an image is the reputation of the news organization publishing it, then a photo running in the *New York Times* or *Wall Street Journal* will always be given much greater credence over an amateur photo by a citizen journalist. But what if that citizen journalist can show that her image is verified as authentic via the blockchain? Suddenly, the overwhelming monopoly of credibility held by a few institutions falls away. Or rather, gets spread around.

News Media in a New World

Anyone anywhere can become a journalist and publish reputable images that are verified as authentic.

What is possible with still photos will also be possible with video. And once *this* catches on, I suspect that most credible news outlets will change their editorial policies so that they *only* publish images or share video that has been verified and preserved on the blockchain. (It is important to point out that photographers and videographers will still be able to customize which data is shared publicly on the blockchain. For example, a photographer taking pictures of soldiers in a war zone might omit location information so as not to betray troop positions. All other circumstances of the image, however, could still be verified as real.) This is because the photographer in question is going to be able to decide which facts about an image are minted to the blockchain, and made searchable using a block explorer.

Propaganda, fake news, and misinformation will always be challenges in any free society, but the Age of Imagination will soon make news integrity more widespread. Certifying the point of origin of a piece of news will become increasingly customary, easy, and also inexpensive. A small-town newspaper will be able to check the veracity of a photo on the blockchain just as easily as the *Times* or the *Post* before they run it.

Freelance photographers and videographers will like this system because it'll help ensure they receive credit when it's due. The person who took the photo—and who should get the photo credit and/or payment—will be preserved right there in the blockchain. (And if someone takes a photo from social media and tries to pass it off as their original work, that will be immediately evident as well.) Freelancers will also like this arrangement because it has the potential to easily create new revenue streams. In addition to the circumstances under which a photo was captured, the blockchain can also mint the current (and any previous) owners of an

image. Whether a freelancer is hoping to sell a photo they took as a collectible—such as an NFT—or they're hoping to license it to a major new organization, they will always be able to prove ownership and authorship. Photojournalists will be able to manage their copyrights, and can employ targeted smart contracts allowing their work to be licensed in some ways but not others. The fact that images will be searchable using a block explorer will be the great equalizer. It'll be just one more way that the Age of Imagination will level the playing field.

This technology also has the ability to positively impact other important areas, such as law enforcement and the courts system. Both video and photo evidence are used in the conviction (or exculpation) of legal defendants in court. However, in the twenty-first century, it's more than reasonable for judges and juries to wonder if an image has been electronically tampered with. They may also question if it was actually shot where and when a prosecutor or defense attorney says it was. With images and footage backed up to the blockchain, the potential for false convictions or exonerations will drop even further.

I'll also note one final use case that is near and dear to my heart as someone who works in the fashion industry and someone who is also a parent of young children who consume media. Much has been written about the impact of unrealistic, unobtainable beauty standards on young people. Consumers of media related to beauty—especially girls and young women—too often come away from reading fashion magazines or online blogs feeling bad about their own bodies, and convinced that they don't "measure up." Well, a lot of this feeling that the beauty standards being presented are "impossible" turns out to be literally true, because the images being shown are digitally manipulated. It's one thing for models to wear flattering clothing and to use makeup, but it's quite another when Photoshop is employed to give bodies

proportions that are unobtainable naturally. I can definitely foresee a body positivity moment happening in the fashion world when young women are able to look up images of fashion models on a block explorer and see if the photos show an unaltered image, or an image that may have been digitally enhanced. It's my hope that this could give all of us more realistic standards for beauty, and leave us feeling better about our own bodies.

At the core of freedom of speech is the ability to confront those in power with facts that they might not like. From the earliest ages of still photography, images have been altered by dictators and tyrants seeking to change the facts of history. The most famous example is probably Joseph Stalin's removal of Nikolai Yezhov—a secret police official who had fallen out of favor—from an iconic photograph in which he stands adjacent to Stalin. (Stalin did this a number of times with photographs of various Soviet officials who he had come to dislike, but the Yezhov example is the most famous.) Stalin also had photos of Russian victories during World War II altered to make his troops appear more heroic. But no amount of false claims and exaggerations by a dictator can stand up to the truth.

What dictators fear is that people will be shown the world as it actually is—as opposed to what the ruler claims it to be. Even today, we still hear unelected (or, more often, "elected") rulers claiming that images and videos are "fake" or "fake news" if it runs contrary to their narrative. And because photo and video manipulation is indeed so prevalent, these dictators kind of have a point. For now, it's at least a possibility that these images might be artificial and manipulated—evidence of nothing.

But when we enter the coming Age of Imagination, and journalists can automatically preserve the circumstances of their filming on the blockchain, it will be a trickier thing (maybe an *impossible* thing) to dispute the truth of what they have captured.

SOME FUTURE DAY

It will not be a magic bullet against all forms of oppression and rule by strongmen, but maybe things will get a little bit easier for the good guys and a little bit harder for the bad guys.

In conclusion, the Age of Imagination will benefit the news media (and consumers of news media) by making the authenticity and provenance of news assets like photos and video easy to verify on the blockchain using a block explorer. This will empower people to be able to find the truth in a world where it's increasingly easy to deploy propaganda. Whether we're wondering if a president of the United States really took a bribe, or if a fashion model is really that thin, we'll be able to know if an image or video shows it conclusively.

Ownership of images—and who or what entities may have licensed an image—will also be easy for consumers to verify. Freelancers will be able to compete with legacy media entities, and it will be easier for them to sell and manage their digital rights (i.e., to make a living freelancing).

An atmosphere of increased transparency in media coverage will be the result. From news outlets with an agenda to repressive dictatorships, it will be more difficult for those in power to manipulate the news. Censorship of certain perspectives—and just censorship in general—will be more difficult to carry out. Photographers and journalists will become more trustable.

Captured media minted to the blockchain will create powerful and unchangeable records of images, allowing historians of media to understand the evolution of an image that may have historical significance. Laypersons, too. It will also be helpful in letting future generations know if a beloved work has been updated or altered digitally. (Think the original *Star Wars* films.)

Creators of images will be empowered to engage directly with audiences while having the same kinds of "cred" and authenticity they might otherwise need an affiliation with a major news outlet to achieve. They will have additional monetization opportunities from this. However, they'll also have increased professional freedom. They won't need to have a major news outlet in their résumé or byline for audiences to take their work seriously.

All of this will foster a more secure, safe, and transparent atmosphere for news gathering, news reporting, and news consuming. Just about anybody will be able to become a citizen journalist. The window of history in which people look at news coverage doubtfully and think to themselves: "Ehh, that might be Photoshopped," or "Ehh, that might be digital animation," is going to begin to close.

In this way, the Age of Imagination can also become an Age of Authenticity.

Changes in Media and Reporting will benefit your:

- Career: Citizen journalists will be able to work from anywhere, and their content can have the importance and credibility of anything captured and shared by a major news organization. Anyone can be a journalist, anyone can start their own news journal, and anyone can make a meaningful contribution to the conversation.
- Community: From national news to hyper-local coverage, communities of all sizes will benefit from accurate, verifiable information captured by small and large news gatherers alike. We will have greater trust in one another as the ability to produce "fake news" falls by the wayside.
- Family: Families will be able to make better decisions—and with greater confidence—because they will have a much improved picture of the world they live in. It will be easier than ever before to have the kind of information that impacts the decisions families make, from the safety of neighborhoods, to the quality of schools, to the cleanliness of the local environment. Better access to accurate information will create better places to live, work, and play.

Where and how to engage with this technology now:

- Go online and educate yourself on the leading block explorers that allow you to check the provenance of items minted to the blockchain. Blockexplorer and Blockcypher are excellent places to start.

- *Learn about products like Camera Mint by Phantom that are already allowing photographers to automatically mint images to the blockchain.*
- *Explore platforms and services like Huggingface, Foto Forensics, and V7's Deep Fake Detector that can already help consumers discover if images or video may have been digitally altered or enhanced (or created out of whole cloth).*

In some future day, parents will use the metaverse to better connect with their children through Virtual Reality.

**Roberto Hernandez
Chief Innovation Officer, PwC**

CHAPTER SIX

BANKING, FINANCE, AND TRUST IN AN AI WORLD

There are few areas in which trust is more important than in financial transactions. One reason for this—at least in America—is that our financial system and the worth of our money is entirely based on trusting in the strength of the government.

In 1933, the United States took its currency off the gold standard, and in the early 1970s President Nixon "cut the last tie" by formally ending the redeemability of the US dollar for gold. Since that moment, American money has famously been backed only by the "full faith and credit of the US government." This was accomplished amid some controversy, yes, but overwhelmingly Americans (and other countries) seemed willing to accept this change. The dollar is still strong.

But why is a dollar worth a dollar? The answer used to be:

"Because it can be redeemed at any time for a dollar's worth of gold." Now it's . . . "Because we say so."

And it's one thing when the country "saying so" is the United States—which has the largest economy on earth and whose money is the global reserve currency—but what about smaller nations with less developed financial systems?

In the COVID and post-COVID economy, we've seen nations around the world experiencing ruinous inflation rates, often well over 100 percent. That inflation impacts the citizens of that nation certainly, but it also impacts other nations—that may have managed to keep their national currency stable—in the form of refugee immigration. Having extreme inflation tends to make you into a bad neighbor. Extreme inflation destroys a country's economy, and that gives rise to increased hardship, increased crime, and rule by political extremists. One need only consider the fate of Venezuelans: they experienced sustained triple-digit inflation, and this led over two million citizens to leave, with more than 10 percent of those coming to the United States so far.

There has always been a relationship between financial institutions and the ability of citizens to trust their government. In some nations—such as China—the government has a very strong hand in ensuring the stability of the banking system and provides deposit insurance. In less stable countries, deposit insurance does not exist, and when new government administrations come into power, they can often seize the money kept in banks for themselves. (Naturally, in such nations, trust in the banking system is incredibly low, with many citizens preferring to quite literally keep their money "under the mattress.")

The good news is that the period of remarkable technological change we are living through has the potential to have a stabilizing effect on economies and "financial cultures" of every size.

However, it also has the potential to allow us to utterly reimagine how we think about the security of our money, where we keep our money, and how we conduct financial transactions.

A law of human nature that seems to be true across cultures (and across time) is that people want to keep their money in a place where it's secure and safe. I mentioned above that the US dollar is the global reserve currency. In case you're not familiar with the term, the global reserve currency is the kind of money in which most countries choose to keep their reserves. Generally, this will also be the currency that they use for international transactions with other countries. It's the currency that the country in question uses to weather fluctuations or crises in their own currency. (For example, if a country decides to keep 50 percent of its reserves in US dollars, and then their domestic currency undergoes extreme runaway inflation of 200 percent, only half of the reserves will be impacted.)

There is no international law that says which country's money is going to be selected as the global reserve currency. Rather, it is selected—moment to moment—whenever nations convert their reserves into money not their own. It can be anything they choose. However, across time, it has virtually always been selected by asking the question: "Where will my money be safest?"

The US dollar has only been the global reserve currency since the 1940s. Before that it was the British pound. However, as the United States emerged as the leading global superpower, most nations reached a consensus that the money of the USA would be the safest place to keep their reserves. If you look back further in history, you'll find periods where the money of Germany or the Netherlands was the global reserve currency.

Because it changes, economists have already started conjecturing as to what the global reserve currency will be *after* the US dollar. For years, the leading candidate has been the Chinese

Renminbi/Yuan. However, those conjectures were made before the Age of Imagination.

The rise of AI, the metaverse, and cryptocurrencies allows us to ask questions that would have been unthinkable just a few decades ago. What if the next global reserve currency doesn't belong to a single country? What if it's something you can never hold in your hands or keep under a mattress? What if it's backed by something more valuable than gold, or more powerful than the strongest nation on earth?

There is good reason to believe we are entering a financial "post trust" era. In a system where the government (*i.e.* the Federal Deposit Insurance Corporation) keeps banks secure, people are feeling increasingly anxious. If you can't trust the government—and the government regulates the banks—then how can you trust that your money is safe? As America swings back and forth to opposite ends of the political spectrum in election after election, Americans wonder how long the stability and dominance of their own national currency will last.

But in the Age of Imagination, we won't have to wonder how safe our money is. If we want to, we will be able to check—moment to moment—exactly how secure it is. And that's because we now have options to keep money in a decentralized, transparent platform that's always safe. Namely, we have the option of moving wealth to stable cryptocurrencies that are minted to the blockchain.

If you've read this far—and/or you know anything about me—it should be clear that I'm an enthusiast when it comes to digital currency. I like it because of the way its decentralized nature keeps government overreach in check. I like the way it makes transactions transparent and keeps people (and institutions) honest. I like the way it allows transactions to take place quickly and inexpensively, and to create spaces where more people can be included in the economy.

Banking, Finance, and Trust in an AI World

The good news is, I'm not the only one who feels this way.

In the years ahead, it's more and more likely that individuals and governments will decide that the safest and most secure place for their money is on the blockchain. The advantages of this are so self-evident that the capacity of the currency of any single nation to "compete" begins to feel unserious. In crypto, transactions can be conducted immediately. There is no way that your reserves could be sanctioned by an enemy government. You won't have to waste time making the case in the public sphere that your nation's finances are strong because anybody will be able to verify on the blockchain precisely what you've got.

The changes resulting from this will be immense, and exciting new possibilities will be opened.

First of all, we may see the end of one of the definitions of a country being "an entity that issues currency." (Can you imagine a country that didn't print and issue its own money? I have a feeling that before too long, you'll no longer have to imagine. We're going to see some real examples.) Shifts into digital currency—for governments and citizens alike—will free up people and countries to do other things. It will also save money. (For example, the United States spends about a billion dollars a year printing and managing the distribution of physical money.) If a full or partial transition was made to keeping reserves in crypto, then time, energy, and currency itself could be saved.

But even more exciting is the notion that cryptocurrency might truly allow someone to become "a citizen of the world." Calling oneself a "citizen of the world" or a "global citizen" is something often done in hyperbole by people who travel frequently, who reside in different countries at different times, or who work in nonprofit fields to the benefit of everyone on the planet. Yet most of these folks—as least as of right now—still find themselves

paying taxes to a single nation, and using its currency. The movement into crypto during our transition to the Age of Imagination will allow people to imagine what it might be like to *truly* be a citizen of no country at all. Imagine a fully functional financial system that was decentralized, with users all over the world. They could still use a single currency, but it would be issued by no government. Yet, this currency could be accepted anywhere, by everyone—whether in the flesh and blood world, or in the metaverse. A person who attuned their personal finances in this way would be able to say that they were a "citizen of the world" and actually mean it!

But let's go even deeper. . . .

What creates "a country" or "a nation"? How do they form?

Historically, the answer has been that a bunch of people get together *in the same physical space* and declare that this space is now Country X. Then other nations—especially the ones bordering that new country—either agree or disagree. If enough countries agree and recognize that "Country X now exists" then congratulations, you've got a country. (Now it can make laws, negotiate trade deals, and come up with its own flag.) But if most countries *do not* agree that Country X exists, then it becomes an "unrecognized state" or an "illegal military occupation" and so forth. (I should point out that international entities like the United Nations can also have a hand in determining whether or not a country exists.)

But what if something could be recognized as "a country" or "a nation" that was *not* a cluster of people living in the same geographic area? What if the defining criteria could be something else entirely . . . ?

We've all heard of "nation states," but in the near future, I have a feeling that we're going to be hearing about "network states" (a phrase first coined by Balaji Srinivasan, the former CTO

of Coinbase and former general partner at the venture capital firm Andreessen Horowitz).

If a group gets together and asserts that they have values in common, a culture in common, and a financial system in common . . . then who's to say that such a group should not be "recognized" in the same sense that a country can be, just because they don't occupy the same physical space? Or just because that space is in the metaverse?

In the Age of Imagination, established countries will still continue to be recognized as they always have, but I won't be surprised if we begin to see the formal, international recognition of these other kinds of states.

The UN's own charter says that it exists "to maintain international peace and security" and "to achieve international cooperation in solving international problems of an economic, social, cultural, or humanitarian character, and in promoting and encouraging respect for human rights and for fundamental freedoms for all without distinction as to race, sex, language, or religion."

Could not a network state help the UN to achieve these lofty goals just as well as a nation state can? If indeed these are the UN's true goals and priorities, it would be foolish to dismiss the power of networks of ideologically committed people connected in the metaverse and by a shared electronic currency who want to help make the work a better place.

Will these network states have their own flags and passports? Will members get to represent their network states in the Olympics? Hey, it's all on the table as far as I'm concerned! Stranger things have happened. What I do know is that the ways that humans can get together and form groups is about to undergo the largest change in human history. Connecting with other people who share your goals and values is going to be easier than ever before.

SOME FUTURE DAY

Another reason I'm excited about the potential of cryptocurrency to decentralize finance is the ability of decentralization to overcome an ancient problem that has bedeviled free people (and free markets) since nations threw off the rule of kings. That is: the tendency for citizens to free themselves from rule by the few over the many—usually through a revolution—only to see a gradual accretion of power by an elite that eventually creates the same situation that the revolution sought to overthrow.

German-Italian sociologist Robert Michels (1876–1936) famously called this "The Iron Law of Oligarchy." Michels's reading of history holds that the reversion of any society to an oligarchy—that is, the rule by a few powerful elites—is inevitable. Inevitable and even necessary. Michels believed that even a society that began as a perfect democracy with a perfectly equitable distribution of wealth, power, and resources would eventually revert to oligarchy. (What of countries like the United States, that maintained an enthusiastic and active electorate, even as income and power inequality began to rear its head? Michels thought that representative democracies like the USA were essentially "window dressing" serving only to make the oligarchs *appear* legitimate and organic.)

Why did Michels—and other followers of his "Iron Law"—believe that there would always be a reversion to oligarchy? Michels gives several reasons, from the need for a centralized bureaucracy to oversee large societies, to the need for people with specialized knowledge, to the simple tendency of humans to want to hang on to their positions of power if it is at all possible to do so. Michels thought that people who are put in charge of something tend to develop a *feeling* that they ought to be in charge forever. As he put it in his seminal work, Political Parties: A Sociological Study of the Oligarchical Tendencies of Modern Democracy:

> The consciousness of power always produces vanity, an undue belief in personal greatness. The desire to dominate, for good or for evil, is universal. These are elementary psychological facts.

Michels was born 150 years ago, but we can see examples of his ideas still playing out today. How many contemporary politicians can *you* think of who do everything possible to cling to power, even if it means debasing themselves, changing constitutions, or playing to the whims of horrible, base people?

I don't know if I agree with Michels on everything, but it's hard to argue that oligarchies don't often arise after revolutions. What's frustrating and troubling is the idea that this is inevitable; that nothing can prevent it (except possibly *another* ground-clearing revolution, which will raze the good parts of the society as well as the unfair ones).

Yet economics is very much at the heart of Michels's ideas, as it is at the heart of most things. One of the reasons why citizens will often accept the rule of an oligarchy is that it brings stability—specifically, economic and monetary stability. Without a stable currency, it's just hard to get anything done. The implementation of thoughtful monetary policy—even if it is implemented by literal or figurative kings—tends to create stability and prosperity. Regulation and oversight tend to help ensure that financial institutions are not taking inappropriate risks with the wealth entrusted to them.

People want regulation and stability, even if it comes from a king. One reason that democratic reforms—or fledgling democracies—can fail is because people grow tired of economic chaos. It has an exhausting effect. If we're being honest, history is full of examples of dictators who were allowed to assume power simply because they brought an end to economic chaos. But what if we

removed this ability from would-be oligarchs? What if we didn't need a heavy-handed kingly figure to help ensure that the currency was safe? What if it was *already* safe and stable . . . because that stability was decentralized and linked to the users of the currency themselves?

A decentralized currency minted to the blockchain is resistant to manipulation. A dictator can't make it stronger or weaker on a whim. It is also more transparent. (One thing about the move toward economic oligarchy is many Americans don't know the extent to which it is happening. A 2015 *Scientific American* article reported on a survey of income inequality and public perception in the United States. Tens of thousands of Americans participated in this survey, and they found alignment on the idea that income inequality was too high. Yet the average respondent said they suspected that the average ratio of pay between corporate CEOs and their unskilled workers was likely 30-1, but that something more like 7-1 would be ideal. In reality, the true ratio of CEO to unskilled worker pay in America is over 350-1.) A decentralized currency tied to the blockchain makes it easy to know who has the money, who has how much, and why they have it. The corporate excesses that may contribute to oligarchy might be at least curbed somewhat by this kind of transparency.

A decentralized blockchain currency can also check the power of oligarchs by limiting inflation and transaction costs. If a cryptocurrency is created with a finite number of coins—like Bitcoin—then a powerful central government cannot simply "print more coins" whenever it needs money, and so devalue the savings of others. And when people buy things using a decentralized currency, it eliminates the ability for the oligarchy to grow itself by imposing transaction taxes. For example, many municipalities impose transaction taxes on major purchases like houses, taking a portion of a home's purchase price for themselves. Yet when

transactions can be conducted in a currency not controlled by the government—and not requiring government intervention—then the levers of oligarchy aren't really there to pull.

Oligarchs also can't use control over a decentralized digital currency to control the growth of businesses. Government leaders—on the national, regional, or municipal levels—can all enact policies to encourage the growth of businesses in their areas; these would be things like tax abatement, deregulation, and investment in location infrastructure. And if they think a business or industry is growing too quickly, they can likewise enact policies to slow things down. (Think of the policies enacted to mitigate the consequences of the "tech boom" in the Bay Area over the last twenty years.) Any government—at any level—that is part of a system that issues or controls currency is going to feel like they're in a position to dictate terms when entrepreneurs and employers have to use their centralized money supply. But when businesses are not relying on a currency tied to the small centralized government of oligarchs, employers of any size are freer to do whatever they want to do. To grow however fast they want to. A local city council member may picture their community as ideally having a small (or large, or medium-size) business community, but businesses using decentralized currency for transactions will find that these local politicians now have at least one less lever to pull to bend local employers to the government's ideal size.

So these are the benefits in this area. And look, every society is going to have to think about how aggressive it wants to be in arresting a gradual slide back into oligarchy, inequality, and a ruling class. If a decentralized currency can help make that happen—can be one more arrow in the quiver of the good guys—then by all means we should use it.

If we see the rise of network states, they may be able to function

as a counterbalance to an oligarchy-trending nation state. In many ways, they can be a literal alternative.

There are also changes to financial services and financial identity that we can expect to see in the nearer term. Some of them are already happening now. Traditional financial institutions—banks, currency exchanges, and so forth—will still exist in the Age of Imagination, but they're going to need to evolve in order to come up with the products consumers want and need.

Financial services providers will always maintain some physical retail presences for the customers who like a personal touch, but online banking will soon be joined by metaverse-banking and virtual banking. As more and more consumers move into cryptocurrency, it may become normal to see crypto wallets offered just as regularly as checking and savings accounts.

The coming changes to financial services in the Age of Imagination will eliminate the boundaries to financial inclusion that still leave too many citizens unbanked or under-banked. People who are unable to produce the proper proof of identification often find themselves turned away at traditional banks. (Sometimes, even if they *do* have all the documentation needed to open an account or apply for a loan, members of marginalized groups still avoid traditional banks out of the perception that they somehow will not be accepted there. It is an unfortunate self-selecting-out.) Americans who are unable to access traditional financial services then find themselves forced to resort to "gray market" or "black market" providers who charge higher fees, demand usurious rates of interest, and place other unfair demands on their customers.

With the rise of digital currencies—possibly under the purview

of a network state as opposed to a nation state—the criteria needed to own, borrow, or exchange a currency may have entirely new qualifications. Someone's place of birth, immigration status, and personal wealth (or lack thereof) may no longer be barriers to opening an account or accessing certain forms of currency. With the rise of digital wallets, the ability of underbanked consumers to send money—quickly, safely, and seamlessly—to friends and relatives around the world will be easier than ever before. Large money transfer fees will become a thing of the past. Financial services in the Age of Imagination will become increasingly democratized, too, and it will be easier than ever for consumers to find financial institutions and entities willing to offer them the services they need—whatever their demographic might be.

Meanwhile, the entire banking system is going to become more customized, better, and friendlier. That last one is important. For years, banking has often been considered an industry without character or personal touch. Banks were too often viewed as devoid of humanity or warmth; as impersonal places where a credit score or loan repayment history will be used by a robot to determine whether loans are granted or terms extended.

This will all change . . . because now it can.

Banks will use AI to create better demographic profiles that can customize the banking experience for each consumer. For example, the AI at my bank will know my hobbies, the social causes I am passionate about, and the cultural "tribes" I'm a member of. (We can see the earliest, most primeval inklings of this today, as banks offer "themed" credit cards, allowing you to flash a New York Yankees or Chicago Cubs logo each time you pay for something with plastic.) In the very near future, I'll be able to walk into a bank branch, and have a customer service entity—either an AI or a real person using AI tools—introduce me to a panoply of financial services products based around my personal ideology,

my presence in the metaverse, and my hobbies and interests. Yes, I'll still be able to get a Yankees Mastercard, but I'll also be offered accounts that comport with my personal views and passions. Maybe I want to make deposits in an account that will be used by the bank to help lower-income persons get a loan for their first home. Or to support the environment. Or to support peace in the Middle East. I can be presented with a suite of investments tailored specifically to my philanthropic interests.

In the Age of Imagination, there will also be greater transparency when it comes to the stability of financial institutions. Because of the number of stable, secure, and transparent options available to consumers—including entities using digital currency that can be verified on the blockchain—in order to compete, traditional banks will have to become more open about their available capital, capital ratios, and so forth. The rise of artificial intelligence will also give banks added tools to genuinely become more stable, secure, and competitive. Algorithms will look for fraud and undercapitalization. Electronic safeguards will help protect banks against becoming unwitting facilitators of money laundering. AI will also improve the value proposition of banks by allowing them to automate many functions, and use AI to fill Balaji Srinivasan in if/when there are staffing shortages. The result will be better customer service and lower costs to the consumer.

Customers will also find that the traditional banking experience is just plain easier overall. (This is true whether they are unbanked/underbanked, or already very engaged with the formal financial system.) More than typical businesses, financial services providers face "pain points" when it comes to basic consumer engagements. Becoming a customer of a bank requires many more steps than becoming a customer of a retail store where you can just walk in and exchange money for goods. (Even if you register for some kind of rewards program, it's still going

to be easier than what you'll encounter at a bank. . . .) But in the Age of Imagination, it will be faster and simpler to provide all the details you need to become a customer of a financial services provider. It will also be easier to access the services, and to obtain financial information you might be curious about. For example, in 2025, it's already fairly quick to walk into a bank and—via an ATM or human teller—get the basic info about my account. (I can do that online or on my phone, point of fact.) But if I have questions about certain loans I may qualify for, or how unusual life situations might impact my personal finances, I'd typically have to make an appointment to sit down and talk with a personal banker. Now, an AI will be able to converse intelligently with me about those nuanced personal finance questions. Even if my questions evolve over the course of the conversation, an AI will be able to keep up.

The Age of Imagination will help banks use predictive analyses to anticipate customers' needs. The recommendations made to customers in the Age of Imagination will have a much better chance of being "just right" to ensure financial stability and grow the customer's money. Banks won't waste their time trying to sell consumers loans that the consumers aren't interested in (or don't qualify for). Every offer will be smarter and will speak to something relevant to the customer's financial needs (whether that's saving, spending, or investing).

JPMorgan Chase has already launched a new AI-powered feature called Cashflow360. Designed for entrepreneurs and small businesses, this feature uses AI to examine a customer's historical transaction history, and then generate cash flow projections for the coming year. This gives small business customers the ability to manage risk, prepare in advance for any "lean times" in the business cycle—or other challenges that may be on the horizon—and to save time. (Chase estimates that small

and medium-size businesses can save up to five hours a week by letting Cashflow360 handle their cash flow management projections.) There are also benefits for Chase. In addition to bringing efficiencies to the customer, Cashflow360 can notice when a customer may have a surplus on their hands, and can make suggestions about investing those extra funds (with Chase, naturally). Likewise, Cashflow360 can see when a business might benefit from a bridge loan, and can immediately approach the customer with an offer.

There are also examples of AI already at work in another part of the financial sphere—filing taxes. ChatGPT 4o is being used to help Americans complete taxes, and also to find the best ways to file. For some time, we've known that AI can help with basic organization, such as locating W-2 and 1099 forms, and extracting the data needed for filing. Using AI for these functions saves time and eliminates errors. AI can also help with error detection and correction. It can spot instances in which figures just don't add up. It can also receive and implement immediate updates—like changes to the tax code—that might impact someone filing their taxes.

But ChatGPT 4o is going deeper.

It can use information about the tax filer to model hypothetical scenarios. These results of these models can help the filer make fundamental decisions about what kind of taxes they file. For example, does it make more sense to file individually with a spouse as opposed to filing jointly? ChatGPT 4o can also suggest specific deductions to take, and make strategic recommendations to minimize tax liability. It can notice when certain deductions (or other aspects of the return) have historically triggered alerts for potential fraud (or at least tended to result in audits). And in a development that is most helpful, ChatGPT can help both individuals and small businesses with filing by forecasting tax

environments over time, allowing for a multi-year approach that helps taxpayers make informed decisions throughout the year(s) to optimize their outcomes at tax time.

Beyond taxes, AI is set to revolutionize personal accounting. Where automated tools once simply helped by processing transactions, with the help of AI they are becoming more like personal accountants. Just as AI can help researchers in scientific fields by "noticing" trends or reactions over large populations, so can it help consumers notice patterns and influences in their personal spending. For many years already, credit card companies have been providing consumers with basic breakdowns of their spending habits. Card users can see how much they spent on basic categories like food, groceries, lodging, fuel, and so on. AI is going to take this kind of information and supercharge it in ways that empower consumers. For example, an AI-enhanced spending report might point out when impulsive, regrettable spending occurs (such as late night online shopping). It might compare grocery shopping trips made just before mealtimes with those made after meals. We'll be able to know our own susceptibility to items offered on sale versus those sold at full price. This kind of knowledge will allow us to have much better perspectives on personalized budgeting and financial planning. We'll also have much better predictive analytics for financial forecasting generally. A better knowledge of how we tend to save and spend will let us plan for upcoming financial needs like never before. We'll know the factors in our lives that make us tend to spend more. We'll know when we tend to save. This will help us save for big purchases and prepare for predictable variations in income.

AI will assist with financial goal tracking over the longer term, too. Current financial planning programs already allow consumers to set basic savings goals—or debt repayment goals—and track progress toward them. With AI-based assistance, we're

going to be given proactive suggestions for ways to better meet our goals. AI will know so much about us, it will have suggestions for investing, controlling spending, and so on. It will have the capability to give us specific suggestions for resisting the temptation to spend in ways we might later regret. It can suggest when taking a vacation might be most affordable, and when it would ruin our budget. It can provide motivation for saving up an emergency fund. As AI knows us, it can come to know the kinds of things that will keep us in the right mindset to save. By helping us to focus on the satisfaction that meeting long-term goals will bring, it can give us the right headspace to continue on our saving journey.

AI-driven platforms can also use knowledge of us to prejudge things like our own tolerance for risk in investments. Most investment instruments ask clients about their tolerance for risk. Yet when we answer, are we being honest with ourselves? Are we likely to respond in a way that we'll later regret—opting for either too much or too little risk? As AI gets to know us, it will have a strong sense of what we *really* want to do with our money, and will make recommendations accordingly. It can also change things as we change. Has a major event upended our personal lives and changed how we feel about risk? Our investment strategies can be tweaked to account for that.

AI can also make our financial and investing journey a journey of learning as well. Many of us reach adulthood without a full or comprehensive knowledge of the financial tools available to us. By offering financial information in the form of tips and suggestions, AI can help us make informed financial decisions, and can grow our knowledge along with our money. AI can make achieving financial literacy a pleasure, not a burden. It can teach us in a conversational way, without our even knowing that a lesson is taking place.

Banking, Finance, and Trust in an AI World

Investment companies will benefit from this. People fear what they don't understand. Educated consumers who have a good working knowledge of the financial products being offered are more likely to engage with them.

Demystifying the investment process and enhancing people's comfort will make things better for everyone. AI guides that are customized to the extent that they can understand our unique wants and needs—and the particular foibles that might tempt us into not sticking to a budget—can keep us on the right track and increase the odds that we'll actually meet our goals.

In conclusion, the Age of Imagination will make access to financial services better than it has been at any time in human history. Better risk assessment and monitoring, the automation of compliance and transparency requirements, and the automatic prevention of certain kinds of fraud will make consumers more confident than ever before that they can accurately gauge the strength of their financial institutions. And AI will make banking personalized, human, and possibly even fun!

Most exciting of all: there will be entities *other than the governments of countries* backing financial currencies. The rise of network states will cause us to rethink how we may picture ourselves as members of one group but not members of another. Powerful new collective entities will be empowered to make choices about what they'll accept when it comes to currency, and what they won't—and who they will or won't admit into their groups.

The Age of Imagination will be a "post trust" era. Quite candidly, we won't *need* to trust in the way that we do today . . . because we'll just know! Things like the underpinnings of a currency's value, the financial health of a bank, or what changes in

the economy will mean for an individual consumer are *all* more likely to be transparent and knowable. With AI-driven predictive analyses and information minted to the blockchain, we will have very early warnings about any kinds of financial distress at any level. This long view will allow nation states, network states, and individual persons to take proactive measures far in advance to head off disasters and enhance confidence and integrity.

> **Changes in Banking and Financial Services will benefit your:**
> - *Career: In a world of decentralized finance powered by AI and blockchain, anyone who wants to become involved in the financial services or investing worlds will find that the significant barriers have fallen. AI will help with improved decision making, and concerns related to risk management and fraud will fall by the wayside.*
> - *Community: AI and blockchain will be a powerful engine for financial inclusion. Any community of any size—including those that have been historically financially underserved—can leverage these tools to build wealth, make investments, and educate themselves on the financial world. With these world-changing changes, the next Warren Buffett may well come from a historically economically excluded community.*
> - *Family: Families will be able to save and invest better and more safely than ever before in the AI-driven world. At financial institutions, they'll have a greatly enhanced customer experience because of AI-driven customization. Risk and fraud will be greatly reduced.*

Where and how to engage with this technology now:

- *Educate yourself about reputable providers that can offer entrances into the world of investing on the blockchain and digital assets.*
- *Explore online communities to find like-minded individuals who may share your beliefs around the future of finance and regulation. Or just eavesdrop and learn where the conversation is. It's always evolving!*
- *Check out personal finance sites and apps—like Rocket Money, Empower, and Simplifi, just to give examples—that can use AI-based tools to forecast your budget needs, share investment opportunities, and help you get the most out of your money.*

In some future day, artificial intelligence will provide children with a world where they can learn anything in a fun and engaging way and are then driven by their curiosity and excitement.

James Villarrubia
Presidential Innovation Fellow, NASA

CHAPTER SEVEN

MEETING HUMANS ... AND METAHUMANS

Probably, there has been no greater prophet of the coming Age of Imagination than the seminal American science fiction writer Philip K. Dick (1928–1982). The author of such prescient works as *A Scanner Darkly*, *The Man in the High Castle*, and *Do Androids Dream of Electric Sheep?* (which was adapted into the film *Blade Runner*), Dick presciently imagined worlds where advertising was customized to each person, microtransaction upgrades were available for nearly every product, and virtual worlds were so real that humans often had trouble distinguishing the organic from the digital.

Yet, it is in his 1978 essay "How to Build a Universe That Doesn't Fall Apart Two Days Later" that Dick comes closest to showing his hand when it comes to the core ideas he is trying to explore in his writing. In this essay, a pair of questions underpin everything for him. They are: "What is real?" and "What does it mean to be human?"

SOME FUTURE DAY

These questions at the core of Dick's writing are exceedingly meaningful to us today as we consider perhaps the most exciting and culturally powerful development in the coming Age of Imagination: the rise of metahumans.

Tinkerers have always been interested in creating gadgets and toys that could "mimic" humans in one way or another. Yet it was not until the twentieth century that computer programmers began to achieve a level of mimicry that seemed to have risen to the level of "thinking" by making decisions and reacting to stimulus in the same ways a human might. The goal of these early experimenters was not necessarily to create a digital program that could "pass" for human—see: the Turing Test—but they were still creating programs that seemed able to behave as though they were intelligent. (It is important in any discussion of metahumans and AI to note that many creatures can be intelligent without being human.)

With the advent of video games, narrative storytelling saw the rise of the NPC. This stood for Non-Player Character and referred to an entity in the game universe that presented itself as a living character, just like the player of the game. In the first text-based video games of the 1970s and 1980s, players would encounter virtual "people" with whom they could sometimes interact. They could fight with them, sure, but they could also ask questions or have conversations. However, because of the limitations of the games, these conversations were very short and only possible within very specific parameters.

With the advent of arcade shooters like *Space Invaders*, players interacted in yet another way with electronic intelligences. Granted, it was a bit primal and primitive. . . . The "intelligences" were things like invading aliens who only wanted to kill the player. However, the player and these NPCs could still interact with one another. If the player shot at the alien, the alien could

Meeting Humans... and Metahumans

have a real-time reaction—usually making an effort to move out of the way. As these games evolved, players began to notice that they could anticipate how an enemy NPC was going to "think" and adjust their own play accordingly. Although the humans and aliens were not speaking to one another, they were still interacting and learning about each other.

Next, the rise of role-playing computer games saw a great leap forward for NPCs. Suddenly, there were many characters in a game who were not adversaries, but behaved like other humans might within the world of the game. For example, in a role playing game, an adventurer might visit a village and interact with the local blacksmith, innkeeper, and healer. These NPCs would impersonate the human equivalents of these village residents (in as much as character might need to speak with them and buy items or services). As the "open world" element of role-playing games grew, game developers expanded the ways in which characters could interact with NPCs. In Elder Scrolls games like *Oblivion* or *Skyrim*, players could assault and kill the village blacksmith, instead of buying helpful weapons from him. The blacksmith would "stay dead" for the rest of the game, and this only made things harder for the player—making it more difficult to complete the main quest of the game—but the overwhelming response of gamers was that they desired this possibility to exist.

The other important evolutionary event for NPCs was their incorporation into multiplayer online games. In these games, multiple human players would genuinely be occupying the same in-game universe (or their avatars would, at any rate), but there would also be computer-driven NPC characters, too. In these situations, the lines were blurred. A player in a game might interact with another character and not be able to tell if they were interacting with an avatar being controlled by another human player or by a nonhuman NPC. This example is so interesting to me

because I think it foreshadows the kinds of ambiguity we will be forced to embrace in the Age of Imagination.

In the near future, if I am playing a video game or interacting with avatars in the metaverse, I may be unable to tell if the characters I'm interacting with are driven by humans from the physical world, or an AI from the digital world. At the same time, I will be able to encounter things in the physical world—drones, cars, humanoid robots—and I will be unable to tell if they have a pilot who is in the physical world like me, or if they are controlled by AI. We're going to see the wall between the two worlds become more porous, and ultimately less distinct.

And after a while, we will not care.

AI will upend human interaction in many positive ways that add all sorts of new options to our lives. There will be both "good and bad" developments in this connection, but overwhelmingly, the changes that come from this will be positive and unlike anything we have seen before. The rise of metahumans will occur naturally as they are used in models and simulations, and this will soon translate into our becoming at ease with metahuman-to-human interaction.

To address head-on the negative consequence that people think of first: yes, there *will* be a small amount of workplace disruption that occurs when AI and metahumans become part of the workforce. Yet only a very tiny number of people are genuinely in danger of "losing their jobs to metahumans." What I think we'll find instead is that with a little training, workers are going to use interactions with metahumans in the workplace to augment how they do their jobs. The introduction of the calculator, the personal computer, or Internet connectivity to the workplace are the only somewhat comparable examples. Yes, a very small number of workers might have lost their jobs because calculators came along, but just a few.

Meeting Humans... and Metahumans

In the coming future, the overwhelming majority of employees will find that working with metahumans allows them to do their jobs more effectively (and often more easily) with enhanced capabilities. Imagine how much more helpful an employee is going to be when they can confer with a virtual colleague who contains an unfathomable wealth of institutional knowledge. Imagine how effective a clerk in a store can be if he or she can introduce shoppers to virtual assistants who already know their preferences, and can guide them through their shopping experience.

As we see virtual assistants doing everything from helping us buy a car to helping our physician make a diagnosis, we're going to have to decide what we're comfortable with—and what we desire—as the world between humans and virtual humans becomes blurred. I predict that in the Age of Imagination, at least *some* humans will want to know with great certainty if they are communicating with a human or with an AI (in a situation where either might be possible). One of the reasons I think this stems from a 1919 work entitled *The Uncanny* by the great psychoanalyst Sigmund Freud. In *The Uncanny,* Freud explores why humans can have eerie or unpleasant sensations when encountering a waxwork or a lifelike doll. He asks why we get a shiver down our spine when a statue in a museum looks "too real." Freud's answer is that humans are classification machines. In fact, one of the things that has allowed us to become the dominant animal on Earth is that we can quickly make classifications and determinations. We put stuff into categories, and we do it fast. For example, "That animal is friendly, and that other animal is dangerous." Or, "That kind of berry is good to eat, and that other kind of berry is poisonous." And so on.

But one of the most fundamental and most important classifications we make is: "That thing is *not* alive, but that other thing *is* alive."

Freud thought that the reason so many creepy, unnerving horror tales involved dolls or statues or lifelike paintings is that they are things that can momentarily confuse our senses when it comes to making the most basic classification—whether we are dealing with a living thing or not.

The uncanny, as Freud called it, is the creepy feeling that results when our brain goes back and forth between placing something into categories, and we feel correspondingly uncomfortable.

In the early twenty-first century, this word would be incorporated into the term "uncanny valley" to address the negative reaction of many audiences to CGI characters in television and film that seemed to blur the line between a human actor and an animated one.

The Age of Imagination is going to take us to some amazing places—and will definitely be a great leap forward for our species—however, I expect that there will still be some hardwired tendencies that will be difficult to shake, and one of them will be a feeling of discomfort that comes from suddenly realizing that you can't tell if the "person" you are talking to is an AI or a human.

Not all people will have a problem with this. Many will embrace a world where they could be talking to an AI or they could be talking to a real person. These folks won't care. In fact, they'll probably wonder why other people have a "hang up" regarding whether or not the person on the screen is flesh and blood or ones and zeroes.

However, for those who *do* have this hang up—and I expect that a significant part of the populace *will*—we can feature labels and indicators to let consumers know if they are dealing with an AI or a real person.

But I think most Americans will fall into the category of those who *don't* care if the entity assisting them is an AI or a flesh and

blood person. Instead, I think what they'll care about is whether or not they are getting the help they need in a friendly, competent way.

Most of those with initial qualms about AI becoming a presence in their lives are likely to adjust as time goes by. It makes me think of an acquaintance of mine who had become a vegetarian, and then tried one of the "beyond" plant-based meat substitutes that features a flavor and texture very similar to actual hamburger meat. At first, this acquaintance of mine was *not* delighted—as I thought he'd be—by how much his burger tasted like it was made out of real cow. Instead, his reaction was: "This is disturbing. I don't like how I can't tell if I'm eating meat or not. I have to trust the packaging to tell that it's just processed pea protein."

But a little time passed, and can you guess what happened? This acquaintance decided it didn't bother him anymore that he "couldn't tell" by taste and mouthfeel alone if something was meat or not. Now he just enjoys his burgers.

Whether in customer service, education, or entertainment, very soon we're going to be dealing with artificial intelligences that function like humans. They will draw on the awesome power of AI to get to know us and learn our preferences, just like an attentive human might. While there may be a period of coming to terms with this—and learning to "trust" the AI—I have the feeling that most people will decide that the pros outweigh the cons. They will choose to "just go with it," and this will open up a whole new world of interactivity for them!

Once we get comfortable with metahumans, one of the most interesting ways we'll see them used will be as a kind of "deputized personal assistant." Let me explain this in more detail.

SOME FUTURE DAY

Some metahumans powered by AI will be composites of many different personalities, or they may be designed with a specific personality in mind. Their design will depend on their intended function. But what if I desire an AI that helps me out by doing *the exact things that I would do* . . . if only there were more hours in the day?

Let's say I have to do some routine shopping, but I've got a busy schedule. I can deputize my avatar powered by AI—which has learned my preferences and how to reliably "impersonate me"—to go into the metaverse and do my shopping for me. It knows what I like and what brands I prefer. It knows if there's something I only buy if it's on sale, or if I'm loyal to a certain product whatever the cost. It can then walk down the virtual aisle of the store, purchase what I would purchase at the store in person, and have it all shipped to my door.

And as AI avatars get smarter, ordering the groceries won't be the only time-saving thing it will be able to do.

Imagine an AI that has learned not only my preferences, but my voice and writing style. I could decide to allow it to respond to certain emails for me. Just as we can currently sort emails into categories like "Focused" "Other" "Archive" and so on, in the near future we'll be able to sort into "Answer Myself" and "Let My AI Reply" if we want to. Think about how much time we spend responding to messages in 2025, and you begin to understand what a time-saver this is going to be. There is already precedent for this sort of thing. Think of the president of the United States. For many years already, US presidents have authored (and signed) some documents themselves, but which are written by staff . . . and then they get the autopen signature from the president. Soon, you won't have to be elected to the highest office in the land to have someone replying to your

Meeting Humans ... and Metahumans

correspondence for you. AI technology will deploy these efficiencies to nearly everyone . . . not just world leaders.

Or imagine that I am selling my house. I could "deputize" my AI-powered avatar to meet with a potential buyer in an immersive environment that re-creates my home using photos. With AI, we can sort of "physically inhabit a real estate listing." My AI could take them on a walkthrough of my home, and answer basic questions about it. Then, if the visitor was interested, they could meet me in person and take an actual tour. But think of how much time I'd save "weeding out" the potential buyers who will decide they're not interested after an initial glance.

Does all this sound far-fetched? I understand why it might, but really, this is just an extension of many of the things we've already been entrusting to automation. (The AI powered version will be just a bit "smarter.") We already trust robots to perform our repetitive and mundane tasks, like sorting and folding things. When our bank or credit card company sends us a breakdown of our spending, we trust it to do financial thinking for us, and we can give it parameters. I can tell an investment program I'm comfortable with X or Y amount of risk, and it selects a mutual fund for me accordingly. Or I can tell my bank to send me an alert when my credit card debt goes above $5,000, or my credit score drops below 700, and can adjust my spending accordingly. We trust AI vacuum cleaners to putter about and vacuum our floors when we're away. We tell a slow cooker to turn on and start cooking our dinner at noon, even though we won't be home until six. We can give smart homes if/then commands and trust they'll be followed: "If the wind gets above ten miles an hour, then lower the shutters. If the temperature falls below 60, then turn the heater on. If the motion detector senses something after 9:00 p.m., then turn on the floodlights."

SOME FUTURE DAY

And many of us already use automation to track inventories of household products, and reorder when supplies get low. This feels very different from an avatar walking down a virtual supermarket aisle in the metaverse, but it's essentially the same thing.

These kinds of activities are not really that dissimilar from having an AI "deputy" who can act in our stead in the metaverse. My point here is that we already trust automatic and automated systems to function in our stead, and to do simple tasks for us. This isn't going to be a "new thing" in the Age of Imagination. AI is just going to make it easier and better.

Now let's talk about metahumans and *feelings* . . . both ours and (potentially) theirs!

An important question in the Age of Imagination will be whether or not we should make rules or laws against cruelty to metahumans and/or discrimination against them.

I want to frame this question by talking about animals.

For most of recorded human history, there were no laws against cruelty to animals. Yet in 1828, New York State became the first entity in the United States to pass laws against needless animal cruelty. A few decades later, the American Society for the Prevention of Cruelty to Animals (ASPCA) was founded, and by the early twentieth century, *every state in the union* had a law on the books making unnecessary cruelty to animals illegal.

Even those who feel that the lives or feelings of animals are not very important can have good reasons for supporting laws *against* animal cruelty. For example, criminologists often point to statistics that show humans who hurt and abuse animals are more likely to hurt and abuse humans. This is directly relevant to considerations we must undertake in the Age of Imagination. For

just as a criminal might start by abusing animals and "move up" to hurting humans, so might a cruel person begin by perpetrating violence against realistic AI metahumans as "practice" for a career hiring real people.

But what if the opposite is true? Some futurists have suggested it might provide cathartic relief for someone to "hurt" an AI or metahuman—and to get an urge to commit violence out of their system—so they would then be less inclined to commit violence against a real person. The thinking is: If someone is already psychopathic and lacks empathy, "hurting" an AI isn't going to give them a taste for cruelty. They've already got that.

Whatever the psychological effect, if we decide that cruelty to AIs still qualifies as a kind of cruelty, then there is good reason to believe that at least some humans will want to make rules against it. And who's to say that's a bad thing? If cruelty is cruelty, then we may want to err on the side of forbidding it in both real and virtual forms.

Another interesting question will be cruelty *between humans* in the metaverse.

If humans intentionally offend or disparage one another as virtual avatars interacting in the metaverse, will the same rules apply as in the physical world? If two people's avatars meet in the metaverse—and one is white and one is Black—and the white one calls the Black one a racial slur, should that be legally equivalent to the slur having been hurled in person? Let's go further. What if avatars are allowed to attack one another? What if they are allowed to act out the equivalent of something like sexual assault?

These are things we're going to have to think about in the years ahead. While it might initially sound silly to worry about "a computer getting offended" or "an AI getting its feelings hurt," I think we can use an investigation into these questions as an excellent chance to reflect on ourselves, and to ask what kind of

people we want to be—and what behaviors do we want to condone—in a metaverse-driven AI-powered world.

Now to another interesting—and often-posed—question: Will the rise of AI-controlled metahumans lead to better human connection, or just to more human loneliness?

I feel like most of the time, this question is asked in bad faith by someone who pictures an awkward young man living alone who chooses only to interact with a computer-generated girlfriend instead of learning social skills and mustering the courage to socialize with real women.

What I want to point out is 1) as opposed to making us more isolated and disconnected, AI actually has the potential to connect us to other humans more effectively, and 2) in many cases, human-to-AI connections (romantic or otherwise) may be more benign than people think.

Let's start by examining how humans might have better organic connections with the aid of AI.

Going back to ancient times, there has been the cultural trope of a "matchmaker" who would help ensure young people connect with a compatible partner with whom they're likely to be happy. For centuries, this matchmaker was an actual person who drew upon a wealth of experience to suggest who in the village or town might make a good pairing. Closer to our own time, we've seen the rise of professional matchmaking services with multiple employees, personal ads, and dating sites and apps. When it comes to providers like Hinge, Tinder, and Bumble, there's a very basic architecture in place that allows algorithms to help customers perform rudimentary sorting when it comes to compatibility. Users of these apps can indicate things like political views,

Meeting Humans ... and Metahumans

relationship orientation, stylistic likes and dislikes, and then the service will recommend other users whose answers indicate that they might meet the desired criteria.

The Age of Imagination is going to take this model and supercharge it beyond our wildest imaginings.

AI will be able to go deeper and find connections between people that they may have never thought about or known existed. AI-enhanced dating platforms will also be able to draw upon large historical datasets to notice new trends when it comes to what makes an effective match, and what doesn't result in a successful pairing. Preferences in dating can be mysterious and even contradictory. Someone may say that they prefer a particular quality in a partner, but their actions may show that they actually prefer something else. AI will notice these instances and redirect accordingly. In another example, AI might notice that something people put down as a "dealbreaker"—not dating someone of a different political persuasion—is actually not a dealbreaker at all once they try it. In these cases, we'll find tremendous benefit in trusting that an AI may know more than we do about what we *really* want.

AI and the metaverse will also make dating easier, safer, and more fun.

Anyone who has used an online dating platform recently knows all about the awkwardness of connecting with someone after you make a match. (This goes beyond the initial awkwardness of coming up with a good opening line.) Many people who do online dating start by trying to verify that the person on the other end of the profile is who they say they are—that is, they're not a fraudster or a scammer! Sometimes, this is accomplished by asking them to send a photo of themselves in a certain pose, just to verify that it's really them. And after their identity has been established, there's the awkwardness of an initial meeting. This

can bring up safety concerns, too. Most dating apps advise having a first date in a crowded public place, but this is not always possible for, say, dating app users who live in rural areas.

What if these initial interactions could be so, so much better? The good news is that with AI, they can.

First of all, with AI, there will be many quick and easy ways for people to verify that they are who they say they are. Users will be able to seamlessly display verifiers of authenticity before they even start chatting with someone. And when it comes to meeting up, there's an excellent chance that a cultural shift will occur and a new kind of date will occur between messaging online and meeting in person—namely, a first date in the metaverse.

Just think about it: Say a potential couple have both indicated on their profiles that their favorite place to visit is Hawaii. As a step before meeting in person, they could enjoy a "date" that consists of taking a walk along a beach in Hawaii using virtual reality. Their avatars could stroll next to one another on a perfect, sandy beach at sunset. The participants could have a real conversation, using their real voices, just as they might in real life. Every part of the date can be tailored to the preferences of the participants. And if things go well, the couple that has already met virtually may *then* choose to go ahead and meet in real life, having had an excellent, fun, and safe opportunity to enjoy a virtual date first.

AI and dating can work when it gives people a *more* realistic idea of what dating someone will be like, *not less*.

One of the early criticisms of Internet pornography was that it gave people—especially young people—an unrealistic idea of what sexual interactions are really like. In porn, everything always goes perfectly, everyone always experiences terrific sexual pleasure, and boring conversations about birth control, consent, and similar topics are never necessary. Similar concerns arose

Meeting Humans ... and Metahumans

more recently with the rise of "fan platforms" like OnlyFans. Despite recent attempts by OnlyFans to position itself as a venue for accessing "all types of content," the vast majority of its creators still use the platform to share adult/pornographic images and videos. But unlike a porn site, OnlyFans creators generally also offer additional interactions. For example, for a fee, one can have a video chat with a performer, exchange text messages with them, and/or buy them gifts and presents and receive a thank-you note in return. It is easy to become concerned that this might evolve into something like "the porn of dating" or "the porn of social interaction." It creates a venue where (mostly) young, heterosexual men can approach women and—after paying—find themselves charming in every conversation, that every gift is thoughtful and appreciated, and that every text message is desired. But this is, quite simply, not the real world. In the real world, young men trying to flirt with women often aren't initially successful. Their jokes might not be funny, or their comments won't be appreciated. This failure is important because it can teach young men to reflect on their approach, and on themselves. It can challenge them to educate themselves about women, and to learn what women actually want (which may not always be identical to what men want).

I believe that when it comes to dating and relationships, AI can help to right this ship.

AI can allow people to forge realistic connections and encounters with one another—in safe spaces—as a prelude to meeting up in person. It will make it easier to screen prospective dates for any concerns (like a criminal record), but AI also can help curate connections based on the qualities and preferences about a partner that actually matter to those entering the dating pool. But AI can also offer "virtual dates" and interactions where meeting up is never the goal—rather, young people are simply learning how

to interact. Make jokes. Flirt. Whatever. A safe space for doing these things might be very educational for everyone. For example, if AI metahumans are endowed with the true personality traits and preferences of an actual person, it might create a way for socially awkward humans to *learn* to interact with others. The metahuman would be just as hard to please and authentic as the real person it was based on—which would be a challenge to the socially awkward person interacting with it—but there would be the added benefit of the interaction being "not real" or at least not occurring with the stress of another person in the room.

AI-driven social interaction can be a place to make mistakes, to test things out, and to see what works and what doesn't when it comes to hitting it off with another person.

Will some humans choose never to advance beyond the "tutorial level" and choose simply to date metahumans? Of course. And I don't know if that's necessarily a bad thing.

Some people might have developmental issues that will never allow them to become comfortable having a relationship with a real human. For these folks, AI might be vastly preferable to nothing. Or imagine someone with an isolating job, manning a remote outpost in the wilderness. In situations where zero human contact is the only option, a relationship with an AI could be very welcome. Metahumans can help isolated or awkward people have a sense of community, build virtual support networks, help them feel inspired, or just combat isolation in the same way that one can feel less alone in an empty house by leaving the TV or radio on.

I don't think there's anything weird or bad about that!

I'd like to close this section by saying something about how these AI tools can serve seniors especially—whether for dating, connecting for platonic friendships, or just avoiding loneliness. Dating sites and apps already allow people in similar age groups

to connect. With AI, dating for seniors will allow for the incorporation of additional compatibility factors. It can impose additional security safeguards to protect against the kind of dating fraud that might target seniors. It will also allow seniors who might have age-related disabilities to have an easier time communicating via features like text-to-speech. But what's most exciting might be the ways that AI has the potential to help seniors find companionship . . . whether it comes from another senior, a metahuman, or something else completely.

We all know that as couples age, they generally don't have physical sexual intercourse as frequently and intensely as when they first started dating. That's just life. But as those who've been married a long time can attest, one's relationship with one's partner can still be remarkably satisfying and pleasurable because of shared experiences—even if those experiences don't involve sex as much as they used to.

Couples travel together. They discover new places. They learn new skills together. And these are all things that a metahuman may be able to participate in nearly as realistically as an actual human.

There are already ways that technology is helping seniors with companionship. For example, many seniors love dogs and cats, but because of age-related conditions, they may no longer be able to care for actual animals. Robotic "companion pets" have been available for nearly a decade already. They're essentially realistic stuffed animals that can react to being touched. They purr or bark, vibrate when touched, and feel warm when you put them on your lap. Many seniors with conditions like dementia find these robotic companions an exceedingly effective deterrent to loneliness.

So just imagine what AI could do.

Personally, I would love to have an AI companion that I take

along on adventures. I think sharing experiences with an artificial person who knows me and who I have a history with could be very satisfying. And as metahumans get more and more realistic, I think people of all ages will have this companionship option for a sort of "digital friend" who tags along.

And because I don't want to shy away from hard questions in this book, let me bring up a doozy: what about seniors who lose their human life partner? Will it be psychologically helpful to allow this deceased partner to continue in the metaverse as a "digital twin" of sorts? (There's already an episode of the science fiction TV show *Black Mirror* called "Be Right Back" that imagines a woman using technology to "resurrect" her deceased husband as an AI powered android.) We're entering an era in which people are going to have their digital data captured from about the age of ten. It will not take much for a program in the future to draw on these data—everything you ever typed, posted on social media, said on a recording, indicated as a preference, and so on—to create a metahuman that can effectively impersonate you, and correctly guess how you would have reacted to certain input. It can even have your voice.

I think that if people want to have these digital "continuations" of a loved one, it will be more than appropriate. And in most cases, if it brings solace to the surviving spouse, it will be what the deceased spouse would have wanted.

Let me give you an example of this from my own life.

I'm friends with Alan Hamel, whose wife—the celebrated actress and fitness guru Suzanne Somers—passed away in 2023. Alan and Suzanne are some of the most interesting, selfless, and genuine people I've ever known. I'll never forget how we met. I had traveled to Los Angeles at the tail end of the COVID lockdown. I was giving a speech on blockchain and NFTs for the Motion Picture and Television Fund at the Beverly Wilshire Hotel. I was

Meeting Humans...and Metahumans

contacted by Alan and Suzanne, who asked if I would visit them in their Palm Springs home after my talk. Suzanne had read my first book, and was interested in learning how she could incorporate blockchain into her business (which, at the time, was doing upward of $20 million a year).

I took them up on their offer and drove out to meet them after my talk—and I was totally blown away right from the start! They were some of the kindest people I'd ever met. They greeted me at the door of their house—despite their success, they had no household staff—and acted like I was family. Suzanne personally cooked us an amazing meal of healthy, fresh food, and we spent an entire afternoon talking and connecting. They were both very candid, and told me personal stories from their lives that seemed to convey an implicit trust in me. (Some of these stories were hard to hear, like Suzanne sharing how she and her mother had had to lock themselves in closets to hide from Suzanne's abusive, alcoholic father.) When we were finished, we all cleaned the dinner table together like longtime friends!

In the subsequent weeks and months, I became close with Alan especially, despite our age difference. To this day, we still talk about everything from business to politics to Judaism. I confide in him about many things, and he always provides outstanding guidance. He's the only person I know who has introduced me to potential business partners with no prompting—and these partners have ranged from Rock and Roll Hall of Fame musicians to Hall of Fame baseball players! Alan is also very open-minded, and his career has always been about taking risks. I think that's why, today, he's so receptive to the possibilities of AI.

When Suzanne passed, it was like losing a friend I'd had for years, even though we were still just getting to know each other. She and I had lengthy conversations over the phone toward the end. She was a lovely, salt-of-the-earth person. So is Alan.

SOME FUTURE DAY

Because of his open-mindedness—and because of the powerful presence Suzanne had in his life—Alan is currently exploring ways that Suzanne can be "present" again through the use of AI. Alan already leaves an empty seat for Suzanne at the table at Thanksgiving dinner and at Jewish holidays. Now, Alan is hopeful that by drawing on the wealth of digital assets featuring Suzanne that were left behind after she passed—combined with the power of AI—it may be possible to have that empty seat filled with a digital "continuation" of her . . . whether through a hologram, animation, voice chatbot, or some combination thereof.

If this will help him feel closer to Suzanne, I say more power to him!

As the cost of technology continues to shrink, we're not only going to see holograms used at major concerts and presentations. That kind of technology is bound to grow and become accessible broadly—and eventually used in people's homes. If we can have an AI-powered metahuman hologram literally fill an empty seat that used to be occupied by a loved one—and it can react to things and carry on conversations with the living—many people will take great solace and satisfaction from that experience.

To conclude, it's clear that the advent of metahumans will require humanity to make some psychological adjustments—and will require people to decide what they're comfortable with. I'd submit to you that if we look at major technological changes that have come before, we see a pattern of hesitation and perhaps even concern . . . and then immediate adoption by most of the populace! There's little reason to believe that humanity will fail to embrace meta-humanity after a brief period of getting comfortable with one another.

Meeting Humans... and Metahumans

As AI grows more effective and becomes more and more integrated with society, we'll be able to learn if any of the concerns about metahumans creating alienation (or etc.) are well-founded. But I'll point out that these transitions won't happen overnight. Americans won't go to sleep and wake up the next morning to find they've been suddenly issued a metahuman assistant.

Personally, I think the vast majority of people will keep metahumans around—in a manifestation they can view and interact with—simply because it's fun!

The companies that will make and provide access to metahumans will also make tweaks based on customer reactions—for the very good reason that they'll want to retain customers. If AI metahumans are given a capability that feels disturbing or inappropriate, the businesses involved are going to want to make changes quickly. (There's precedent for this in the tech space. Think back to around 2013 or so, when Google introduced Google Glass. These were "smart glasses" fitted with a camera that could take video of anything the wearer was looking at. It's now generally agreed that Google had not thought through the legal and privacy concerns. But what was more, early adopters found that other people didn't like being around them when they were wearing Google Glass. It was creepy to think the wearer could be filming and recording you. Faced with widespread resistance to the product, Google quietly phased it out.) In the same way, I have every confidence that if the market attempts to introduce a manifestation of metahumans that troubles people—or is simply "too much, too soon"—the market is going to let us know.

The benefits are going to strongly outweigh any qualms we might initially have. For years, we've trusted machines to do mundane (or complicated, or dangerous) tasks for us in the analog world. I predict that once people get a taste of metahumans

helping us out in the digital world, they'll never want to say goodbye to their new assistants.

A lot of what people already use digital tools for can be centralized in a metahuman. You can ask it what you did with something—like where you put your car keys—and its memory is going to be literally unparalleled.

I, for one, can't wait!

Meeting Humans... and Metahumans

The rise of metahumans and AI-driven human connection will benefit your:

- *Career:* Throughout workplaces of every type, metahuman proxies able to assist with certain tasks will help us become more productive. We'll be freed from the mundane and repetitive, and will be allowed to focus on driving innovation where it really matters.
- *Community:* Because AI knows so much about us—both "us" specifically, and "us humans" generally—it will be able to recommend effective human connections with stunning accuracy. From activity groups to join to people we might want to date on a dating site, AI is going to make it easier than before to find "our kind of people."
- *Family:* Metahumans will free up humans, giving them more time for genuine interactions with the people that they really care about. AI will also help us connect to "form" families. And hey, if someone wants to decide that a beloved AI is a part of their family... I'm not here to judge.

Where and how to engage with this technology now:

- *Companies like FS Studio, Epic Games, Synthesia, and Daz 3D are already creating realistic metahumans that will only improve year-over-year. We're going to see these metahumans in everything from advertising to customer service.*
- *IBM's watsonX Assistant and Thoughtly's Perfect AI Receptionist are examples of workplace metahumans that are already available in the marketplace.*
- *Dating apps powered by AI are already here, too! Check out services like Swipes AI, FlirtAI, and Iris to see if one might be right for you.*

In some future day, NFTs or digital artwork will provide women with even more emancipation than they have today and true financial independence.

**Raphael Malavieille
Founder & CEO,
World of Women**

CHAPTER EIGHT

THE REVOLUTION OF SIGHTED AI

One particular feature of AI in the Age of Imagination will have far-reaching impacts across many disciplines, and that feature will be "sighted AI"—that is, AI that uses a camera to recognize shapes, objects, and people, and to read text.

Open AI's ChatGPT 4o is already performing this very function. It allows AI to answer questions about the world in real time, without the user needing to provide text or verbal descriptions. Armed with camera functionality, ChatGPT 4o can already do things like assess whether someone's outfit is appropriate for a job interview or describe objects that are sitting on a desk. As we get further into the Age of Imagination, it will be able to do much, much more.

I'll give several examples of how I think sighted AI is going to be impactful, and I'll start with one that may sound mundane, but which I believe people are going to deeply appreciate—and

that's how it will augment our experience of going to eat at a restaurant.

I imagine myself walking into an exciting new restaurant and wearing a camera that allows my AI to see the world around me. I imagine myself sitting at a table and picking up a menu. Right off, my AI will know enough about me to spot the dishes I'm likely to enjoy the most. It can also scan for anything I might be allergic to (or that I just don't like). After I order something, the AI can look at the wine list and suggest a drink that might pair well with it. Or what if I look across the room and see someone else eating something that looks delicious? My AI can immediately tell me what it is. When my food arrives, the AI will also be able to take a look at it and make reasonable guesses about nutrition and calorie count. Near the end of the meal, it can give me a handy running total of how much I've spent so far—and how much my bill would be with a tip—so I can decide if I want to splurge and order dessert or not.

In this way, something as simple as going out to eat is going to get easier and better. (And if there's something I want to know that the AI can't find, I can always ask my waiter.)

But consider other activities that could be augmented. What about sports? People already track their workouts using wearable devices. But by giving my AI access to a camera, it is going to be able to critique my form, letting me know if I'm exercising in a way that's likely to achieve the results I want, and/or a way that could lead to injury. It can make nutritional suggestions based on the way I exercise.

Or what about staying safe while exercising—or doing anything else out in the world? Just walking down the street with a camera-enabled AI is going to make everything safer and more secure. An AI can monitor surroundings much better than humans can, and without getting distracted. It can locate a danger in your

The Revolution of Sighted AI

path—like an open grate or a sharp drop-off—and it can also spot mobile dangers, such as a car that might be swerving erratically.

AI will be able to spot clear dangers, but also things that are simply "unusual"; it'll let you know, and then you can make a determination as to whether the anomaly is any cause for concern. What if you're the one driving the car? AI will be able to notice if you may be getting sleepy, or if you're driving inattentively, and make suggestions around pulling over to take a rest. And what about encountering specific people? Maybe you didn't have time to glance at the new photos from the FBI's new 10 Most Wanted list, but AI certainly did. AI will be able to give you a heads-up if someone who is approaching you might have criminal intent or a criminal background. Whether or not you still want to interact with that person will still be up to you. But by giving consumers more information about situations that may pose potential dangers, AI is going to increase public safety and decrease risk when it has camera capabilities.

Say you're not walking in an urban environment, but in a rural one. AI can recognize animal sounds, and alert you if you might be in proximity to something dangerous. It can use your camera to spot dangerous animals that might be hiding using camouflage. It can also keep an eye out for dangers in the terrain that ought to be avoided. This could be an unsafe incline where you're likely to fall, or it could be a plant that is likely to cause a rash if you touch it.

Yet one of the most exciting uses of sighted AI is going to be as an aid to the disabled. Visually impaired people will enjoy some of the greatest benefits of this technology. Using its camera, the AI can describe their surroundings to them, as well as any objects they might wish to interact with. It can warn them of dangers—just as it might for a sighted person—and it can read signs in just about any language to them. Visually impaired users will be

able to interact with the AI to curate the experience. Someone can tell their AI to "describe that in greater detail" and it will comply. Imagine a blind person walking down the street wearing a small camera and with sighted AI enabled. The AI could narrate their walk for them, just as a sighted human could—pointing out what's around them, when there's a step or an obstacle ahead, and warning them when they near any fellow pedestrians. The AI can tell them their location at any time, as well as the direction they're facing. And when the AI recognizes someone on the street that the person may know, it'll tell them. For someone who is blind, this is going to be a remarkable option. Whenever the blind person wishes, they can have a sighted person narrating their journey—except that person will be an AI using a camera.

Where you go, what you see, and what you look at, are all very private things—or at least they *can* be. The ability of AI to be "another set of eyes" in our world will come with incredible transformative benefits, yes . . . but also some privacy concerns that will require us to think about what features we want to enable, and how comfortable we are with data collection. Our phones already trace where we go, and search engines already keep records of the kinds of things we look at online. (And the criminal justice system is already able to request this information when they suspect someone may be guilty of a crime.)

But having AI be able to physically see things around us may open up entirely new questions around privacy and security. Firstly, will we want software and app companies to have access to information that's collected (and preserved) by an AI that is looking where we're looking? Will the AI companies be tempted to sell that data?

The Revolution of Sighted AI

And even if an AI doesn't choose to sell the information it garners using cameras, it may still use that information internally, for training purposes. It's one thing when an AI is trained on something that we've written or recorded. Authors and YouTubers have experienced the odd sensation of learning that an AI has been trained on content they've made. But what about when an AI is trained on *your life itself?* I have a feeling some users will be absolutely enthusiastic about that idea, while others will find it potentially very disturbing, and there'll be every reaction in between.

Camera-enabled AI will also be able to *look at screens*, which is an important consideration. Both Google and Facebook collect data about you—as does the Apple or Lenovo computer you use to access them on—but these separate entities do not necessarily share the information they each obtain. However, when an AI company is literally looking over your shoulder and watching how you interact on different programs online, we're going to potentially have one single entity capturing information that used to be the provenance of others. How will this shake out? Will Meta lose value if OpenAI is also capturing every Facebook post and Like?

To go to an even more serious concern, what about data safety? It's one thing to allow an AI to look over your shoulder when you're browsing social media or doing some online shopping, but quite another when you leave it on while you're at work. AI-enabled cameras will be constantly looking, and if we forget to turn them off when we answer a quick work text or read a work-related email, we may be providing private companies with access to content that is meant to be private (or must legally be so). The same kinds of issues will be faced if one's AI-enabled camera can be "hacked." Relying on an AI to provide visual assistance might mean that bad actors could also be taking a look at whatever we're looking at. It's one thing when a criminal can

steal a particular file with information on it, but what if a criminal could steal a record of someone's entire day or days? We don't really have precedent for that yet, except perhaps in fiction. The great Argentine writer Jorge Luis Borges published a story in 1942 that's usually translated as "Funes the Memorious" or "Funes, what a memory!" It's about a man who, after being kicked by a horse, finds that he can now remember literally everything that happens to him. If he wants to, he can relive a day that has already happened, having conversations with people—and interacting with objects—who are not there, because he is remembering and reenacting the day when they *were* there. He can remember the position of the clouds in the sky on any day from his post-accident life. When AI can capture memories from our lives—and remember them better than we can—how will it monetize this? Will it sell the memories back to us? Sell them to other people? Perhaps we will be willing to pay to see the position of the clouds on our wedding day. Clearly, there is much for us to consider here.

We also don't have a lot of legal precedents when it comes to capturing this kind of content. In the United States, courts have consistently found that it's legal to photograph or record someone if they are in a place where there is not a "reasonable expectation of privacy." So street photography—that is, just taking photos of people as they walk down a public street—is completely legal because nobody standing in a public street expect that they are "in private." (I should note for any budding photographers reading this that just because you can legally photograph someone in the street, doesn't mean they'll appreciate it if you do so!) But people tend to know when they're being photographed—in the street or anywhere else. If AI is always taking a look through a camera on someone's body, those having their images (and audio) captured may not understand what is

The Revolution of Sighted AI

happening. There will be no implied consent. Subjects will have no idea of how their images/voices may be used.

We know that AI-enabled cameras will have to comply with privacy laws, but I have a feeling that many of those laws are going to be rewritten when we see more AI augmentation. And how will enforcement work? For example, what if a city passed a law that street photography must be conspicuous to be legal—someone must hold and point a camera—but that wearing a camera that records everything the wearer sees and uploads it is not legal? How are the police possibly going to enforce something like that?

And perhaps it is more of an abstract question, but how will a ubiquity of AI-enabled cameras impact human-to-human interaction? There are going to be tremendous benefits to living an AI-augmented life, and if part of this involves cameras, will it become natural to assume that everyone around you might have a camera recording? Before people have a private conversation, are they going to want to say: "Let's turn off our AI cameras first?"

I think the answer is "Maybe."

People are definitely going to change their presumptions when it comes to when and where they're unobserved, and what likely counts as a truly "private" space. For better or worse, humans may adopt the "default setting" of assuming they are being monitored, as opposed to assuming they are unobserved. Some people will like this sense of someone "looking out for them," keeping them safe, and ensuring things are on the up-and-up. Others may find it "big-brothery" and intrusive. I expect people will be more cautious when it comes to the things they talk about in public. There may be some cultural pushback against AI-augmented surveillance, but that remains to be seen. I have faith that humanity will find a balance between technological benefits and privacy

concerns. The benefits outweigh the drawbacks. If we're careful and thoughtful, we can ensure that the rise of sighted AI also respects and preserves our fundamental need for privacy.

The Revolution of Sighted AI

Sighted AI will benefit your:

- *Career:* Sighted AI is going to make us more productive in the workplace, while also recognizing workplace hazards in locations like construction sites. The workforce will also become more open to people who might be visually impaired.
- *Community:* Communities will become safer and more secure when AI can point out issues and/or dangers that it can notice using camera technology.
- *Family:* The ability of AI to see things and make sense of them will help our families stay safer from environmental hazards and protect kids from "stranger danger."

Where and how to engage with this technology now:

- Right now, the best place to go is ChatGPT's 4o. Its capabilities are stunning!
- You can also check out competitors working in the same space like AlwaysAI and Teledyne FLIR Prism.
- For more specialized uses in the space, check out RealEye and their use of AI to analyze facial expressions.

In some future day, our walk together will get us to a place where we can sit around the dinner table and not argue with each other.

Drea De Matteo
Emmy Award-Winning Actor
from *The Sopranos*

CHAPTER NINE

SCAMMERS AND CRIME

As we've seen already, AI is going to make remarkable things possible across many different industries and disciplines. It will allow for greater automation and scalability, and for creators to have a bigger reach and impact. But what happens when the thing that people want to automate and scale is crime? Or if the impact someone wants to have is a criminal one?

It will be important to go into the Age of Imagination with our eyes fully open, and that means acknowledging the reality of bad actors who will attempt to harness the power of AI for nefarious ends. The good news is that we will have many tools with which to fight (or, more preferably, prevent) AI-related crime. The first step to preventing these crimes will be the need to educate the populace on what they're up against. The weak link in most crime—no matter what technological advancements are made—still often comes down to simple human error and gullibility.

SOME FUTURE DAY

Let's talk about automation and scalability. To do that, I'll give an example of one of the oldest (and simplest) crimes currently being run by scam artists in the digital age. Though not the most remunerative, it remains popular because it can be done from just about any location, by virtually anyone. It works like this: A scammer will create a fake social media account on a site like Twitter/X, writing a fraudulent description and using stock photos of an attractive person. The scammer will then follow other accounts—and get followed back—until they have some "friends" and appear to be a genuine social media account. The con then begins in earnest when the scammer initiates conversations with other people online who (importantly) live in a different city. The scammer will identify a target and become flirtatious, spending time building a rapport with the target through messaging. The trap is further sprung when the scammer shares that they'd really like to visit their new friend for a romantic weekend, but money is just too tight right now. When this happens, the target usually offers to send a few hundred dollars—through PayPal, Venmo, or a similar service—to pay for the cost of a plane ticket. When the money is received, the scammer deletes the social media account and starts all over again.

Lather, rinse, repeat.

While this crime is certainly hurtful (and embarrassing) to those who are victimized, the scope of the damage it can do is limited by the bandwidth of the scammer. The criminal can only maintain so many social media accounts, and engage in so many late night DM conversations at once.

The problem is that AI is about to make those bandwidth limitations disappear.

Imagine a world in which an AI—programmed to act autonomously—can create accounts on social media platforms on a massive scale, populate them with AI-generated human-looking

Scammers and Crime

profile images, and then initiate conversations with unsuspecting human users following a script that eventually ends in a request to send money. A scammer using AI can have an unlimited number—thousands, millions—of these fake accounts all "farming" unsuspecting social media users and "harvesting" money. After configuring the AI, the scammer won't have to do anything further; they'll just sit back and watch the money roll in.

In an AI-driven future, we're going to have to work harder than ever before to ensure that scammers are disincentivized, and that we create tools to prevent AI-driven scams from being successful. This will mean a massive public education campaign—that is ongoing and never really ends—because the scammers are going to keep updating the scams.

To give another example of the kind of scam that will become scalable with AI: In 2023 and 2024 many Americans fell victim to a scam known in the criminal underworld as "pig butchering." This scam is pulled when the criminal sends the victim a text that appears to be a simple wrong number. Something like: "Tammy? This is Bob. I'll meet you at the restaurant in five minutes." If the target chooses to write back—if only to advise whomever is on the other end that they have the wrong number—the scammer then attempts to initiate a conversation. They introduce themselves under a fake name and identity, and will update their "character" to appeal to the victim as much as possible. The scammer will intentionally drop hints that they are very, very wealthy. (Often, this alone is enough to keep the victim texting.) Then the scammer will share that they recently made a lot of money in a way that was easy and involved very little risk. (I mean, who would *not* want to hear more at that juncture?) Aware that citizens have, by now, usually been educated not to "send money to strangers over the Internet," the scammer will share that they made all of their money by investing in a certain commodity—like a new

cryptocurrency—that is only traded on one particular website. The scammer shares the name of the site, and then the victim looks it up on their own . . . never guessing that the person who texted them "accidentally" and the proprietors of the website are one and the same. Lured by the prospect of fast cash, the victim then creates an account at the website, and purchases the cryptocurrency in question. However, the website is fake, the crypto is fake, and so are any gains that the website reflects. The money that the victim gives to the scammers, in contrast, is very real.

Here again, we see a con that is incredibly hurtful to the victim, but has historically been limited when it comes to the number of people it can impact simply because of the logistics involved. Scammers must manage conversations with victims—learning about them, making guesses about how to appeal to them, and then casually dropping the name of a website where easy gains can be had if they act fast. But when AI becomes advanced enough to take over these lure/messaging functions—and when it can generate images from a fictional but alluring luxury lifestyle to boot—we face a world where many, many more Americans will be at risk of succumbing to fraud.

But scale is not the only way that AI is going to help scammers commit fraud. It will also allow them to improve the *quality* of the criminal tools they already work with.

For example, the elderly are frequently the target of cons, often because they are assumed to lack a general canniness and/or they may be unfamiliar with technology. In some cases, fraudsters will take advantage of these (real or perceived) traits to target them. In one classic con—which is still run today—scammers will call an elderly person and claim to be their grandson or granddaughter. (If the grandchild has videos of himself on YouTube, Facebook, or a similar site, the scammer can use this as "source material" to impersonate their voice.) After making contact, the scammer

Scammers and Crime

will deploy a script along the lines of: "Grandma/Grandpa, it's an emergency and I need your help! I went backpacking with some friends in [unstable conflict zone country], and we got arrested. These people are telling me I have to spend the night in jail with criminals unless I can come up with $5,000 for bail. Is there any way you can go to the bank and wire me the money? I can pay you back as soon as I get home. It's an emergency!"

For a confused, elderly person who may not have spoken with their grandchildren in a while, the urgency of the situation often does the trick. However, many seniors are still savvy enough to avoid the con. They realize something is wrong. Before anything else, they notice that their grandchild's voice does not sound right. And if pressed for identifying information, the scammer generally cannot come up with it quickly enough to be convincing. These two factors alone can be enough to help the potential victim conjure the correct amount of reasonable doubt.

But—here we go again—AI is going to make this con harder to spot.

Using AI, scammers are going to be able to "sample" a recording of someone's voice and then impersonate them on the phone with an eerie degree of accuracy. AI bots will also be able to scan and retain information about the person they are impersonating using online social media accounts, online reference directories, and other publicly available information. This information will not only allow the AI to reference things that make the simulated person seem authentic, but they'll also be able to answer questions—with great accuracy—if the potential victim does press for more information.

It's going to be rough when grandma or grandpa says: "It sounded just like Bob. It knew everything Bob knows. How was I supposed to tell it wasn't really Bob?"

(It is worth noting that AI voice technology is controversial,

and even legitimate uses for lawful purposes are often criticized. Just last year, it was revealed that a voice message recorded by New York City Mayor Eric Adams—originally in English—had been deployed to communities across the city in several languages the mayor does not speak. It was the mayor's *voice*, but AI had been used to translate the English message into Spanish, Yiddish, Mandarin, and several other languages. Lots of New Yorkers were upset at this use of AI, and for many different reasons. Some said it was unethical for the mayor to make people assume he spoke languages he does not speak. Some thought that the message was tantamount to campaigning—even though it was not an election commercial—because it had been deployed targeting certain demographic groups in their own language. Some felt it was simply duplicitous to give the impression the mayor was skilled enough to speak so many languages. Others still asked broader questions like: "Does something count as a 'fake' or 'deepfake' if you make it yourself, and the changes are intentional and used for the public good?")

The bar for bad actors potentially using AI in this way is going to be very low. Soon, it will be doable from almost any laptop.

This technology holds the potential to negate two-factor authentication as we know it today. That is: if someone can steal someone's image and also their voice, many of the ways we can traditionally authenticate our identity are compromised. Banks and other institutions are going to need to formulate new ways to keep transactions secure. And they better start soon, because the criminals have already started. . . .

In February of *this year*, a bank was robbed of $25.6 million when a scammer used AI technology to place a fake video-conference call to the company's CFO. All of the "people" on the call were animated AI deepfakes impersonating other high-level bank employees. These fake employees instructed the authentic CFO to

Scammers and Crime

immediately make a funds transfer to avert a disaster. The CFO did so, and the bank lost millions of dollars to the criminals.

Even very powerful people in high places in a major organization can be scammed. In the Age of Imagination, we'll need to work hard—and work together—to thwart criminals at every potential point of attack. A new tone of caution and healthy skepticism needs to be set.

However, I believe that if we spread awareness of these fakes, most consumers, from retirees to bank executives, will learn how to avoid becoming the victims of fraud.

At the time of this writing, we're entering another bull run on crypto. Bitcoin has shattered its previous record price, and many other coins appear poised to follow. Many industry analysts are already saying 2025 might be the best year in history for crypto. And while this boom could be good news for savvy, longtime crypto investors, it is decidedly bad news for people who are new to the space and vulnerable to fraud. As always happens when any form of boom occurs, newbies are going to flood the space wanting to get in on the action, and scammers will try to rip them off.

Some crypto watchers have already forgotten how much fraud we saw during the 2021 crypto bull run. (The Federal Trade Commission estimates that approximately $1 billion was stolen in crypto scams during 2021 *just in the United States*.) The fraudsters have been sharpening their claws, and if large numbers of neophytes enter the market again, we can expect the same outcome . . . only worse. And I say "worse" because this time the criminals are going to have AI, large language models, and conceivably computer-generated animation to pull their cons.

Unfortunately, that's what's in front of us. We have to be ready.

SOME FUTURE DAY

The fraudsters are going to make insane claims. They're going to make incredible boasts. They're going to assert things that most people would want many layers of proof before believing. They're going to do this because the new people rushing into the space *won't know what's a reasonable claim and what isn't.*

The larger a claim is, the larger the amount of evidence needed to prove that it is true. If you have a breakthrough to share—or an astounding development to relate—there is no reasonable reason why you couldn't share proof, too. There's no good reason why you would need people to "take your word for it." There's no good reason to say: "The proof will come soon, but invest now."

Yet as it stands, we still have people walking around claiming to be Bitcoin creator Satoshi Nakamoto while offering no proof of the claim. And one thing about Satoshi Nakamoto—whoever they are—is that they could easily prove their identity if they wanted to. *Numerous* mechanisms exist. In my opinion, the only reason these fraudsters and impersonators continue making crazy claims is because Bitcoin enthusiasts as a whole are still not adequately educated on the mechanisms of cryptocurrency.

To give another example, deceptive champions of certain cryptos will often make bold assertions about what their particular altcoin can (or can't) do. They'll promise that their coin is more secure than other coins, more easily convertible to cash, or more easily suited to a particular cause or purpose—like philanthropic giving, technology, or travel. Yet no science or proof will be provided to substantiate these silly claims, because enough gullible people new to the space will not know to ask for it.

In a subsequent chapter, I'm going to discuss the benefits and challenges of an AI-driven social media space, but it's important for me to also note here how social media is going to be one of the main venues of crypto-fraudsters exploiting this situation. They will use social media to defraud people by making the

kinds of ridiculous claims I've just outlined, but they will also use social media to try to create a climate in which specific features and benefits of the coin are not the reason why one would purchase a crypto. Think about what happened with meme coins like Dogecoin in May 2021, and now imagine that on steroids. Fraudsters are going to attempt to move crypto financial markets by pumping social media full of content designed to make people feel that buying a particular crypto is cool, or fun, or revolutionary. It may not even be a crypto. Look at Reddit's influence on GameStop stock in early 2021. Why was a stock that was worth under $5 a few days before now suddenly worth $80? I think the true answer is because the WallStreetBets subreddit created online momentum with clever posts and memes, and that spilled onto mainstream social media, and that began to move the price, and that led to "what if these guys are actually right?" FOMO (a.k.a. fear of missing out). You might call this the coin-ification of a corporate stock. The method of attack was the same as with a meme coin, and the ultimate result has been the same. (At the time of the writing, GameStop stock has fallen back to near its original price.)

And look . . . it's fine to do things based on emotion, *as long as you understand that's what you're doing.* Doing things just because they're fun is an essential part of being human. It's fun to place a bet on a long shot team in March Madness just because you have "a good feeling about them," or to put all your chips on one number in roulette because it's your lucky number. People do that all the time. But in those situations, people understand the odds. They understand what their decisions are (or aren't) based on.

The challenge is that the crypto markets (and markets for memed stocks) are being moved based on people who don't really understand what they are doing; they're just chasing a trend.

A novice to crypto might reasonably assume that if message

boards and social media platforms are flooded with memes saying a crypto is awesome, then there must be something to it. There must be some benefit or efficiency that has all of these people so gosh darn excited. But in fact, the crypto's price is rising based on . . . *excitement alone.* People are excited about it because . . . people are excited about it. Newcomers won't know to look out for this, and they will be tempted to purchase cryptos just to feel a part of the excitement. And then, at least in most cases, the excitement will wane just as suddenly as it appeared, and the price of the digital asset will fall accordingly.

This will not impact everyone in every country identically. I believe it is important for me to note that those who are already in more financially precarious situations may be *more likely* to fall prey to this—precisely because the technology will be new to them.

A good example of this phenomenon is the work of the Russian con man Sergei Mavrodi, who passed away in 2018. After the fall of the Soviet Union, Mavrodi started a fraudulent investment company called MMM (or sometimes MMM Global). MMM was simply a Ponzi scheme; would-be investors entrusted their money to MMM, and were shown remarkable annual returns (on paper) that were entirely fictional. Mavrodi made advertising claims that would sound risible to a worldly, educated investor—for example, that MMM could deliver annual returns of over 1,000 percent. But the thing was, most Russian investors in the 1990s were not worldly or educated at all (at least not about finance). Having grown up under the communist system (in which trading in stocks was technically illegal), newly capitalist Russians had no frame of reference for how an investment might reasonably grow. Into this void of ignorance, Mavrodi was there to say: "You've heard of capitalism and investing—such as they have in Europe and the United States? Well, this is that! If you give me your money,

Scammers and Crime

you'll be doing capitalism!" But it wasn't capitalism. It was just fraud. Sadly, many Russians had no frame of reference for these claims, and lost a great deal of money by "investing" with MMM. (Mavrodi was eventually charged with intentionally misleading investors and jailed, but not until he'd run the scam for nearly a decade. During that time, it's estimated he took money from nearly 10 million Russians, most of them lower-income. When he was released from prison, Mavrodi began attempting similar frauds in developing nations in Asia and Africa where a middle class was beginning to grow, and he could again prey on citizens who were not yet familiar with how legitimate investing worked.)

Between the 2021 cryptocurrency rally and today, millions of new people all over the world have gotten access to smartphones and computers for the first time. Millions of people now have expendable income for the first time. Millions of people have access to the Internet and social media. What Mavrodi did for Russians new to capitalism, a new generation of scammers will attempt to do to investors new to crypto. "You've heard of Bitcoin? See, this crypto is like Bitcoin. It's the next Bitcoin." And sadly, it may not take much more than that, and a few encouraging AI-generated memes, to convince a new generation of vulnerable and uneducated consumers to part with their money.

To prevent this, we will have to work to ensure consumers are as educated as possible. We need to create a culture in which the amount of a crypto that is owned by a founder is completely transparent. Right now, savvy traders can look up where coins were minted, and which digital wallets first held them. We need to ensure that getting this knowledge—and having this knowledge provided to the public—becomes the norm.

It is my hope that in the year(s) ahead, when the price of crypto goes up and fraudsters descend, we use AI to deploy cautionary educational materials to those new to the space. We'll teach the

investing public about peer review and independent validation of any claims related to the market. And we'll also champion the axiom that the bigger the claim, the bigger the proof required!

According to legend, when asked why he robbed banks, career criminal Willie Sutton famously replied "That's where the money is."

This underpinning logic that drove Mr. Sutton is not going to change in the Age of Imagination. We've seen how some con artists are going to use AI to steal a little money from a lot of people. But others are going to try to use it to steal a lot of money from just a few targets. And those targets won't necessarily be people.

New York City, for example, sees 80 billion "cyber events" targeting its computer information system, computer networks, and personal devices each week. But because of AI, fewer than twenty of them have to be manually attended by a human cybersecurity expert. That's according to New York City's Chief Technology Officer, Matthew Fraser. The city expends a remarkable amount of resources each year just to fight these attacks.

The city has become a leader in AI because it has to be. It faces attacks using AI, but it also deploys AI resources to residents.

At the time of this writing, New York is poised to launch My City Business, powered by AI. It's an initiative designed to help people do things like relaunch businesses after the COVID pandemic. It seeks to use AI to deploy the kinds of things people would need to go back to work—such as affordable childcare—and to streamline the interactions with city agencies and regulators that a small business owner must navigate. (New York City first dipped its toe in AI solutions by creating an AI chatbot for its centralized portal for businesses. Entrepreneurs can interact with

Scammers and Crime

the bot to get basic information about what they need to do business in the city of New York. The chatbot was rigorously trained to ensure its answers are always accurate.)

But New York City has a budget of over $100 billion per year. (And, because it is a city, if it ever has a sudden need for more money to fight cybercrime, it can raise that money by levying new taxes.) However, most of the large institutional targets of cybercrime are private. They have significantly smaller budgets, and they don't have the "In case of emergency, break glass" option of raising taxes. These are hospitals, businesses, and private contractors. That last one is important because governments often hire contractors to do important work. For example, a city might have excellent resources to fight cybercriminals, but if they hire a contractor with lousy cyber-defenses, criminals can see that as a "back door" to get in and disrupt or extort the city.

Holding businesses (or other entities) for ransom has become one of the most common ways cybercriminals make money. AI is only going to give such criminals new tools for exploiting holes in defenses. In just the past few years, we've seen instances of hackers gaining access to a major Las Vegas casino and shutting down all of the electronic slot machines until a ransom was paid. More troublingly, we've also seen major attacks on hospitals and hospital systems that froze access to electronic medical records.

To be frank, I suspect the number of hacks and ransomware attacks are strikingly underreported. Just think of how many times a social media network or major website goes down for a few hours, and no real explanation is offered after the fact. These companies will often release an evasive statement with very broad terms. They'll say it was "network issues" or "difficulty coordinating traffic between data centers." I think while legally accurate, the social media companies in question often omit the fact

that those "network issues" and "difficulties" came about as a result of a criminal hack.

Beyond the web, think of how many times a utility has to suspend service. Think of trouble with subway commuter trains. Or maybe the power goes off for a few hours on a clear day with no storms to knock down power lines. Maybe a hospital notifies you that for "scheduling reasons" your medical procedure has to be moved to later in the month.

It is hard to know now—and going forward it will be even *more* difficult—how many of these problems and interruptions are actually being caused by cybercriminals.

There is, however, a foe operating in this sphere that is even more troubling than cybercriminals. And that's cyberterrorists.

A criminal at least has coherent demands and an ultimate objective. Most of the time, they want to steal data they can sell on the black market, or they want to hold an entity hostage until a ransom is paid. They want money. We can at least understand their motivation.

A cyberterrorist simply wants to sow the seeds of chaos and create frustration. Usually, this will be for political (or geopolitical) reasons—but sometimes it's for no reason at all. (Like the famous line in the 2008 movie *The Dark Knight*, "Some men just want to watch the world burn.")

Cyberterrorism is why large municipalities like New York City must be ever on their guard. There is so much to disrupt. And in our increasingly connected modern world, a cyberterrorist only has to take down one core capability to create incredible problems. Consider if *just* the power grid went down. Or *just* the Internet. Or *just* the water supply. How would we conduct business, check on our families, or make plans for the future?

I have a friend who once flew to Chicago to attend a conference, and when he landed he found that smartphone connectivity

Scammers and Crime

was temporarily down. He couldn't contact the people who were picking him up. He couldn't reach out to the conference to let them know he'd be late. It was very frustrating. His story really impressed upon me how much we depend on our phones. It really is the case that life is tech, and tech is life. (Some of us who are old enough to remember the "analog world" might have skill sets we could reanimate. We knew how to read physical maps, had memorized the phone numbers of our loved ones and friends, and could use landmarks to navigate places. But Gen Z and Gen Alpha have always lived in a world where they never had to cultivate these skills.)

To keep our modern way of life functioning seamlessly, we have to be right all of the time. We have to thwart every attack. To utterly disrupt our ability to function, the cyberterrorists only have to be successful once.

In the Age of Imagination, both businesses, municipalities, and individual citizens must be ever on their guard.

Now for the good news. . . .

Just as AI is creating these issues, there remains hope that AI can be a powerful tool in solving them.

Earlier, I noted how AI is useful in medicine and medical studies because it can comb through vast amounts of data and look for anomalies that humans might miss. (For example, a negative reaction to a drug, or an unexpected benefit of a drug. Or a correlation between certain behaviors and conditions.) In the same way, AI is going to be able to help the good guys on the cyber-warfare front quickly analyze huge amounts of data in the network, and look for anything strange that might be a cyberattack. With enough data over time, this ability will also arm the

good guys with predictive analysis, meaning cybersecurity professionals will have a good idea of when and how cybercriminals are likely to strike next, and what form their attacks might take. AI algorithms will continually sift through data to detect anything that looks wrong or unusual, and then prompt the good guys to take action.

AI will also help us to prepare for more specific, known threats.

Google, for example, is now devoting significant resources to provenance authentication at the digital level. ("Provenance" is a term most commonly used in the art world, and it refers to a record of the journey of a piece of art after it was created. That is, who had owned it? Where has it been? And can we trace that line back to the authentic creator/artists?) Google is interested in "data provenance" technology that can track the origin of data.

How will that technology help stop fakers and scammers?

Imagine that you receive a voicemail from someone you know. In the message, they claim they are experiencing an emergency, and they need you to send them money quickly. Imagine dragging that voicemail file into a digital tool that could immediately tell you the provenance of that voicemail. Did it come from a phone number belonging to your friend who's on vacation, or does it come back connected to an AI program on a laptop in China? We may reach a point when messages or video calls arrive "pre scanned" for provenance, and bearing a digital seal or certification attesting to the fact that they have been authenticated.

Companies developing AI video technology—like OpenAI— have already said that they are working on internal provenance tools such as digital watermarking to help the public identify which videos were generated by their product. (This is, of course, just what they would want to say to avoid being regulated.) Until a gold standard of authentication is devised for fighting AI

Scammers and Crime

deepfakes, we're going to have to be creative. But I'm still confident this is something we can be successful at.

Because of the prevalence of deepfakes in politics, responsible politicians may want to take on the responsibility of preventing deepfakes themselves. What would that look like? For one—in a move out of the Dave Eggers novel *The Circle*—politicians could have themselves recorded whenever they were appearing in public or giving a speech. That authentic video could be minted to the blockchain. That way, if fraudulent, AI-generated videos were leaked, the politician would be able to prove "I was never in that location, and I never said that. You can check it against where I was on the blockchain." True, it might become a bit of a burden to have oneself constantly filmed during election season, but if the alternative is leaving yourself open to deepfake propaganda, it may just be something that becomes a part of political life.

On a personal level, the Age of Imagination will use pattern recognition and anomaly detection to identify consumer patterns that deviate from the norm. Most of us have experienced attempting to make a high-dollar purchase with our credit card and getting a quick text from the bank issuing the card to ask if the purchase is genuine. (The bank will usually decline to process the purchase until you respond to the text.) With AI keeping watch, this sort of technology is going to be expanded to prevent crime in many other ways. AI will use behavioral analysis to get a sense of your typical actions and interactions. Banks and issuers of credit will build a profile of you, and notice sudden changes and irregular logins, locations, or spending habits. (This doesn't mean that you'll never be able to make a sudden change in your life, or that you can't decide to make an expensive and unusual purchase. It just means that AI will double-check it's actually you.)

AI is also going to be able to crack down on fraudsters who hack into devices and accounts. Imagine you're an influential

person with many social media followers. Criminals might be incentivized to hack into your social media account and post a link with text suggesting it will take people to a website where you are offering a new product or experience. (In fact, the link will take them to a fake webpage where they'll be defrauded.) And say these criminals strike just when you've gone to sleep for the night. By the time you wake up the next morning and realize what's happened, many of your followers will have fallen victim. AI will help prevent this scenario by using algorithms to recognize text data that is typical for you, and put in place steps to verify any posts that might look suspicious. This will save you from impersonation, even when you're asleep!

AI will prevent fraud by using graph analysis to quickly analyze networks of transactions within cryptocurrency trading to uncover more complex fraud schemes that involve multiple parties working together on criminal (or just immoral) scams. For example, this sort of technology will help tip off investors when it sees early indicators that a "rug pull" scenario might be underway. (A rug pull occurs when the creators of a crypto suddenly divest from the project in unison, "cashing out" and leaving investors with a digital asset that is suddenly worthless, or at least significantly devalued.) AI is going to be able to look at buy/sell patterns across large fields of data, and help investors realize when something unsavory might be going on.

In conclusion, there are some wonderfully positive changes—and safeguards—that will come about with the Age of Imagination. However, basic human nature won't change. Humans will always want to get rich quickly, and will feel tempted when there seems to be an opportunity to do so. Humans will be susceptible to prompts to act quickly. Humans will always find it annoying to take extra verification and security steps. In short, the traits that make humans susceptible to fraud today are not going to go away

Scammers and Crime

in the coming age. However, while AI will give criminals powerful new tools, AI technologies will also give the general public, corporations, and governments a proactive and adaptive approach to fighting back. By leveraging analytics, machine learning, and pattern recognition—as well as deploying education programs that promote good old-fashioned common sense—we can stay ahead of evolving threats and help ensure that we are as protected as possible against threats, which will surely continue to evolve.

In the Age of Imagination, Scammers and Crime will impact your:

- *Career: Cybercriminals will have powerful tools, and they'll use them to target places of employment, from private companies to municipalities. Preventing fraud is going to become everyone's job.*
- *Family: Everyone's personal household—and all members of it, old and young—will be vulnerable to AI-assisted crime, and will need to play a part in fighting it.*
- *Community: We take our community infrastructure for granted. We get on the train, and it's working. We turn on water to cook with, we trust that it's clean. We trust that the heat will come on to keep us warm in the winter. As cybercriminals target whole municipalities, every community will need to do its part to keep shared community assets safe.*

Where and how to engage with this technology now:

- *Learn about businesses like HiddenLayer, Recorded Future, and CrowdStrike that are developing leading-edge tools for confounding cyber criminals and stopping online crime and fraud.*
- *The Federal Trade Commission, the Office of the Comptroller of the Currency, and the FDIC regularly provide updated information about online and AI-based scams that have been reported to the government. Their websites also deploy information on how these scams can be avoided.*
- *Most of all: always trust your gut when it comes to online and AI! If something feels wrong, take added steps to verify before engaging!*

In some future day, artificial intelligence and the mind will become one.

**Chad Bouton
Professor, Institute of
Bioelectric Medicine,
Feinstein Institute for
Medical Research**

CHAPTER TEN

A REVOLUTION IN EDUCATION

How do you empower an individual?

This question is at the core of most contemporary questions about education—from where it is now, to where it needs to go in the future.

Educators—and academics who study education as an industry—are mindful that there are still extreme inequalities of outcome in our system. Despite regular initiatives to improve education in the United States (and globally), we still find it difficult to give children everywhere equal access to a learning environment where they can thrive. And frustratingly, the income level of a child's parents is still the best overall demographic predictor of how that child will score on standardized tests.

AI is going to revolutionize education and help address these issues. Only a subset of developers are specifically focused on using AI in education right now, but that doesn't matter. It turns out, AI

cannot help but improve education because of the way it necessarily increases our access to data, information, and learning.

With the rise of AI, access to facts and news will come more easily than ever before. Anyone looking to research a topic—or seeking assistance from a virtual assistant—will be able to be accommodated. People will be able to do research on any laptop or phone, in any country, and in any language. (I touched on this earlier, but it will also be more difficult for repressive regimes to censor information—including information accessed by students—in the Age of Imagination. I've spoken with blockchain developers in China who have access to information on the blockchain that their countrymen don't . . . simply because it's on the blockchain. But what happens when every student has this access? The answer is a reduction in institutional censorship, for starters.)

We will also see that AI empowers students everywhere by letting them learn from anywhere. Since time immemorial, there's been the sense that students needed to "go away" to attend college. They have to physically matriculate at Oxford or Harvard and so on. With the advent of high-quality online courses, many of them totally free, people have already begun to question the value proposition of the traditional university education. Why are we physically going to college? Is it for the immersive experience? How will things change when AI gets good enough to teach courses in an immersive metaverse? Is being seated in the very back of a crowded lecture hall with two hundred other students really superior to receiving a one-on-one lecture from a knowledgeable AI on the same topic, up close, in virtual reality?

I should point out that some proponents of the traditional university model have stressed that more than "book learning" happens in four years at college. There is acculturation and socialization, too. I think this point is fair, but I also think the world

A Revolution in Education

is changing. While business deals might once have been done entirely with an in-person meeting over a handshake, today major negotiations and transactions occur over Zoom or in the metaverse. The skills that young people need to get a good career and find success are going to be less and less about their physical locations, and more about how they learn to interact with (and through) the panoply of electronic communication options.

Gen Z and Gen Alpha are already spending more time on their phones than any other generation ever has. What does that say about their worldview and expectations? What does that mean they're going to be "comfortable with" when it comes to learning environments? Gen Z and Gen Alpha are accustomed to being able to create and collaborate with friends they know online from all over the world. They are accustomed to learning from tutorials and that may not have been initially recorded in the language they speak, but which are now seamlessly and immediately translated by AI. It is a world in which everyone, everywhere has a right to view content and look for help and knowledge. How are these students going to feel about an education system in which the "top schools" are literally built on exclusion—with the nation's highest-ranked colleges and universities now routinely admitting less than 10 percent of those who apply?

In addition to the looming paradigm shift when it comes to where education physically takes place, AI is also poised to impact what is taught. Great strides are being made to ensure that the new coding language for programmers is simply plain English. At this stage, traditional knowledge of coding is still indispensable for those in the industry, but in a generation, "coders" can be any person using plain English to explain to a computer what needs to be created. (It is hard to overestimate the ground-shaking change this will mean. Imagine a world in which every computer could only be programmed by someone speaking French. Now imagine

English-language versions become available. How much time and instruction are saved for students in English-speaking countries?)

But coding is just one example. More and more, AI will break down the barriers of industry jargon. An AI will be able to put a statement into "legal language" or "contract language" or "medical language" as seamlessly as a trained practitioner in one of those fields.

Curating and cultivating LLMs themselves is also going to become easier. At NYU, we already have business students who are "tuning" LLMs to optimize them to be useful/helpful in a particular field. As the tools to customize LLMs become more widely available, we may see students in the classroom preparing an LLM so it can be of optimal assistance in their schoolwork the same way that, generations ago, students might have prepared for class by sharpening pencils.

When this kind of world-changing technology becomes possible, it will update our sense of what it is useful to learn.

It's the difference between developing a skill set to perform every mathematical computation oneself, and developing a skill set that allows for the fact that you'll be able to use calculators, computers, and AI.

The education industry has always been cautious about incorporating new technologies—even though it's an area where we've seen time and again that technology can make a tremendously positive impact. As we begin to ease our way into the Age of Imagination, we're seeing both "early adopters" who are keen to incorporate AI technology into the classroom, as well as those who remain intent on actively maintaining the status quo. Again, if we look at history, this should not be a surprise.

A Revolution in Education

In the 1980s and 1990s, those on the leading edge of education pushed for the incorporation of multimedia in the classroom. Teachers were encouraged to use movies and filmstrips to augment their lessons. Computers were brought into the classroom. Educational software was deployed to assist students. And despite the fact that these advances seem self-evidently beneficial in hindsight, we must remember that large numbers of educators and school administrators pushed back at the time. They claimed that watching an educational film was "being lazy" or that completing an educational tutorial on a computer was "not real schoolwork." Yes, this seems risible now, but at the time the introduction of these technologies was characterized as contributing to a "dumbing down" of the educational system.

Yet, as ever, the march of technology could not be stopped. In the twenty-first century we've seen the introduction of interactive whiteboards, online learning services, and education apps that students can use to augment their classroom experience. And of course, in the wake of COVID, there was remote learning.

Here again, we saw pushback from many quarters before the inexorable force of technology proved once again that these tools were not lessening academic rigor or giving students an "easy button" when it came to doing their work. Rather, these technologies were giving students an introduction to the kinds of tools they would be expected to use in a contemporary workplace to get things done.

And so we are now with AI.

Schools across the country seem to understand the powerful role it will play in the future, and they generally agree that students will need to use it in future workplaces—but they also remain uneasy about its applications.

Perhaps the most egregious example of this "two faced" approach was seen at Emory University in 2023. A group of

Computer Science students at Emory designed an AI program called Eightball that could be used to create study materials, practice exams, and flashcards. You upload, say, an important essay into Eightball, and the program provides you with study guides to help you learn all about it. A win-win, right? Emory University certainly thought so, praising the students for developing this AI education tool and awarding them first place in the school's entrepreneurship competition and a $10,000 prize. Yet, just a few months later, different administrators at the school declared that Eightball—which by then was being used by several students across the campus—actually violated the school's academic integrity policy. Eightball was characterized as inappropriate for the academic experience, and its creators—who had just been given the school's top entrepreneurial award for it—were suspended. (The students went on to file a lawsuit against Emory, challenging the suspension. This was a completely appropriate reaction, in my opinion.)

The Emory University example is typical of the "multiple personalities" that many schools are now manifesting when it comes to AI. Educators acknowledge that technologies change, and that students must become familiar with new technology to be competitive on the job market and in their careers; yet at the same time, there is a bemusing resistance to actual, practical uses of that technology. There is a deep-seated sense that using AI counts as "not doing the work" or even as cheating.

What I expect we'll see with AI is what we've always seen when new technologies impact the classroom. That is, a period of frustrating resistance, followed by a period of acceptance, and that followed by a disbelief that there was ever any resistance in the first place.

It's just a shame that student innovators (like the ones who created Eightball) have to be subjected to the whims of an

A Revolution in Education

institution that has yet to make up its mind; that has yet to decide if it wants to accept the fact that the future is here. For the sake of our students, we should all work to help K-12 institutions, as well as colleges and universities, to develop and deploy consistent rules about AI that students can easily understand and follow. These rules should be applied equally across departments and disciplines.

The reach of technology has consistently enhanced teaching methods and the educational experience. (Does any serious person think we should go back to teaching in a one-room schoolhouse with a chalkboard on the walls?) We would only do students a disservice by failing to prepare them to thrive in a tech-driven future.

In my experience, people can fear something when they don't fully understand it. I have a sneaking suspicion that many of the current crop of school administrators who want to ban AI in the classroom are not fully knowledgeable about the subject. It's likely they think they understand how AI works and what it can do, but they're actually operating on a bunch of stereotypes and assumptions. To fix this, we'll need to educate the educators.

Schools can deploy (and require) classes and workshops on AI learning for educators. Teachers who *do* have a good understanding of how AI works can volunteer to educate their peers. School districts and accrediting bodies can offer certifications in AI learning to help ensure teachers and professors know how to incorporate it in the right way.

We should address the fears and misconceptions about AI in the classroom head-on. We should listen to feedback from educators who have concerns about it, and we should take their feedback seriously.

However, we should *not* allow people who cannot be troubled to acquire a knowledge of how AI works to be the ones making the

decisions governing the lives of students. Too much is at stake for that.

Just as skill sets will change when technology changes, so too will educators themselves. AI is never going to replace human teachers, but AI *can* be used to augment traditional instruction and help students in new ways. AI tutors are a wonderful example. Imagine your child being able to have the same tutor for their entire academic career, and being able to access this tutor anytime, on any device. This tutor can grow along with your child, learn about your child, and will always be updated with the newest and most relevant information. An AI tutor—which, if you like, can take the form of a friendly avatar—will become a familiar face that can become familiar with your child's learning style, and can help them to learn and grow at their own pace.

Sometimes when I'm at public speaking events, I'll be asked about AI in education by people who have concerns about overuse. Generally, the question will be phrased something like: "If AI can be used by student to create assignments, and AI can also be used by teachers and professors to grade or comment on assignments . . . then don't we risk arriving at a future where AI is evaluating AI, and no human is doing any real teaching or learning?" I would be lying if I said that this scenario does not concern me. Currently, there is tremendous potential for misuse when it comes to AI in education. (See my notes in the chapter that follows about the Age of Dumb.) However, I think while students—and let's be honest, some teachers and professors, too—will enter a period where they will be tempted not to do the right thing, and will want to let AI do the work that they should be doing, I think that period will be a short one. This is because we will figure out

A Revolution in Education

how to do the right thing. As educators, we will learn to balance inspiration, education, and motivation with a world of AI tools that are definitely not going anywhere. Educators working in the very near future would be living in denial—and not really doing a service to their students—if they acted like we weren't suddenly living in a world of remarkable AI-based resources; resources which are going to be used in everything from business to art to interpersonal interaction.

I think educators will figure out how their students can use AI to augment the learning experience without using it for everything. For example, there's already an education company called OptimaEd that has built out two hundred fully immersive virtual reality environments for students that can allow them to physically explore important historical events and locations, like the pyramids in the time of the pharaohs, or the Boston Tea Party. Students can interact with these worlds in VR as part of a lesson. A study from Stanford has already shown that the memorability for these sorts of VR-lessons is about 80 percent. (For comparison, the memorability of a typical classroom lecture or lesson is usually 5-10 percent.) So it's clear there are some ways in which technological assets in the Age of Imagination will give educators AI-based tools that will augment what teachers already do, and help the information they share with students to have a greater impact.

Do I have some concerns in the short term about lazy people—or people who want to scam a system—using AI to replace real work? Absolutely. Yet I also think that if we start now, we can align on guardrails. From an institutional perspective, since this technology is currently barreling forward so very rapidly, I think the best policy now is to "wait and see" and observe what people actually do with AI. (As we all eventually learn, there can often be a gulf between what people say and what they do.) Colleges will

have to create AI policies that cover both educators and students. Obviously, a policy of "nobody is allowed to use AI for anything, ever" does not reflect the "real world" that educators are tasked with preparing students for. At the same time, having no rules for AI at all seems very inadvisable. Schools of all kinds will need to remember that just because you cannot do something perfectly, it doesn't mean that you shouldn't attempt it at all. An imperfect AI policy is better than no AI policy.

AI is going to evolve quickly. Every six months, or maybe every three months, I predict it's going to be able to do something new. Something that may not be covered in most school AI policies. Something that's going to make professors like me say: "Wait a minute . . . it can do *that* now?" So we need a moving, living set of rules. As educators, the onus is on us to inspire the students and help ensure they use AI in the right way.

We cannot trust AI to regulate itself in this area.

Remember, generative AI is trained to predict what's next. All it is is math; it's literally algebra. That's it. That's one reason why you'll still see errors that result in an image of Taylor Swift having six fingers on one hand. The AI will believe that it is providing you with accurate information—e.g.: how many fingers Taylor Swift has on her hand—when it is, in fact, providing you with inaccurate information.

Think about that in the classroom.

There will always need to be a professor or teacher. There will always need to be an adult in the room who can say definitively, "Okay, there's a problem here; Taylor Swift doesn't really have six fingers on each hand."

And I'm kind of trying to make a nuanced point here, because this flawed AI will certainly be better than nothing for many students, even if it is sometimes wrong.

AI can alter traditional Western university educations. Think

A Revolution in Education

back to closing the digital divide on a global scale. Think of a super-intelligent kid born on a farm in Sri Lanka, whose family doesn't have the money or means for them to ever attend Oxford or Harvard. Now that kid is going to be able to access Ivy League-level content wherever they are, because, as current trends continue, even poor farmers in developing nations are going to be able to afford smartphones. Even if the classes on that smartphone are AI-driven—and, accordingly, sometimes not totally accurate—the education that that Sri Lankan receives will still be vastly superior to what would be available without the aid of technology.

And look, in many ways, it's fair to say: "We're not quite there yet." I have a sixteen-year-old child and an eight-year-old child, and I'm encouraging them to both pursue the traditional avenues of legacy education. I wouldn't advocate either of them learning anything "just" on their phones and laptops. Their educations still need to be curated by qualified professionals. But for kids who don't have the option of a first-world education? Certainly, AI is going to be able to level the playing field and help fill in the gaps in lots of ways.

There's an old saying that in life sometimes you have to take a leap off the cliff and then build your wings on the way down. When it comes to AI in education, there will always be specialist skills that will need to be gradually learned by humans over time. AI can't make someone a prodigy overnight. However, AI can allow entrepreneurs to get the ball rolling more quickly on projects. It can help fill in gaps and provide efficiencies here and there until the entrepreneur has more institutional knowledge. In these situations, I think it *will* be able to help you build wings as you go.

SOME FUTURE DAY

In the Age of Imagination, if a rural farmer wants to start a fashion business, they'll be able to get it moving along just using their phone. They'll be able to generate electronic examples of their products, take preorders to production, and learn how to expand and grow organically. For any areas that are new to them, AI will be a teacher, and it will also be able to act as a designated assistant.

In the program where I teach at NYU, the average MBA student already has eight years of work experience. It will be exciting to see how much experience entrepreneurs need in just a generation or two when AI allows them to start a company with the help of an omnipresent teacher/assistant.

Despite these efficiencies that will soon be widely deployed, I think success will continue to come down to who has the motivation and curiosity to learn. AI will enable education, but it will not replace education, and it will certainly not replace a passion to better oneself. Motivated people will still come out on top because they will want to do the work.

I think often of a conversation I once had with Wynton Marsalis, the celebrated trumpeter and jazz musician. We were talking about different musical styles and he said something like: "Hip-hop is great, but hip-hop is like candy. Jazz is more like broccoli. It's good for you. It makes you better. But it also requires you to chew. You have to do the work."

AI can bring incredibly powerful assistance to anyone, but you still have to be willing to do the work.

Many people are lazy, and they will be tempted to let AI "do the work." This not only makes for lazy people, but it makes us intellectually lazy as well. When we see a video on social media—that may be altered by AI, or may be genuine—the lazy thing to do is to accept it at face value. In other words, to not do the work.

For me, this comes back to one of the core points of

A Revolution in Education

education—that it is important to an entire society. Yes, an education is valuable because young people need to learn specific skills that will help them get a job, build their businesses, and earn a good living. But education is also important because we need a populace of informed citizens. We need communities full of people who understand that they need to—as Wynton Marsalis put it to me—"do the work." They must be willing to take the time to consider news or images with a careful and discerning eye. We want our citizens to do this when they listen to a politician, when they evaluate a claim by a company or government, or when they simply watch an advertisement.

We need people who can use logic and deductive reasoning in an AI-enhanced world. We need people who are comfortable revising their position or changing their mind when confronted with new and better information. (I've never understood why changing one's mind about something in light of new data has been derided as a sign of weakness, especially in the political sphere.)

To conclude, I'm thrilled by the wonderful ways AI is positioned to be useful in education. The ability to deploy educational materials to learners all over the world—no matter how wealthy they are, no matter what language they speak—will be a remarkable thing for our collective humanity. It will help to level the global playing field. A long distance education made possible by AI will probably never be as effective as an in-person education facilitated by schools and educators, but it will be so, so much better than what much of the world's population currently has. When it comes to using AI in the classroom, we're going to have to feel our way forward. Educators can't pretend AI doesn't exist now, but that doesn't mean they have to allow students to turn in papers written by ChatGPT. I think that if we can view AI as a remarkable tool that can help democratize and improve

education—while still recognizing that to be successful, motivated humans must still "do the work"—then the future looks bright for learners everywhere.

A Revolution in Education

Changes in Education will benefit your:
- Career: Humans will become lifelong learners from their mobile devices, with no limitations based on location or language. Anyone wanting to learn a new skill to open a new career path will be able to do so, and from just about anywhere.
- Community: AI will redefine educational communities, making them more about shared interests and avocations, and less about physical proximity. The notion that one must physically attend a school to receive a top-notch education will begin to fade as an idea.
- Family: Families will have more choice than ever before when it comes to education. Families unable to afford the most expensive neighborhoods will no longer necessarily have to settle when it comes to education, as so many resources and tutors will be available through AI. Families living in a rural setting can have most of the educational resources of city dwellers.

Where and how to engage with this technology now:
- To read articles on the cutting edge of the discussion around AI in education, consult The Chronicle of Higher Education, Inside Higher Ed, Education Week, and TEACH Magazine.
- ExcelinEd, Skillsoft, and Blueprint Test Prep are all businesses using AI in novel ways in the education field. Keep an eye on their work going forward.
- The US Department of Education is developing policies and protocols around their position on the use of AI in the classroom. Consult their website regularly for further updates.

In some future day, individual liberty and freedom will become the mainstream and dominant in our culture.

Yaron Brook
Chairman, Ayn Rand Institute

CHAPTER ELEVEN

THE DILEMMA AND POSSIBILITY OF SOCIAL MEDIA

In a chapter I hope will be both optimistic and cautionary at the same time, I want to say a few things about the importance of social media as we move into the Age of Imagination. I say that this will be optimistic because I believe that social media contains an awesome power to function as a conduit for the exciting new technologies of the Age of Imagination. And I say it will be cautionary because, if we are not mindful of the growing power and influence of social media—an influence that is not always benign—then we face a future in which our citizens could be worse off, instead of better off, because of social media's influence.

When we look at emerging technologies in 2025, we see all the content engine pipelines converging around social media. It will be one of the easiest ways to access, deploy, and be creative with

AI. These pipelines are also poised to help us access new financial mechanisms and systems, and to facilitate decentralization. Social media will also be the way in which thousands (or millions) of "citizen journalists" securely deploy the news they have captured, and mint it to the blockchain for authenticity.

Theoretically, all of these things will give more power to the individual in the Age of Imagination. More people will be getting their message out. More people will be holding their own money in a currency that isn't subject to the whims of local governments. Social media can be an excellent way to spread the word around more stable financial alternatives, and to access them. Think about what happened to the currency of Venezuela starting in 2014. Imagine the human suffering that could have been prevented if Venezuelans could have learned about alternatives to the bolivar, and transferred their wealth into a decentralized currency that wasn't tied to their mismanaged government. (Even in stable, prosperous countries that are not in crisis there can be tremendous benefits to exploring decentralized places to keep money.)

Social media is also affordable to both consume, and to participate in. Many social media platforms are entirely free, with the only "cost" being occasional advertisements. And with the relative price of smartphones and tablets continuing to decline, even people of modest means can view and access content on social media. It's also an inexpensive way to *deploy your own content* to reach a mass audience. Users can create movies, talk shows, political discussion shows—with whatever content they want—and AI will only help this content look better and better. Importantly, all this can be done without the need for government-run entities or government licensing.

This is the optimistic, hopeful part. I earnestly believe that social media will make content consumption and creativity easy, accessible, and practically free.

The Dilemma and Possibility of Social Media

However, the need for caution comes from the fact that it may be *too* easy to access this content. We may create a place where we'll be "amusing ourselves to death," as the late Neil Postman would say. (Some people think we're already there, and that AI will only make the trend worse.)

When I say "amusing ourselves to death," I don't mean that there will be a mass phenomenon of people literally passing away, but I do mean that overuse of social media—and use of it without thinking critically about it—may lead to a weakening of our collective understanding of the world.

Social media gives us the opportunity to constantly amuse ourselves with fluff. With unimportant things. It is true that social media can be used to access cutting-edge, important information about the most vital issues of the day. But it is equally true that it can be used to enjoy an endless stream of cat videos.

Now, everyone likes a good funny cat video, but if we collectively lose the sense that it's important for a nation's voting populace to be at least somewhat informed, then we risk becoming susceptible to charlatans. We risk some version of the movie *Idiocracy*. We risk what some of my friends have taken to calling "the Age of Dumb."

If everyone consumes large amounts of media—much of it on their phones using social media platforms—but they limit that content to silly amusements, then we risk getting out of practice when it comes to thinking critically. We won't do the hard work of critical thinking, or will at least be out of practice. As Wynton Marsalis put it, we won't eat the "broccoli."

And this is a problem because we need the ability to evaluate statements. When we consider if we should accept an offer—like purchasing a product and knowing the terms, or even accepting an offer of employment—we need to be able to evaluate that offer critically. Do we know what we're signing on for?

SOME FUTURE DAY

This is also very important when it comes to choosing our own leaders. Recent polling indicates that over the last twenty years, Americans have become more dissatisfied with the two major political parties, and a record number are choosing to identify as independents. (Some Gallup polls taken in 2024 show that the number of voters identifying as independent is now nearly half of all voters.) Because of this, politicians will increasingly need to convince voters that their ideas are the best. But for that to happen, we need voters who are able and willing to think critically and be discerning.

Do you ever listen to a sound bite from a politician and think to yourself: *That made absolutely no sense?* I know I do. I think there's a reason our politicians don't make sense anymore. (At least most of the time.) And that reason is, they can get away with it. Doing the work is hard. Writing a speech that proposes real solutions and tackles problems head-on is hard. But writing a speech that offers no specific solutions, and merely plays on a lot of familiar stereotypes and received ideas, is easy.

Politicians don't want to do the work. But this isn't a problem for them because the voters don't want to do the work, either! Most voters don't want to stop and evaluate what the politician is really saying. So nobody is doing the work. And that's a problem. That hurts society, creates wars, and leads to the oppression of minority groups.

A lot of people in the world are already living off pleasure and not doing the work. They spend most of their phone time looking at silly nonsense videos, and if they do watch parts of a political debate, they just want to see silly *ad hominem* zingers, like when opponents insult each other's appearance or give one another silly nicknames. They don't want to stop and consider "Do the things this person is saying actually make any sense? Will the solutions they propose actually solve any problems?"

The Dilemma and Possibility of Social Media

Because that would mean doing some work.

We used to get most of our amusement from fictions; that is, fictional TV shows with plots written by writers. Now—instead of looking at politics to make sense—people are looking to politics to be amusing. They want politicians to compete with comedians and *SNL* sketches. The politicians are realizing this, and they're tailoring their remarks accordingly. Our leaders used to talk about substance and policy, but now they understand that to connect with voters they need memorable insults and quips that have nothing to do with their plans to help America.

A mere generation ago, we seemed aligned on the idea that certain parts of our culture did not need to compete with popular entertainment—from journalism, to education, to religion. These spheres used to be relatively free of trite, silly, or sensational content. We could accept that these were at least somewhat serious areas where an audience might rightly be expected to "do the work."

But I think this is eroding. News outlets, educators at colleges and universities, and even religious institutions feel they need to keep audiences engaged. Is it any wonder that we see more dumbed-down nonsense everywhere we look?

Some pundits have even suggested that this trend—using technology to steer people away from critical thinking, and toward silly fripperies—is a potential danger to long-term national security. They might be right! I think it is at least worth looking at the possibility. For example, we should ask why China is passing laws to limit the screentime of their children. Why have they passed laws limiting people under eighteen to no more than one hour of TikTok per day? Why have they passed laws limiting people under eighteen to playing video games only on holidays and weekends?

China's government has explained that these regulations are intended to combat social media and video game "addiction."

SOME FUTURE DAY

But I think there is room to wonder if it might be something more. Most experts say American teens are averaging between six and eight hours per day on their devices. (That includes watching videos and movies on tablets, televisions, or phones, playing video games, and—of course—being on social media.) These numbers were goosed by the COVID-19 pandemic quarantines, which forced young people to move their socializing online. Still, the question remains: When the current generation of teens and tweens reaches adulthood—and starts doing things like solving complex problems and electing leaders—is there going to be a meaningful difference between a group that spent only an hour a day on TikTok and played videos games just on the weekends, and a group that was spending as much as eight hours a day—*every day*—on their devices?

I'm not sure I'd go as far as to say that this is definitely a plan by China—which, of course, owns TikTok—to dumb down Americans. However, I do think there will be a difference between a group that becomes accustomed to near-constant scrolling for online social media pleasure and another that is more restrained. I say this for the simple fact that time is a zero-sum game. There are only so many hours in a day. We are living in times when social media companies have made great money from "conquering" and "colonizing" our previously unused swaths of time.

Sitting on the school bus. Waiting in a doctor's office. Killing time during a lull in conversation while at a restaurant with friends.

These were all formerly situations in which people previously had time to themselves. They might have read a book and studied, or just chatted with those around them. Now these are all situations where using smartphones to access social media and other online diversions has become the activity of choice.

If every fifteen-year-old boy is scrolling aimlessly for eight

The Dilemma and Possibility of Social Media

hours a day, then they aren't using that time to read books. They aren't doing homework. They aren't taking steps to better themselves. My generation didn't bring televisions or computers on the school bus simply because we couldn't. The technology didn't exist. We didn't have the option of killing time on social media in bed at night or when we were in the bathroom. Frankly, today's teens face temptations and diversions that my generation could never have imagined. (Would we have likewise succumbed, and browsed for eight hours a day if that had been an option? I have no idea.)

Our spare time is being competed-for like never before. Yet, even that might not be the entire story—might not be the endgame. Our mental bandwidth may be the new "real estate" that outside forces are seeking to develop. How we look at the world. What we think is "a big deal" and what we think "isn't a big deal." All of that is influenced by our online interactions and the social media we consume.

In every presidential election since the launch of social media, allegations have been made that there are certain groups—many of them external to the USA—attempting to secretly place propaganda in our social media. To what extent this actually happens seems up for debate, but we know that it happens some. If our citizens consuming social media lose the ability to think critically, then their ability to detect propaganda and misinformation will suffer. Personally, I want to believe, but I am not convinced that young people can still identify overt and extreme propaganda, like someone saying: "Jewish people are bad." However, I believe they now struggle to identify problematic elements when someone says something like: "Denying the Holocaust is not that big of a deal, really."

Whatever our political persuasion—or where we fall on the issues that traditionally separate liberals and conservatives—I

think we can agree that the election of Donald Trump in 2016 took us to new territory. And eight years later, one can easily forget just how certain the political pundits and experts were that Trump had absolutely *no chance* of winning the presidency. When the returns began to come in on election night, we saw the biggest political upset in living memory. In the weeks and months that followed, all the news analysis went to: "How did we get this so wrong?" and "What has changed?" Most of the proposed answers involved identifying forces we already knew about, and saying they had been underestimated—for example: anti-establishment sentiment, fear of demographic change, and economic decline in the Rust Belt and rural areas. I have no doubt that all of these forces were part of the story. However, I also think that Trump was elected by people who had become accustomed to accessing the shallow entertainments of social media throughout the day on their devices.

While campaigning, Trump seemed to intentionally add fuel to this fire. More than any candidate before, he declared that news from reputable sources was "fake news" (a term first used in 1890). In addition to making the case for why his policies would be better for the country than his opponent's, he also spent his time on "gotcha" moments, crafting clever insults, and devising mean-spirited nicknames. At rallies, he led his followers in spirited chants of "lock her up," but not in thoughtful explications of how exactly his opponent might have violated the law. Donald J. Trump was able to use this technique to control the narrative, beginning in the primaries, and then against Hillary Clinton. Is he the best marketer of our lifetime? Today's PT Barnum?

I suspect that if a political observer from a hundred years earlier could have time-traveled forward and observed Trump's campaign, they would pronounce that Trump did *everything but* talk about how his ideas and policies were going to help the country,

The Dilemma and Possibility of Social Media

as his carefully crafted soundbites dominated social media as well as legacy media.

However, Trump was effective. He was talking to people on a frequency to which they had become accustomed. His slogans and nicknames were just as shallow as the latest silly meme, but just like a meme, they brought a momentary grin to his supporters. Trump sometimes spoke about issues at a high level—such as illegal immigration—but his proposed solutions were, likewise, about as simple as an infographic that might be shared on social media. He was saying: the solution is easy and familiar. We don't have to think too hard to solve this.

He asked very little of his followers, just like social media asks very little. He never went too deeply into a discussion of a topic; he kept it very general, just like social media does. Trump's approach was to never engage with the ideas of his opponent. Instead, he simply drowned out any discussion of ideas in a chorus of slogan-chanting, shallow zingers, and clever insults. Perhaps Kamala Harris's communications strategy for the 2024 campaign was influenced by this approach, as she, as of the time of writing, has completely avoided live interviews with the media, debates, and has been campaigning exclusively on emotion and class-warfare.

Yet Trump won.

In an earlier chapter, I wrote about how one of the benefits of AI is that it can make us all citizen reporters. We can take a photo or video of an event, mint it to the blockchain for authenticity, and deploy it to the public on social media. This might result in catching a corrupt politician in bad behavior, or it might show that a candidate says one thing but does another. However, we'll need to understand that even the most compelling proof about a candidate must now compete with a near-endless stream of shiny, attention-grabbing, and yet essentially meaningless information . . . if she wants to be heard.

SOME FUTURE DAY

And that's not a great thing.

Going forward, we must not allow the genuinely important to become trivialized. If a citizen journalist captures video of a political candidate inappropriately conspiring with a foreign agent, we must be able to point out that this is different from him or her wearing an ugly suit, or having a bad hair day, or accidentally misspeaking. When two candidates for office have a debate, we must be willing to point it out if one candidate genuinely shares their ideas and plans, and the other merely shouts slogans from memes.

If we want to keep our country strong, we will have to fight these dumbing-down tactics. We will need to call out politicians when they speak words that mean nothing. We will have to insist that they cite sources and evidence that are backed up (on the blockchain or elsewhere). We can't expect the current government in power, regulators, or the ever-changing landscape of media outlets to automatically do this for us. We're going to need to check these things ourselves. We need to make it "cool" to be someone who always verifies anything they see or hear. (Or at least, make not doing so very "uncool.") Authentication on-chain will be helpful, but we will need to be smart enough to demand it.

We're going to need to retrain ourselves to take what we see on social media with a grain of salt. It's human nature for people to immediately believe what they see or hear. But just as the rise in our ability to manipulate photos led to our taking images with a grain of salt, so too will we need to apply that to videos distributed on social networks. With AI and spatial computing, it will be easier than ever to generate hyper-realistic videos with perfect impersonation. Musical artists ranging from Drake to The Weeknd to AC/DC have already had songs created by people using AI that went halfway around the world—as the saying goes— before anyone realized it was not a genuine song by the actual

The Dilemma and Possibility of Social Media

artist. Keeping things honest and authentic is going to necessitate a shift in how we access content. Until such authentications can be automated—if they ever truly can be—we'll need to create a world in which someone hears a song and watches a video on social media by a musical artist, and then takes a step to verify that the content is real. (This could be as simple as consulting the artist's website.) The important thing here is that the populace is willing to take a moment to make that authentication happen.

Since his purchase of Twitter (now X), Elon Musk has repeatedly attempted to position his social media platform as "superior to" traditional media outlets. While there are many appealing things about X, it remains a platform upon which one can easily upload inaccurate or misleading content with no external verification. For this reason—and/or until that changes—it will be hard to rely on social media like X for important things until we have better solutions for authentication.

Think of the "October surprise" in politics. (This phrase initially meant revelations emerging in the month of October that would impact a November presidential race, but now it's shorthand for any last-minute news that could change people's minds.) An example of an October surprise would be in the 2000 "Bush vs. Gore" presidential election, when, just before election day, (it is presumed) operatives working on behalf of the Democrats released the news that the Republican candidate, George W. Bush, had been arrested for a DUI when he was in his thirties. The advantage for the side releasing the October surprise is that it's so close to the election that the other side will not have time to mount an articulate, coordinated response. (In this example, the October surprise wasn't enough, and Bush still won, but it became one of the closest races in American history.)

In the elections of the near future, we're going to face entirely new challenges when something like this happens.

SOME FUTURE DAY

What do we do when it's just twenty-four or forty-eight hours before the polls open, and a viral video surfaces on social media of one of the major candidates taking a bribe, using a racial slur, or sexually harassing someone? It could be a genuine clip leaked by the opposition, but it could also be an AI-generated fake. Because of the paucity of verification technology currently available to us, *we will not be able to know by the time of the election.* What does this mean? Well, informed voters may simply need to ignore anything they see on social media in the immediate hours before voting, because there'll be no way to prove what's true or not. It also means that if you're a candidate for office, and you've got some *genuine* dirt on your opponent, you may want to release it earlier; make it a "September surprise." Give everyone time to verify that it's authentic.

Look, social media isn't going anywhere. I'm not saying it will, and I'm certainly not saying it should. However, all of us need to be honest with ourselves about what it will mean in an AI-driven world.

In a worst case scenario, we may look back and decide that it's killing us without using a gun. We're "dying" from pleasure, and amusing ourselves to death.

There is a price to pay when you spend every spare moment entertaining yourself to no practical end.

Because we're continuing to lower the barriers to creating high-quality, believable AI content—computers get cheaper, faster, and more portable every eighteen months—we face the potential for a flood of incredible animations that will be deployed in an endless barrage. If you think social media is entertaining now, just wait a decade. It's going to get amazing . . . and that may not be good. (If you think it's addictive now . . . well, you can guess where I'm going.)

I see this trend in my family. My own kids spend an unreasonable amount of time on social media, and they absolutely love it. They're amused and pleasured for hours. When I need them to

The Dilemma and Possibility of Social Media

be quiet in the back seat during a car ride, getting them on their phones is the way to go. But what if that's not a good thing? When my son Jude spends hour after hour watching TikTok videos, it also means he's not reading Steinbeck or Shakespeare. If kids are endlessly scrolling instead of reading the classics, and if they are constantly watching realistic AI videos that they credit as "true," it is hard to feel we are moving in the right direction.

In conclusion, in the years ahead we'll need to ensure that AI is used to improve social media, and not to create supercharged, addictive nonsense. If we do it right, this will be possible. AI will be able to use algorithms to see patterns much better than current computerized (or human) moderators can. These AI powered algorithms will identify and tag (or remove) harmful and false content. They'll ensure that fiction is tagged as fiction, and not fact. They'll also notice if people on the platform are asserting that a false thing is true.

AI will also help ensure content and advertising are targeted appropriately. For example, right now, social media platforms regularly backtrack and apologize when younger users are targeted by a product or service that is age-inappropriate. You'll hear them use the refrain, "We should have acted more quickly." The immediacy of AI will remove this excuse. AI will immediately discern and remove advertising or suggestions that are not age-appropriate. Consumers will demand that this is done.

AI has the potential to help with verification and authentication of content in more ways—and a chief one is making it easier. Right now, I might see a grainy video on Facebook that an acquaintance has posted, and I'll wonder to myself "Is that real?" But imagine the difference when I can simply speak the words: "Facebook, is that real?" and receive a knowledgeable, verbalized response in return.

SOME FUTURE DAY

We also watch leaders at tech companies shrug and backtrack when they are confronted by the problem of fake accounts and bots (which at worst are used for fraud, and at best are used just to pad follower stats). They also make the same mealy-mouthed "I wish we had the bandwidth to address this more quickly" responses when confronted about things like abuse and cyberbullying. Once again, AI is going to take away these excuses. AI algorithms will be able to detect the patterns that occur in cyberbullying and prevent it before it gets going. They'll also be able to detect and delete fake accounts.

If we demand it, AI can help make social media users more physically secure. Imagine a friendly AI that asks "Do you really want to share that?" when a young person is about to post personal identifying content, financial information, or information that could be used by a criminal. (Young people often don't even think of these things until it's too late. AI will help ensure that they do.) In the same connection, AI will alert social media users to risks and dangers that may stem from online interactions. This will be especially helpful for younger users, who might be tempted to emulate a dangerous activity they saw online.

Finally, and most importantly, if we really demand it, we can expect AI to intentionally curate social media content—especially for young people—to make it educational and useful. And I'm not talking about replacing a kitten gif with a math lesson, here. It will be more subtle than that. AI can help social media raise knowledge and awareness among young people regarding issues that may impact them. It can promote literacy and responsible behavior. It can show how ideas and content are connected. It can illustrate the benefits of being connected and informed. By noticing what content keeps a user engaged, the AI can help ensure that their personalized social media journey is also a learning journey.

The Dilemma and Possibility of Social Media

Changes in Social Media will benefit your:

- *Career:* We'll have unprecedented access to new ways in which to learn and engage, meet people, engage with brands, and make our voices heard.
- *Community:* AI will bring about exciting new possibilities for connections between like-minded people on social media.
- *Family:* Families will feel safer exposing their children to AI-driven social media. AI enhancements will make online interactions safer and more educational. But it will still be up to parents to proactively ensure their children don't become addicted to mindless distractions!

Where and how to engage with this technology now:

- The conversation around social media and AI is everywhere, and it's happening now! For a broad-based take, you can see what's being written in publications like the New York Times, Wall Street Journal, and Washington Post.
- *Social media platforms like Facebook, X/Twitter, and Instagram are going to be among the first to introduce AI-based innovations and augmentations.*
- *We're going to see the impact of AI in social media through the content that is created and deployed on social media, as much as we might see it in or on a platform itself. A lot of the content strategy around social media and AI will come from content creators, so look to the creators themselves!*

In some future day, superior creators will thrive.

**John Swab
US Filmmaker**

CHAPTER TWELVE

CONCLUSIONS—AN ACCELERATING WORLD... WHETHER WE LIKE IT OR NOT

In the early 1800s, one of the most infamous—and unsuccessful—social movements in history was born when a group of British textile workers who felt threatened by increasing mechanization formed "the Luddites." They took their name from Ned Ludd, a much mythologized (and possibly fictional) weaver who was known for smashing weaving frames. The Luddites believed they would be replaced by new machinery like the power loom that could perform textile-making tasks more quickly and effectively than human artisans. The Luddites feared they would face unemployment and ruin if these then-cutting-edge machines came into widespread use. But instead of positioning themselves as the workers most suited to use and curate this new technology, the Luddites set out to literally destroy it. They undertook a

campaign of sabotage, physically assaulting and destroying these new machines wherever they found them.

And it didn't work.

The British government—furious about what it would mean geopolitically if their country's technology rolled backward instead of forward—made the intentional breaking of weaving machines a capital crime, and instituted a swift crackdown. (According to historical records, some of the Luddites were indeed hanged, but most were just deported to Australia.) More than any steps that were taken by the British government though, the Luddites were unsuccessful because they could not push back the advance of technology. The cat was out of the bag. The toothpaste was out of the tube. People had seen machinery that could make their lives better, and could make goods of a higher quality more quickly and with less expense . . . and they wanted it!

The Luddites were the last ones to give it a serious go, but the world learned that it is simply not possible to stand in the way of technological change.

I want to close this book by invoking the Luddites because I think it is incumbent upon us—as we move into the Age of Imagination—to understand that while there are many options before us, "going backward" is not one of them.

One of the fiercest debates underway when it comes to AI concerns "acceleration." Some see AI as torn between accelerationists—who want to develop the technology as quickly as possible—and others who want built-in pauses to its development to ensure we incrementally address any issues the new technology raises. In my opinion, this is a false choice. Certainly, as I hope I've made clear in this book, there *are* issues related to AI that should raise some yellow flags. There will need to be regulations and laws—and it remains to be seen if they will be imposed by governments, or agreed-upon by the industry and consumers.

Conclusions—An Accelerating World...

But trying to "slow the growth" of this technology would be like inventing the automobile and then declaring that cars shouldn't be able to go faster than twenty-five miles an hour for the first few years. It's just not going to happen.

Gary Marcus is an NYU colleague of mine whom I respect deeply. He has written extensively on the rise of AI, and has been an excellent voice for some of the deep concerns that are raised by AI's quick development pace. (See his excellent book *Rebooting AI* and his podcast *Humans Versus Machines*.) I might respectfully disagree with Gary on a few points, but one place I think he hit the nail on the head is his assessment that a lot of AI technology has been pushed out before it's ready. I, for one, can see how this raises concerns and makes people anxious about the industry's ability to self-regulate.

At the time of this writing, there have been many prominent instances of generative AI going haywire when it comes to image generation, and causing developers to rethink their approaches. For example, Meta AI and Google Gemini have rendered Black, Hispanic, and Asian men when asked to show an image of America's Founding Fathers. And when asked to show people who have served as Pope, they generated images of people of African ancestry. (All popes so far have been Caucasian.) These errors might have come from a well-intentioned impulse to create inclusivity, but by producing images that are historically wrong, these AI companies have generated doubt about what AI can be trusted to do.

In another example—more mundane, but perhaps even more confounding—AI often can't seem to render fingers very well. It feels like it should be easy to show fingers correctly, but so far AI is showing us that it has yet to master the task. Consequently, images that are otherwise perfectly rendered might still show someone waving goodbye with six or seven fingers, or two men

shaking hands in such a way that their digits become a wad of spaghetti.

I feel like Gary is saying a bunch of prudent, relevant stuff right now when it comes to the way in which these AI models seem to be hitting a plateau. There is the sense that something more needs to happen. To make it past this plateau, we need to think differently.

That's the important part for me. Thinking differently.

Gary faces a lot of pushback because he is a longtime player in this space, and he has been voicing these concerns and hesitations since (practically) forever ago. But that doesn't mean he's wrong. Gary knew what was happening when we started seeing AI images that were ideological rather than useful. When they were aspirational rather than accurate.

If we keep building AI "ladders" taller and taller, we're not necessarily going to get to the AI moon. We need to think differently. When AI images are showing America's Founding Fathers as Black, it's clear that a paradigm shift is needed. Clearly, we can incorporate modern concepts of inclusivity while not literally erasing actual history. But we can't get to the moon with ladders. This may mean more than retraining large language models. We might need a new hardware component. We need a rocket, not a taller ladder.

As I think about where we go next—and how we get to the Age of Imagination—I consider how AI has learned so far. The short version is that AI is mostly getting trained on things made by humans. That is: things humans painted, or wrote, or built, or played on the piano. But AI is going to sometimes hit inflection points where it will need to be trained on something totally new. Where it will realize a paradigm shift is required. If building bigger ladders has always gotten us higher into the sky, how will the AI see that it no longer needs to spend its time thinking

Conclusions—An Accelerating World...

about better, taller, stronger ladders; that it needs to start thinking about nose cones, launch pads, and rocket fuel accelerants?

As we go forward, we'll have to be careful about this sort of thing because AI "learns" from everything that is on the Internet. Which means that one of the teachers of AI is now... AI itself. If AI generates content that we know isn't accurate—and we "let it slide" whether out of fealty to a well-intentioned political agenda, a deference to politically correct "right think" or whatever—then we risk AI ten years from now "learning" those incorrect facts. And so the cycle will continue.

For AI's own sake, we have a duty going forward to insist that it gets things right.

What these concepts (and dilemmas) have in common is the fact that humans will always need to provide a "guiding hand" in this process. But the good news is, this is totally doable. The Age of Imagination doesn't have to be "set it and forget it" for it to still be awesome! We can correct and curate AI to help ensure the content it generates is accurate. At the best, highest-quality companies developing LLMs, humans will ensure AI only trains on correct/true content made by humans, not inaccurate content made by previous generations of AI. Performing ongoing quality checks will be a regular thing. And we already know that we can test an AI by intentionally exposing it to inaccurate content and seeing if it spots the error(s). We can set up validating models facilitated by outside providers to do a kind of "peer review" the way colleges and universities have professors from other schools evaluate the work of their own faculty. We can have greater transparency around the ways that AI is making decisions; if we know how an AI is evaluating learning source content as genuine or fake, we can help to "feed it" content that will ensure it only learns true things.

Finally, though I'm not a fan of accountability models that

would be imposed by "big government" bureaucrats, I *am* in favor of the private sector incentivizing employees working on AI teams to ensure they get it right. When mistakes are made, there will need to be consequences for the humans who are "minding the store."

In the years ahead, we'll need to solve the problem of "feeding" AI's almost bottomless appetite. In April 2024, the *New York Times* reported that by 2021, OpenAI had already exhausted every online document that it could use to train itself—and still it hungered for more! Those curating its development had hard choices to make. They could stop training the LLM, they could lower their standards for the caliber of written text being used to train it, or they could look for something new to train it on. They chose the third option and designed their own speech recognition tool they named Whisper. Using Whisper, they then trained the LLM on over a million hours of YouTube videos.

This capability is certainly interesting, but it raises the question of what AI should be trained on next. (The same April 2024 *New York Times* story noted that some experts conjecture that current AI models will run through all conventionally available training materials by 2026.) If we know that the more an LLM is trained, the better it gets—which is what all research seems to indicate—then tech companies are going to be left with rapacious beasts to feed. The company that feeds theirs the most is going to "win" the AI arms race. If Whisper can already train an AI by listening to YouTube videos, what's to stop it from listening to other things, like conversations in public places near a microphone? Or voicemails? Or phone calls?

When many people sign up to use a social media platform (or

Conclusions—An Accelerating World...

similar service), they might not realize they are giving up some privacy and allowing an LLM to train on their content. Nobody reads the fine print anymore, and tech companies are well aware of it.

An LLM that was constantly eavesdropping on phone calls would be able to change with the times, pick up the newest terms and slang expressions, and could most accurately give responses that are "how people really talk." On the other hand, giving an AI access to phone calls will train it on how people really *do* talk . . . which is often informally, using poor grammar, and saying things that might be morally questionable. People gossip. People slander one another. People use hurtful words.

In our ongoing quest to make AI lifelike (and to make metahumans realistic), will we eventually see LLMs start to reflect a side of ourselves that we don't like? If we train it so well that it becomes a mirror, will we like what we see?

One of the most interesting commentators on the coming Age of Imagination is psychiatrist and writer Ian McGilchrist. When he speaks on the topic, McGilchrist generally examines things through the lens of brain hemispheres. Specifically, he believes that AI has the potential to create systems and programs that will fascinate the left hemisphere of the brain—which is more analytical and transactional—but in doing so the right hemisphere runs the risk of being neglected. McGilchrist believes AI could become part of the problem with our culture today. People are existing on soundbites and quick transactions, which may cause us to lose our ability to think critically. We're training AI to understand what humans will respond to, but those are mostly left brain things. They're also mostly solving problems with short-term solutions. And if AI is being used for quick solutions only, McGilchrist believes, we're taking away humanity, and losing thousands of years of evolution that have equipped us to try to answer big, hard questions in the real ecosystem.

I don't agree with his general tone of cynicism, but I think McGilchrist raises points that we definitely need to consider as we curate our AI-driven future.

Google's AIME helps physicians diagnose things, but doctors still need to bring empathy, broader science, and broader deductive reasoning into every patient interaction. Each patient has their own unique set of circumstances. We need to have right hemisphere thinking in that examining room!

Or what about creativity? The arts have always played such a significant role in moving humanity forward. Art movements are based on innately human reactions to the world. We didn't create cubism because an AI thought it would look good. Picasso's cubism and blue periods come from bigger things. What's happening in that time period? What does it reflect back about the world?

We'll often see incredible art, like Bob Dylan songs raging against the machine and moving social justice forward, that seem innately and uniquely human. I don't think that's something an AI can do for us. An AI might be able to land on the social justice issue of the moment—and produce some kind of response—but will it be as impactful as something produced by a human who can take a long view? Are we speaking to our enemies as well as our friends? Are we making art that tries to bring people closer together? I think what an AI does is very different. Transactionally, AI can predict what a great social justice hymn could be, or what art would look like, but can it really capture what the moment of the time speaks to?

There's a bigger storyline here, and I think McGilchrist is onto it.

The technological innovations of the past two decades have not necessarily made us more ontologically, holistically satisfied. Tech breakthroughs did not automatically equal happiness breakthroughs. And when we look at one subset of the population—our

Conclusions—An Accelerating World...

teenage children—an argument can be made that things have gotten worse.

A terrifying and isolating global pandemic increased isolation and turned young people toward social media like never before. Yet this has not been a satisfying substitute for in-person interaction. There's growing evidence that it has all made teens feel worse about themselves. In 2021, the *Wall Street Journal* reported that Meta—the parent company of Instagram and Facebook—knows from user feedback that spending time on Instagram makes over 30 percent of teen girls feel as though they aren't pretty enough and/or that they aren't wealthy enough. Teen girls' ER visits for suicide has gone up 50 percent in the past two decades. This is not a coincidence.

There is a problem with how our children are interacting with the online world. Too often, virtual tools for connecting with one another become tools for generating envy and jealousy. Even my own eight-year-old is like: "How do you get so many followers, Dad? How can I be like you?" Children want to be part of a social group, to have their physical appearance accepted, and have good self-esteem. I bring this up here because I want to make certain that we're aware of what's at stake, and what we need to correct.

What keeps me positive is there are already so many examples of how the problems raised by this technology are going to be solved by it.

One of my favorite examples is a business called MARCo Health founded by Jacob Boyle. It has become the world's leading company that improves mental health care through social robots. Jacob was a guy who went through challenges and suffered from suicidal ideation himself. Now he has created plush toys that are powered by AI to interact with children. They talk, and kids can have conversations with them. Parents get notified if a child says something to their doll that could signal a mental or emotional

issue. It's affordable mental health care achieved through social robots.

Philosophically, AI can have an amazing "balancing effect" on human knowledge, human perspective, and on power—and that this can happen on a global scale. It can close the digital divide and empower the individual. For this to happen, we will need to commit to a decentralized approach—in much the same way that Bitcoin is decentralized. More specifically, we will need decentralization when it comes to training AI. What happened with Meta AI and Google Gemini recently is a microcosm of what will happen on a greater scale if we let single companies control the narrative. Or single governments. Or single political parties/positions.

To be very clear, I'm not saying that the lens of history through any single government—including that of the United States—is going to be totally unbiased. Consider an AI asked to create content about the Vietnam War. Even if all the AI developers in the United States agree about what kinds of content should be shared on that topic, something very important will be lacking if we don't include the perspective of the people of Vietnam. (And the perspective of the countries that neighbor Vietnam, like Laos. And countries that had fought in Vietnam *before* the United States, like France. And of neutral countries that had no stake in the conflict.)

If we allow one centralized government, company, or entity to control the training of AI, the model is weaker and lacks perspective. But if we include as many perspectives as we can, then we'll end up with an AI that is worldly, objective, and remarkably nuanced. (Not to dwell on this overlong, but imagine the challenge if an entity like China controls information about what AI shares when someone asks "What happened in Tiananmen Square in 1989?") Centralized governments shouldn't control the narrative. Instead, everyone everywhere should have input when

Conclusions—An Accelerating World...

it comes to how AI learns. If everyone contributes to this corpus of knowledge, it will be open and free—and so will the people who use it.

There will always be small risks involved when it comes to AI learning something untrue, but with human intervention we can mitigate and control those risks. Obviously, the good outweighs the bad here. We should never hesitate to train an AI on the basis of a fear that it might learn the wrong things. As long as we're willing to do the work—and we act like we really give a damn—I'm confident we'll be able to prevent all AIs from perpetuating inaccuracies over time.

I'm so passionate about what we teach AI because I've seen how my own children interact with this world.

My eight year old recently showed me a computer-animated video on her phone titled something like "The Five Biggest Sea Creatures That Have Ever Threatened the United States." I took a look, and there was an AI-generated blend of photography and animation that showed an US Navy ship fighting the Kraken from mythology. And I have to admit, the video looked pretty real. It was definitely the kind of thing that would fool a kid.

I pointed out to my daughter that this was a fictional animation someone had made with AI, and that the Kraken is a legend.

My daughter responded: "No, though. It's real. Look! I'm looking at it. These creatures are fighting the US Navy fleet."

Eventually, I was able to persuade my daughter that the video was a work of fiction, but the experience really drove home for me what a precarious point in history we're in. Children growing up now—who are just beginning to use electronic devices—are going to be naturally inclined toward trusting what they see. Part of the reason is that *most* of what they see on the screens that surround them from birth *will* be accurate. Another part is that, as I've noted, humans naturally resist "doing the work"; it is easier

to trust what a video clip is showing you than it is to view something through a skeptical eye, evaluate the quality of the outlet sharing the video, and check the provenance of the footage on the blockchain.

Just as we're going to have to train AI itself, so too will we have to train users of AI in the Age of Imagination. Again, I return to the theme of "AI provides so much, and asks so little . . . but it does ask *something*." That "something" is the fact that we'll need to teach our children to be responsible, informed, active users!

Like just about every parent ever, I want to leave my children with a better world than the one I found. That's one reason why I'm so excited about the potential of AI, and so passionate about getting it right. There's no doubt that it has transformative potential. And so many things need to be transformed right now.

What about climate change?

This is a question that many are just beginning to consider seriously, but I want to put it on the radar here in my concluding thoughts because I think it will begin to become a part of the conversation around AI and future generations.

We know that just about everything we do has an environmental cost—from flicking on a light bulb to choosing to drive a monster truck. Estimates vary, but most industry authorities agree that *around* 1-2 percent of the total electricity use of the United States now goes to mining crypto, maintaining information on the blockchain, and enabling other electronic pillars that support the Age of Imagination. As AI falls into more general use, this percentage is likely to increase further.

That's one side of the coin.

The other side is that AI holds the potential to help us make

Conclusions—An Accelerating World...

environmental breakthroughs that will allow humanity to lessen its carbon footprint overall, and slow global climate change. That said, there's no denying that there is an environmental cost to the Age of Imagination. Companies like Microsoft have not been very forthcoming about sharing the environmental impact of services like OpenAI (and similar LLMs). Does the processing power create electricity use along the lines of Bitcoin mining? Right now, we don't know.

And that's just regular operation. What about the training costs?

Exactly how much electricity is used to train an LLM? Considering all the front-end work it takes to develop an LLM, we should be very interested in that question. It's unclear whether or not LLMs are hurting the environment in a significant way. We know that training an LLM takes thousands of processors—enough that this sort of training could only take place in a data center. (We know that data centers would also be needed to keep up with the millions or billions of requests that a popular LLM fields from users each day.) Estimates vary on how much it costs to "train up" a new iteration of an LLM like ChatGPT, but the low end I've seen is that it takes the amount of electricity 1,000 American families use in a year to advance an LLM to the next generation. That might not sound like that much —1,000 households are maybe one small town—but keep in mind that we're just getting started. We don't know where it goes from here. Maybe the next generation of LLMs is somehow more energy-efficient when it comes to training, but maybe not. Maybe it takes *a lot* more energy to go from ChatGPT 4o to ChatGPT 5.0 or 6.0.

The concern with the environment is real. I hope as we go forward into the Age of Imagination, you'll join me in insisting that the companies creating new LLMs become transparent about the amount of energy they use. From blockchain and crypto, we know—for certain—that important new innovations can come

with environmental costs. We need to go into this with our eyes open, and ensure that everything possible is done to mitigate potential negative environmental impacts.

In closing, I want to reiterate that we have the tools to ensure that AI makes humans more connected to one another, not less. I think the Age of Imagination will bring about not only a world in which AI notices patterns we might have missed in fields like medicine or science, but also a world in which AI can notice injustices. Where AI can help us to find the voiceless who ought to be given a voice. It can help us understand why certain groups might be feeling frustrated. And I'm willing to bet it will give us excellent recommendations for steps to take that will make our world more just, fair, and sustainable.

There's a very famous quote by Apple cofounder Steve Jobs from an interview he did with *Newsweek* in 1984:

> *I think one of the things that really separates us from the high primates is that we're tool builders. I read a study that measured the efficiency of locomotion for various species on the planet. The condor used the least energy to move a kilometer. And, humans came in with a rather unimpressive showing, about a third of the way down the list. It was not too proud a showing for the crown of creation. So, that didn't look so good. But, then somebody at Scientific American had the insight to test the efficiency of locomotion for a man on a bicycle. And, a man on a bicycle, a human on a bicycle, blew the condor away, completely off the top of the charts. And that's what a computer is to me. What a computer is to me is it's the most remarkable tool that we've ever come up with, and it's the equivalent of a bicycle for our minds.*

Conclusions—An Accelerating World...

AI is going to be an extension of this. But it won't be another bicycle. It'll be more like a rocket ship. AI is poised to propel humanity forward at previously unthinkable speeds.

As I hope I've made clear in this book, the old axiom: "Humans + Tools = the ability to destroy *or* create" will still apply. Previous innovations have meant that we could work toward nuclear bombs, or we could work toward clean nuclear energy. AI is a nuclear-level superpower. In the correct hands, it liberates. In the wrong hands, it destroys, corrupts, and perpetuates inequalities.

We have to do this in the right way.

As I've shown, AI will accelerate progress and create efficiencies across a myriad of sectors. If we thoughtfully curate it as its growth accelerates, we can enter an exciting new phase of human development. Accelerationism is the American way. We need to out-compete our enemies with freedom of speech, and with a diverse array of ideas. We need to ensure America is a place where all ideas *about*—and all applications *for*—AI can be tested in the marketplace of ideas so that the best ones will win.

All information is valuable, but the truth is priceless. You can't "regulate" access to the truth, but you can foster a culture of ideas that maximizes incentives to innovate, protect, and defend liberty. To be abrupt about it: If we try to regulate AI here, in the United States, then it will move "there"; and "there" can be any place that chooses to grant greater freedoms—but that could be China, Russia, or North Korea. AI will present yet another defining moment—or defining *choice*—for Western liberal democracies. Allow for the freedoms of speech and thought that will give AI its free, organic evolution, or risk an unfriendly power harnessing AI and using it to turn the world into an unfriendly surveillance state.

Freedom of speech has always protected the individual. The fact that we have it in the United States has meant that we remain

one of the nations that attracts the world's top talent. It's no secret that freedom of speech and leading innovation have gone hand-in-hand all over the world. Just like a child, AI will be trained so that it reflects the culture, environment, and information with which we have educated it. There's no good time to give in to the forces that want to curtail freedom of speech and freedom of thought. But an era that will be the cradle of AI would be the worst time possible.

In the Age of Imagination, it will be our duty to be good parents—not just to our actual children who will be using AI-enhanced tools, but good parents to AI itself. We must raise it and train it with good, free information. This will increase the chances that AI leads us to long-term personal, industrial, and societal good health.

I, for one, strongly believe that it will!

Fin.

In some future day, technology will bring people together again on a global scale to provide hope.

Hillel Fuld
Tech Insider, Columnist,
and Visionary

APPENDIX OF ADDITIONAL RESOURCES

The Most Influential People in AI

In no particular order of importance, below is a list of the people I believe are poised to most profoundly impact the evolution of AI in the decades ahead. If you want to see the explosive inflection points that will lead to great advances in AI in the years ahead, keep an eye on these men and women, and their remarkable work!

- David Salvagnini—As the Chief Data Officer at NASA, David is working at the leading edge of AI in space exploration.
 - Katherine Calvin—NASA's Chief Scientist, Katherine is poised to bring AI to the space race.
 - Yang Zhilin—Not yet thirty years old and still a computer science PhD student, Yang is the cofounder of Recurrent AI, which uses AI to detect and develop speech. Look for big things from this young man!

SOME FUTURE DAY

- Yuxin Wu—Formerly of Google and Meta, Yuxin is building large multimodal models.
- Kevin Scott—As Microsoft's Chief Technology Officer, Kevin is one of the most influential people working in the AI space. He and his team are well-positioned to chart the future of AI.
- Greg Brockman—Greg is the president and a cofounder of OpenAI. Enough said.
- Mustafa Suleyman—Mustafa is the CEO of Microsoft AI. If Microsoft's LLM becomes as dominant as their software, it may largely be this man's doing!
- Gabe Pereyra—Gabe is the president and cofounder of Harvey, which is poised to use AI to revolutionize the legal profession.
- Winston Weinberg—Winston is the CEO and cofounder of Harvey.
- Elad Gil—Elad is a leading technology entrepreneur and investor.
- Othman Laraki—Othman is a leader in the use of AI in the medical and health care fields.
- Alexander Wang—Alexander is the CEO and founder of Scale AI, which helps companies put their raw data into machine learning.
- Abhinav Gupta—Abhinav is a professor at the Robotics Institute at Carnegie Mellon University.
- Deepak Pathak—Deepak works in Computer Science at Carnegie Mellon University.
- Aidan Gomez—The founder of Cohere, Aidan works on making neural networks efficient for businesses.
- Martin Kon—Martin is the President and COO of Cohere.
- Jaron Waldman—Jaron is the Chief Product Officer at Cohere.

Appendix of Additional Resources

- Pradeep Sindhu—Pradeep is the Chief Development Officer and cofounder of the data center technology company Fungible.
- Brian Harry—Brian's job title is now "Technical Fellow" at Microsoft, and he is behind some of their most important AI initiatives.
- Pope Francis—The current pope has sounded a clarion call indicating he intends to call upon world leaders to insist that AI is curated and deployed in such a way that it enriches humanity, not demeans it. Expect him to stay involved in the conversation for the rest of his life.
- Joe Biden—President Joe Biden has stated that he believes AI can "help deliver better results for the American people" yet he has also indicated an intention to regulate and govern it. It remains to be seen if he will genuinely use his power to ensure America remains the leader in AI.
- Donald Trump—President Trump has also made statements indicating he believes the United States should be the leader in AI, and he acknowledges its "strategic importance" for the nation. In or out of office, he has the power to continue to drive the conversation.
- Thom Tillis—Senator Tillis has been a leader in introducing legislation aimed at keeping AI safe in its applications. I expect him to be involved in the regulation in this space for years to come.
- Gary Peters—Senator Peters has been another leader in AI safety legislation. Expect to hear more from him going forward.

SOME FUTURE DAY

- Xi Jinping—The President of China has enormous power to cultivate his nation into an AI leader, and also to dictate if AI will be used to enhance or to suppress human rights and democracy. He can also set a tone regarding whether or not Chinese companies pursue Western competitors using fair and legal—or unfair and extra-legal—means.
- Benjamin Netanyahu—The Prime Minister of Israel has insinuated himself into the center of the conversation around AI, and has worked to make his country the center of tech in the Middle East.
- Guillaume Lample—Guillaume is the Founder and Chief Scientist at Mistral AI, probably the leading European AI company.
- Timothee Lacroix—Timothee is the Chief Technology Officer at Mistral AI.
- David Ha—David is the cofounder of Sakana AI.
- Llion Jones—A former Googler, Llion is also a cofounder at Sakana AI.
- Kevin Weil—Kevin is the CPO at OpenAI.
- Ilya Sutskever—Ilya is the Cofounder and Chief Scientist at Safe Superintelligence.
- Jan Leike—Jan is a leading machine-learning researcher.
- Todor Markov—Todor is a deep learning researcher at OpenAI.
- Yoshua Bengio—Yoshua is a computer scientist who directs the Montreal Institute for Learning Algorithms.
- Pieter Abbeel—Pieter is director of the Robot Learning Lab at Berkeley.

Appendix of Additional Resources

- Satya Nadella—As the CEO of Microsoft, Satya is centrally positioned to drive the future of AI in business.
- Andrew Moore—In 2023, Andrew was named the first-ever CENTCOM Advisor on AI, Robotics, Cloud Computing, and Data Analytics.
- Jared Kaplan—Jared is the cofounder of Anthropic, an AI safety and research company, and a leading expert on AI.
- Yasmin Razavi—A General Partner at Spark Capital, Yasmin is a leading investor in the AI space.
- Daniela Amodei—Daniela is the President of Anthropic.
- Yamini Rangan—Yamini is the CEO of HubSpot.
- Dev Ittycheria—Dev is the CEO of MongoDB.
- Mamoon Hamid—Mamoon is a General Partner at Kleiner Perkins, and a leading investor in the AI space.
- Aydin Senkut—Aydin is the founder of Felicis Ventures, a leading AI space investor.
- Nat Friedman—The former CEO of GitHub, Nat is a leading mind in the tech and AI space.
- Daniel Gross—Daniel is the cofounder of Safe Superintelligence.
- Martin Casado—Martin is a software engineer and founder of Nicira Networks.
- Saam Motamedi—Saam is a leading tech investor and a General Partner at Greylock.
- Brandon Reeves—Brandon is a General Partner at Lux Capital and a leading tech investor.
- Grace Isford—Grace is a Partner at Lux Capital.

SOME FUTURE DAY

- Sonya Huang—Sonya is a Partner at Sequoia Capital, a leading tech and AI investor.
- Colette Kress—Colette is an EVP at NVIDIA.
- Chris Malachowsky—Chris is the Founder of NVIDIA.
- Clement Delangue—Clem founded and owns Hugging Face AI, a machine learning company.
- Michael Chen—Michael is a research fellow at METR, a nonprofit that focuses on AI policy.
- Jiaji Zhou—Jiaji leads engineering for Amazon Web Solutions.
- Vipul Ved Prakash—Vipul is a software engineer and founder of the anti-spam company Cloudmark.
- Brett Granberg—Is CEO of Vannevar Labs, an AI digital and safety leader.
- John Dulin—John is the CEO and Founder of Modern Intelligence, a company that develops AI for the defense space.
- Cristóbal Valenzuela—Cristóbal is the Founder and CEO of Runway, one of the most important AI video generation companies.
- David Holz—David is the CEO of the AI-based image generator Midjourney.
- Adam Selipsky—Adam is the CEO of Amazon Web Services.
- Safra Catz—Safra is the CEO of Oracle.
- Frank Slootman—Frank is the CEO of cloud data company Snowflake.
- Melanie Perkins—Melanie is the Cofounder and CEO of Canva, the graphic-creation platform.
- Demi Guo—Demi is the Cofounder and CEO of Pika Labs AI.

Appendix of Additional Resources

- Mati Staniszewski—Mati is the Founder and CEO of ElevenLabs, a voice tech AI company.
- Neil Serebryany—Neil is Founder and CEO of CalypsoAI, an AI safety and security company.
- Aravind Srinivas—Aravind is the Founder and CEO of Perplexity, an AI development company.
- Erik Bernhardsson—Erik founded Modal Labs, the data and infrastructure AI company.
- Vijaye Raji—Formerly of Microsoft and Meta, Vijaye is now the Founder and CEO of Statsig, an AI company.
- Chris Cox—Chris is the Chief Product Officer at Meta.
- Mira Murati—Mira is the Chief Technology Officer at OpenAI.
- Wang Chuanfu—Wang is the CEO of BYD, a Chinese conglomerate that is poised to be a major player in the AI space.
- Stuart Russell—Stuart is a British computer scientist and a leading author and thinker on the subject of AI.
- Larry Ellison—Larry is the Cofounder of Oracle.
- Sheikh Mohammed bin Abdulrahman bin Jassim Al Thani—The Prime Minister of Quatar is passionate about shaping the future of tech in the Middle East.
- Peter Norvig—Peter is a leading American academic and AI researcher.
- Dario Amodei—Formerly of OpenAI, Dario is now Cofounder and CEO of Anthropic.
- Ajay Banga—As President of the World Bank Group, Ajay is uniquely positioned to spur investments in tech and AI, especially in developing countries.

- Sam Altman—Sam is the CEO of OpenAI.
- David Barnea—David is the leader of Mossad, and perhaps on the leading edge of the use of AI in warfare as no other living human is today.
- Li Qiang—As the Premier of China and a man known for building infrastructure, Li is well-positioned to make heretofore unimagined investments in AI tech within his country.
- Ali Ghodsi—Ali is Cofounder and CEO of Databricks, a company building generative AI and machine learning models.
- Jensen Huang—Jensen is the Cofounder, President, and CEO of NVIDIA.
- Dave Ricks—As the CEO of Eli Lilly, Dave is investing heavily in the use of AI in drug development and medical research.
- Julie Sweet—As the CEO of Accenture, Julie has been an advocate for AI in the consulting and business space.
- Sundar Pichai—Sundar is the CEO of Google.
- Mark Zuckerberg—Mark is the creator of Facebook and CEO of Meta.
- Yann LeCun—Yann is the chief AI scientist at Meta.
- Reza Zadno—Reza is the President and CEO of Procept BioRobotics, a leader in the use of AI in the medical space.
- Jeff Bezos—Jeff Bezos is the Founder of Amazon.
- Jayshree Ullal—Jayshree is the CEO of Arista Networks, a cloud computing and AI company.
- Matthew Prince—Matthew is the Cofounder and CEO of Cloudflare.

Appendix of Additional Resources

- Sridhar Ramaswamy—Sridhar is the CEO of Snowflake Computing.
- Wahid Nawabi—Wahid is President and CEO at AeroVironment, a leader in robotics.
- George Kurtz—George is the Cofounder and CEO of security company CrowdStrike.
- Marc Benioff—Marc is the Cofounder and CEO of Salesforce.
- Andrew Ng—Andrew is a leading expert on AI, with an extensive background in tech. He currently heads the AI Fund, a $175B investment fund.
- Arvind Krishna—As the CEO of IBM, Arvind is positioned to help deploy AI in global business in the twenty-first century.
- Sean White—The CEO of Inflection AI, Sean develops custom generative AI models.
- Fei-Fei Li—Fei-Fei is a leading computer scientist and expert on AI. She is a professor at Stanford and serves on many boards.
- Nikesh Arora—The Chairman of Palo Alto Networks, Nikesh works to integrate AI into online safety and security.
- Geoffrey Hinton—A towering figure in computer science, Geoffrey's groundbreaking work has led to his being described as "the Godfather of AI."
- Ian Goodfellow—Ian is a leading computer scientist and researcher, currently at DeepMind, an AI focused subsidiary of Google.
- Ryan Tseng—Ryan is Cofounder and CEO of Shield AI, and leader in the development of AI for the defense space.
- Demis Hassabis—Demis is the CEO of DeepMind.

- Brett Adcock—Brett is the Founder and CEO of Figure AI, a company working to develop AI-driven humanoid robots.
- Arthur Mensch—Arthur is the CEO of Mistral.
- David Laun—Formerly at Google, David is a Cofounder at Adept AI Labs.
- CC Wei—CC is President and Co-CEO at TSMC, a leading semiconductor manufacturer.
- Shantanu Narayen—Shantanu is the CEO of Adobe.
- Andrej Karpathy—Andrej has served as a director of AI at Tesla and was a Cofounder of OpenAI.
- Kate Crawford—A leading global expert on AI, Kate cofounded the AI Now Institute at NYU.
- Alex Smola—Formerly of Carnegie Mellon University and Amazon, Alex is now Cofounder and CEO of the AI startup Boson AI.
- Kai-Fu Lee—A Taiwanese computer scientist and businessman, Kai-Fu is a leading writer, thinker, and critic on the subject of AI.
- Christophe Fouquet—Christophe is the CEO of ASML, a leading semiconductor supplier.
- Elon Musk—Elon is known for his roles in SpaceX and Tesla. He is developing an LLM for X known as Grok.
- Joshua Xu—Joshua is the Cofounder of HeyGen, a company seeking to transform visual storytelling through AI generation technology.
- Wayne Liang—Wayne is Cofounder and CPO at HeyGen.
- Eric Lefkofsky—Best known as the founder of Groupon, Eric is now heading up Tempus AI, a health-care technology company.

Appendix of Additional Resources

- Arkady Volozh—Arkady is a computer scientist and probably the most important technology investor in the history of Russia.
- George Nazi—George is the CEO of SCAI, the AI-investment arm of the public investment fund of Saudi Arabia.
- Aidan Gomez—Aidan is the Cofounder and CEO of Cohere, a tech company specializing in large language models.
- Chris Walker—A tech veteran, Chris is the CEO of Untether AI.
- Jonas Andrulis—Jonas is the Founder and President of Aleph Alpha, which develops AI for companies and also governments.
- Jarek Kutylowski—Jarek is the Founder and CEO of DeepL SE, an AI-based translation company.
- Emad Mostaque—Emad is the creator of Stability AI, best known for its AI image generation capabilities.
- Arthur Mensch—Arthur is a leader at Mistral.
- Aviv Frenkel—Aviv is the Cofounder and CEO of Moonshot AI, an e-commerce focused AI provider.
- Chandra Khatri—Chandra is Founding Head of AI at Krutrim, a cloud-focused AI company.
- Karen Hao—Karen is a leading journalist and data scientist who writes about AI for the *Wall Street Journal*, the *Atlantic*, and other leading publications.
- Xu Li—Xu is the founder of the Chinese AI company SenseTime, which provides AI solutions to industry.
- Hoan Ton-That—Hoan is the CEO of ClearviewAI, which specializes in facial recognition capabilities.

SOME FUTURE DAY

The Most Influential Businesses in AI

I believe the following businesses are going to have a massive impact on the future of AI in the years ahead. If you want to see where things are going to go next, keep a close eye on all of them!

- ChatGPT—This is the big dog in the space! The groundbreaking LLM designed by OpenAI, ChatGPT is not only credited with bringing attention and investment to the AI space, but its continuing tradition of innovation shows why it deserves to be at the top of the heap!
- Facemoji—Facemoji was the first app to allow users to send custom and colorful emoji messages. As emojis become driven by—and compatible with—AI, you can look for this market to explode.
- DaVinci—DaVinci is one of the leaders in the AI image generation space. It has been on the cutting edge of allowing users to generate photorealistic unique artworks from text prompts. I expect them to continue to astound us with new capabilities in the years ahead.
- Photomath—Photomath is an AI-driven technology that helps users complete math problems (and math homework) using optical character recognition. The ability to show a program your math homework and immediately get a customized tutorial is going to make the world a better place for students and learners everywhere!
- Microsoft Edge—Though often derided for the foibles of its Microsoft Explorer predecessor, Microsoft Edge is positioned to draw on AI capabilities being

Appendix of Additional Resources

developed in-house by Microsoft to become one of the leading browser products. Really!
- Character.ai—Character.ai is doing groundbreaking work when it comes to making avatars and metahumans seem, well, more human! If you want to see the next iteration of metahumans being more helpful, empathetic, and relatable, keep an eye on what they're developing next.
- Phind—Phind is about to corner the market on creating targeted AI to help developers. And what a market to corner!
- Gemini—Gemini is Google's foray into the LLM space, and we can expect its impact to be massive. From writing, to planning, to teaching humans new things about themselves and the world, Gemini is well-positioned to be at the forefront of AI for years to come.
- Brainly—Operating in the same space at Photomath, Brainly aims to be a "one stop shop" for all things learning- and school-related. If it can deliver on what it promises, it will become a valuable resource for students in just about every subject and discipline.
- Liner—Liner is an AI-powered tool designed to help train machine-learning models. This will deliver tremendous value in the years ahead.
- QuillBot—QuillBot aims to establish itself as the go-to solution for writing, paraphrasing, and summarizing. It may just do it.
- Poe—Poe is an AI chatbot, but its angle is speed. If AI consumers want quick answers, and they want

them now, Poe could become a popular choice from a field of many competitors.
- Perplexity—Perplexity AI aims to corner the market on accuracy and conversational responses. It stands to emerge at the fore of the industry if consumers show us that they want responses rendered in plain, easy-to-understand language, and with an emphasis on only providing correct information.
- CrushOn AI—Most LLMs are attuned to functionality in the workplace, and/or in a family setting. CrushOn AI intends to become the leader in AI that is decidedly not safe for work. When work is done for the day, and the kids are out of the house, users who want to engage with an AI on rude, sexual, or otherwise adult topics are going to come here.
- Janitor AI—Janitor AI is a conversational AI platform that specializes in managing and refining data. It can respond to user queries while cleaning data.
- NOVA—NOVA AI may emerge as a leader in chatbot technology, and also image and video creation. It aims to become an AI-powered virtual assistant for users.
- Civitai—Civitai seeks to become a leader in open source generative AI, with no censorship. It might emerge as a leader in the NSFW space, or just a leader!
- Claude—Claude is an AI-powered personal digital assistant that will be appropriate for use in workplace settings, but will also still inspire creativity in users. A fine line to thread, but it may just be doable!

Appendix of Additional Resources

- ElevenLabs—Elevenlabs is likely to emerge as a leader in text-to-speech and AI generated voices. If we want AI to tell jokes that make us laugh, or speak in a serious tone when we need to attend to something urgent, ElevenLabs may well be behind generating those nuances.
- Beat.ly—An AI music video making tool, if Beat.ly stays popular, it could become a powerful force in curating how artists deploy the visual aspects of their work.
- Hugging Face—Hugging Face develops powerful computation tools for building apps using machine learning. It will be a powerful tool for AI developers behind the scenes.
- Chat & Ask AI—Chat AI and Ask AI have emerged as useful assistants for writing and practicing conversation.
- Remini—Remini is a "photo enhancer" that can take existing photos—even ones taken back in the days of film cameras—and render them in stunning HD. There may well be a strong market for this service.
- ImagineArt—ImagineArt is creating free AI art generators for use by creatives. They may become a major player in what will surely be a competitive space.
- Dawn AI—Dawn AI is an avatar-generator that is helping consumers define and refine how they would like to be perceived in the metaverse and beyond.
- AI ARTA—AI ARTA aims to be a one-stop shop for generating videos, images, and avatars for users. If

it can become prominent for all three of these uses, it will become influential indeed.
- Leonardo.AI—Leonardo.AI is another candidate for dominance in the art, images, and video space. It can create high-quality content for a wide variety of uses.
- Midjourney—Midjourney is an independent research lab that's exploring how AI can impact new mediums. Though small in size, it may have an outsize impact as AI think tanks go.
- SpicyChat—This service offers NSFW avatars and chat capability. Users can create and tune chatbots, and also explore their own adult personas.
- Hypic—Hypic uses AI to help users adjust existing photos, and create entirely new AI art.
- Tarteel AI—An app designed around study and memorization of Quran using AI, if it catches on with the world's nearly two billion Muslims, its impact will be outsized.
- Gamma—Gamma is establishing itself as a leader in using AI to generate presentations and slideshows using AI. I don't think corporate presentations and slide decks are going anywhere, but with Gamma they stand to be remarkably enhanced.
- Cutout.Pro—This service stands to be a leader in visual content generation of all sorts.
- Qanda—Quanda is an AI-powered program for teaching students math. It's not reinventing the wheel, but it's incredibly popular. As of 2024, it had over 92 million users.
- PIXLR—PIXLR is an AI image generator that also gives users easy-to-use tools that are similar to

Appendix of Additional Resources

services like Photoshop. It may succeed based on this ease of use.
- VEED.IO—This service aims to connect with aspiring YouTubers and TikTokers to allow even novices to easily create video content that looks like it was done by professionals.
- PhotoRoom—PhotoRoom is AI-powered photo editing software, and it specializes in removing unwanted things in photos and fixing unwanted backgrounds. Solving these common photo issues could make them a leader fast.
- Question AI—Question AI is designed to help students with their homework, but to do so with an interface that quickly answers one-off questions. It may become very successful for students who don't want a whole tutorial when they're just looking for a quick answer.
- YoDayo—This is a creative AI platform for anime fandom. It allows users to create their own avatars and characters, and creatively engage with the genre. Becoming dominant in this space would solidify a connection with a large and loyal fanbase.
- Clipchamp—Clipchamp is doing something hard—trying to create voice-based film editing software using AI. But if they can succeed at allowing creators to edit video simply by describing their desires, their impact is going to be massive.
- Runway—Runway is using generative AI to give creative people tools for visualizing their videos, images, and multimedia content. It's become a powerful one-stop shop.

SOME FUTURE DAY

- You—You aims to become a powerful text-based virtual assistant that knows you better than anyone else does.
- ChatOn—ChatOn is an AI chatbot with a variety of compelling applications.
- DeepAI—DeepAI is a powerful LLM that can generate text, video, and images. It could be a major competitor to ChatGPT.
- Eightify—Eightify uses AI to summarize YouTube videos. This is an incredibly valuable service not just for traditional users, but for those training LLMs.
- ArtMind—ArtMind uses AI to help people design and decorate their home interiors. With partnerships with home goods companies already in the works, this model could become very successful.
- Candy.ai—This service aims to generate fun and realistic AI boyfriends and girlfriends. We know there's a big market for this service!
- NightCafe—NightCafe is a free art generator that's been getting great reviews.
- VocalRemover—This service uses AI to remove vocals from things like songs to potentially create karaoke tracks. Self-evidently, this technology also has news, intelligence, and archival applications.
- PixAI—This service generates free anime art using AI. If it can connect with the anime fanbase, it could become a very big deal.
- Ideogram AI—This service focuses on using AI to create things like posters and logos. It could become a "must have" for small businesses that can't yet afford an in-house art department.

Appendix of Additional Resources

- SnapEdit—SnapEdit deploys photo editing tools, and its angle is speed and ease-of-use. If you can use AI to anticipate what people want done to a photo, you can dazzle them and exceed their expectations!
- AI Mirror—This service allows users to create art using AI, with an emphasis on avatars and characters for online games; an enticing space in which to dominate.
- Invideo AI—Invideo generates videos from text prompts using AI. With millions of users already, it aims to do one thing and do it well.
- Replicate—Replicate aims to produce open source AI models for businesses, and to help businesses scale their uses of AI.
- Playground AI—Playground AI is a free image generation AI software that is growing quickly in popularity.
- Suno AI—Suno AI is a leader in using AI to create music, alter existing music, and give musical artists new creative options.
- Chub.ai—Chub uses AI to create interactive storytelling experiences for users. Chub is poised to become a leader in the space that may enable stories that literally never end.
- EPIK—EPIK is a photo and video editor that can easily generate "themed" nostalgic photos. It went to #1 in the app store when it's nineties-inspired "yearbook"-style AI photos caught on like wildfire.
- Speechify—Speechify is a leader in AI voice-to-text and text-to-speech generation. These will be some of the most important uses of AI.
- NovelAI—NovelAI is a cloud-based, AI-powered service to help storytellers of all types. Look for it to

become a critical asset for writers, novelists, filmmakers, and more!
- MaxAI.me—This service is designed to help those who write but also research. It may become indispensable for college professors, scientists, and anthropologists.
- Craiyon—This is a free image generator that makes drawings from text prompts. It can generate a wide variety of images.
- Wonder—Wonder is a leader in generating AI art based purely on text prompts.
- LISA AI—LISA generates free art, with an emphasis on avatars, based on text prompts.
- Copilot—Microsoft Copilot is designed to be the most powerful and effective AI virtual assistant and companion. It isn't perfect yet, but because of Microsoft's reach, it stands to become the dominant tool in the space.
- OpusClip—OpusClip specializes in "video repurposing" through AI, which generally means extracting short clips from longer video for repurposing on clip platforms like TikTok. This is a very specific use for AI, but one that may prove exceedingly popular.
- Blackbox AI—This platform is designed to help developers and coders answer coding questions and solve problems related to writing code. It may dominate in this crucial function.
- ChatPDF—Interacting with PDFs has always presented special challenges, and this AI-powered platform aims to solve them. PDFs aren't going anywhere, and neither is ChatPDF.

Appendix of Additional Resources

- Vectorizer.AI—This service uses AI to vectorize JPG images; a niche to be sure, but a valuable one.
- DreamGF—It does what it says! This platform aims to create the best possible "AI girlfriends" using leading-edge graphics and LLM technology.
- Photomyne—Photomyne specializes in using AI to preserve and improve extant physical photos that are scanned into the system. It will long be useful for historians and boomers alike!
- Otter.ai—This service specializes in AI-guided notetaking and transcriptions in meetings and corporate settings. There are a number of competitors in this space, but Otter is well-positioned to come out on top.
- Bobble AI—Bobble seeks to "enrich conversation" with everything from AI-generated stickers and emojis to translation services to writing assistance. If it can expand communication and make it even more fun than it already is, Bobble is sure to develop a stalwart following.
- Reface AI—Reface is a leader in image face swapping and funny AI photos and filters. Humans will always use technology in playful ways, and Reface feeds right into this.
- ELSA—If ELSA succeeds in realizing its vision, it will be the number-one place for learning and improving English globally, with an AI-powered guide helping users master the language step-by-step. With English essentially the default "global language" between nations, this service can have a powerful impact if it does what it does better than anyone else.

Twenty Key Data Analytics Tools

It is important to note the obvious—the best tools for you and your company certainly depend on your goals, budget, and level of expertise. That said, the comprehensive list of twenty tools below will provide a very strong starting point as it includes many of the best when it comes to data analytics, business intelligence, and related issues.

- Microsoft Power BI—Interactive data visualization software.
- Tableau—Business intelligence (BI) and analytics software.
- Looker—Data exploration, discovery, and modeling system.
- Zoho Analytics—A powerful business intelligence and data analytics platform that allows users to easily create insightful reports and dashboards from their data. Great for small businesses with limited budgets.
- Stata—A general-purpose statistical software package that is strong with data manipulation, visualization, statistics, and automated reporting.
- Mode—Provides a central hub for an organization's analysis of several data sets used to drive defined business outcomes.
- Databricks (Think data intelligence)—Data unification combined with AI used to unlock valuable insights from vast datasets. This tool breaks down data silos and fosters a culture of data-driven decision making within an organization.
- Sigma—Excellent for data visualization; uses spreadsheets, SQL, Python, or AI. Fast and secure.

Appendix of Additional Resources

- Looker Studio (Formerly Google Data Studio)—An online tool converting data into customizable, informative reports and dashboards.
- Sisence—A data integration tool—very intuitive—to develop workflows.
- Google Analytics—Data-backed insights that can help you improve how customers experience your brand—there is no fee to Google. Learn about the customer journey and how to improve your brand's marketing ROI. Best for website and app analytics.
- Semrush—Analyzes the competition—their strategy, etc., using data. Uncover how the competition generates traffic, dissects their marketing mix, gets actionable insights.
- RillData—Rethinks Business Intelligence dashboards with embedded database and instant UX—Reduces cloud data warehouse costs.
- Spotfire—An AI-based analytics platform.
- Alteryx—Best for data science and analytics; designed to make advanced analytics automation accessible to any data worker.
- Qlik Sense—A data visualization and discovery tool that relies on business data to drive results.
- Klipfolio—Klips is a great tool for small businesses, as it connects to hundreds of API's and builds customizable dashboards. Also integrates a client reporting element.
- Domo—A cloud-based platform designed to provide real-time access to business data for decision makers across the company with minimal IT involvement.
- SAP Analytics Cloud—Leader for enterprise analytics.

- SQL (Structured Query Language)—A domain-specific language used to manage data, especially in a relational database management system.

Search Engine Optimization Tools
- Semrush—SaaS platform used for keyword research, competitive analysis, site audits, backlink tracking, and comprehensive visibility insights.
- SE Ranking
 - "Rank Tracker"—Accurate data across five search engines.
 - "Competitor Research"—Access any site's metrics, including traffic, domain authority, and backlink count.
 - "Keyword Research"—One of the biggest and most reliable keyword databases.
 - "Backlink Analysis"—scans +7 billion pages per day to manage and update its database of over 3 trillion backlinks.
 - "Website Audit"—identify crucial and minor site-wide issues.
 - "On-page SEO checker"—analyzes the top SERP results.
 - Nozzle—Enterprise level tool to uncover google keyword rankings.
 - Mangools—Several SEO tools, including keyword research, SERP analysis, rank tracking, backlink analysis, and SEO metrics / insights.
 - SEO PowerSuite—A comprehensive platform (all-in-one software) featuring rankings, SEO audits, automated alerts, backlinks, and reports. Another feature: customizable.

Appendix of Additional Resources

- AccuRanker—Known to be a very fast and accurate rank tracker.
- Advanced Web Ranking—Rank tracking beyond Google, including YouTube, Amazon, plus country specific search engines such as Baidu and Naver.
- Ranktracker—Rank tracker, keyword finder, SERP checker, Web audit, Backlink checker, etc.
- Wincher—Google-specific insights.
- Serpple—A SERP tracking tool.
- Nightwatch—Impressive set of features, competitive pricing, very strong rank tracking, uses AI.
- WhiteSpark—Builds tools and provides services that help businesses and agencies with local search marketing.

Bonus: AI SEO Tools

- ChatGPT—Mentioned again here because it is the best AI content writing tool.
- Surfer—SEO content editor that also auto-generates fully optimized SEO articles.
- DALL-E—Unique images are important to stand out from the competition and ensure engagement.
- KeywordInsights.Ai—An AI powered keyword research tool that takes thousands of keywords and groups them into clusters quickly.
- Fireflies.AI—Note-taking tool. Automatically transcribes meetings. Provides analysis, insight, and action items.
- Originality.Ai—SEO tool to make sure content sounds human and readable.

- Claude—Chatbot used to summarize documents like PDFs, eBooks, articles, etc. Use to easily summarize and highlight new knowledge.

Thirty-Nine Performance Marketing Tools

Paid Search
- Google Ads—Lead generation, online sales, offline sales, brand awareness, apps.
- Microsoft Advertising—A pay-per-click advertising system whereby you bid on how much you are willing to pay per click on your ad. It is worth noting, there is a massive community on the Microsoft Search Network (almost 1 billion users).
- SEMrush—Extensive keyword research (see SEO list for more detail).
- SpyFu—Evaluate competitors' keywords and ad spend.
- WordStream—Provides tools for creating, managing, and optimizing PPC campaigns.
- Google Search Console (GSC)—A free tool that helps you monitor your site's performance.

Paid Social
- Facebook Ads Manager—Create and manage ads on desktop and mobile.
- LinkedIn Ads—Build strategic campaigns targeting the professional community.
- Twitter Ads—Create a targeted ad campaign.
- Snapchat Ads—414 million people use Snapchat daily. Create and optimize ads.

Appendix of Additional Resources

- TikTok Ads—The King: $15B in revenue for US small business in 2023.
- Meta Ads—Create ads for Meta products, including IG.

Organic Social

- Hootsuite—Publish and schedule, analytics, engagement tools, inbox and messaging, social listening, AI content creation, best times to post. Etc.
- Buffer—Social media promotion platform including dashboard and an AI assistant.
- Sprout Social—Craft social media campaigns, define goals, select the right platform, and measure success.
- Later—Social media strategy creation, implementation, and management. Influencer marketing component.
- CoSchedule—All-in-one AI marketing calendar for content, social, and beyond.
- Canva—Design graphics and original content.
- Planoly—Social media planner tool.
- SocialBee—AI powered social media management tool.
- Tailwind—"Made For You" marketing powered by advanced AI.
- BuzzSumo—A tool that helps you analyze content engagement, track trends, and spot outreach opportunities across social and search. Use it to find new content ideas, customer questions, and journalist contacts.
- Loomly—A social media management platform that helps you craft & schedule posts, track analytics,

and manage a unified social inbox across your social media channels.
- Agorapulse—Management software.
- Iconosquare—Analytics, reporting, post scheduling, collaboration tools, and AI tools.
- SocialPilot—Publishing, collaboration, analytics, and AI.
- Zoho Social—Management.

Email Marketing
- Mailchimp—Marketing automation and email marketing.
- ActiveCampaign—Nurture leads, foster repeat buyers, turn customers into brand evangelists.
- Sendinblue—AI-powered email marketing.
- HubSpot—Social media scheduler, aggregator, post, trend analysis.
- ConverKit—Grow audience, email designer, visual automations, monetization.
- Amped—A no-code builder for email and SMS.
- Breakcold—Cold email campaigns, follow-ups. Etc.

SMS Marketing
- Twilio—Programmable messaging API; send transactional MMS, SMS, and WhatsApp messages.
- EZ Texting—Leading SMS marketing service.
- SimpleTexting—Great for automated out-of-office messages, welcome messages, etc.
- TextMagic—All-in-one solution for businesses: two way SMS chats, notifications, and staff communication.

Appendix of Additional Resources

- Attentive—AI marketing platform, hyper personalized SMS and email.

Thirty NFT Tools

NFT Marketplaces

- OpenSea—The largest NFT marketplace, which helps to keep track of the NFTs listed on the platform and provides information related to the NFTs like the floor price, volume, sales, and average price on the leaderboard.
- Rarible—An aggregated NFT marketplace for Ethereum and Polygon.
- SuperRare—High-end digital art market on Ethereum.
- Foundation—Curated marketplace that requires prior approval.
- NBA Topshot—If you are a fan . . .
- Binance—This huge crypto platform added its NFT marketplace in 2021.
- Nifty Gateway—Known for hosting exclusive and expensive NFT sales; owned by the Winklevoss family.
- MakersPlace—Known for rare pieces of artwork.

Creation Tools

- Mintbase—A great hub for brands, creators, and developers for minting on the NEAR blockchain protocol.
- Manifold—Manifold Studio allows you to build your own personalized web3 creative platform and sell digital goods (NFTs).

- Metaplex—Solana focused.
- Crossmint—Fully integrated suite of APIs; provides all infrastructural needs. One of my favorites for multiple reasons.

Wallets

- MetaMask—The leading self-custodial wallet.
- Trust Wallet—Self-custody / multi-chain wallet.
- Ledger—Stores your private keys in a secure, offline environment.
- Phantom—Arguably the best Solana wallet.
- Lanyard—A tool used to create wallet allowlists & manage NFT launches.

Analytics Platforms

- DappRadar—Arguably the most comprehensive analytics platform surrounding NFT collections, marketplaces, and beyond.
- CryptoSlam—NFT rankings, Fan Tokens, Collection Rankings, etc.
- Nansen—On-chain analytics.
- Nonfungible.com—Real-time NFT market metrics, project rankings, and sales history. Assess the value of your non-fungible tokens before buying or selling assets.

Notables & Misc.

- OpenSea SDK—Allows developers to access OpenSea's official orderbook, filter it, create listings and offers, and complete trades programmatically.
- Pinata—An important IPFS tool that makes it simple to store and retrieve media on IPFS.

Appendix of Additional Resources

- Alchemy—A multi-chain API to launch, verify, analyze, trade, and display NFTs.
- Oxalus—AI-powered NFT insights and socialization. Learning from leading player strategies and gaining insights into how to invest in NFTs more effectively and profitably. A platform of easy-to-use NFT tools that provide access to NFT tools, an NFT wallet, and a game tracker with just one Oxalus ID.
- BitDegree—A platform that tracks 357 different NFT collections from 3 protocols, spread over 58 different NFT marketplaces.
- Upcoming NFT—A tool that helps investors explore the trending NFTs being minted on the blockchain and provides more insights into them in real-time.
- NFT Drops Calendar—A platform that lists upcoming NFT drops and presales, allowing early supporters of an NFT collection to get access to the project before it officially launches.
- Rarity Sniper—A NFT rarity calculator that allows users to check the rarities of 1970 NFTs listed across Ethereum, Solana, and other blockchains. It also provides features such as an NFT Drops calendar, NFT Stats, and NFT news.
- Etherscan—A tool to look up raw data on any NFT collection, such as total supply, number of transfers, and the details of all holders and trades.

Twenty-One Meme Coin Ecosystem Tools, Resources, and Projects

Please keep in mind that we are currently in a "trend phase" when it comes to meme coins. In my opinion, this is similar to

what we saw in 2020 with NFTs. The tools and projects below illustrate the diversity and innovation within the meme coin ecosystem, from AI integration to gaming and community-driven initiatives.

- DexScreener—A real-time tracking tool that provides insights into decentralized exchanges (DEXs) and the tokens traded on these platforms. It offers detailed information, including price charts, trading volume, liquidity, and more.
- CoinCodex—Useful to track new listings and find early meme coins.
- Arkham Intelligence—Arkham boasts many features, from an on-chain intelligence marketplace where users can trade intel related to specific wallet addresses to tools that showcase a wallet's current/historical holdings as well as their overall profits and losses.
- CoinGecko—Track new meme coin listings; solid filtering system for easier search.
- DEXTools—Great tool to analyze real-time data, such as trading volumes, traders' activities, and liquidity pools.
- Zapper—Zapper transforms blockchains into a social media platform, helping you navigate trending DeFi apps and tokens, veteran DAOs, and NFT collections with ease. This monitoring can be filtered by network (i.e.; Base, Arbitrum, ETH) or a number of other qualifiers, including top holders of tokens, recent buy and sell orders, or the most profitable traders.

Appendix of Additional Resources

- Dex Screener—Use this to analyze real-time data, such as trading volumes, traders' activities, and liquidity pools.
- Solscan—Solana specific data analytics tool.
- Dune Analytics—One of the best tools, in my opinion; also great for very specific data surrounding lifestyle NFTs. Strong with Ethereum traded digital assets.
- DefiLlama—A tool for monitoring Total Value Locked (TVL) across all DeFi, blockchains, and the dApps built on top of them. With an easy-to-use database, DefiLlama allows users to get a bird's-eye view of the DeFi landscape overall, evaluating trends like stablecoin flows and volumes over specific time frames while also enabling users to zoom in on particular ecosystems and protocols to analyze trends—like how token prices correspond to TVL or user growth over a set time. Further, it tracks raise announcements for new protocols, categorizing them by type and backers to help you pattern match.
- Pepe Unchained—A Layer 2 blockchain designed for meme coin enthusiasts, offering unmatched speed and minimal transaction fees. It also features a unique staking mechanism with high rewards.
- WienerAI—This dog-themed meme coin stands out with its AI-powered trading bot that helps users find the best deals and offers MEV-resistant trade execution. The presale has raised significant funds, reflecting strong investor interest.
- Coinglass—This platform stands out for its comprehensive data on cryptocurrency derivatives, such

as futures trading volumes, open interest—both frequently referred to for identifying the market's fear or greed—and the quite useful Bitcoin Rainbow Chart, which helps users navigate Bitcoin's volatile market cycles, offering insights into whether the flagship cryptocurrency currently appears to be over- or under-bought and the action one should take as a result.

- PlayDoge—This meme coin introduces a play-to-earn mobile game that combines nineties nostalgia with financial incentives, allowing users to earn tokens by taking care of virtual pets and competing in mini-games.
- Shiba Inu—One of the most successful meme coins with a large ecosystem and a dedicated community. It features Shibarium, a Layer 2 scaling solution that burns SHIB tokens with every transaction.
- Floki—A utility token within the Valhalla metaverse, offering high staking rewards and backed by a strong community.
- Book of Memes—An experimental project that merges meme culture with decentralized storage technologies, aiming to create a digital compendium of Internet memes. It has achieved notable success and is listed on major exchanges.
- Base Dawgz—Utilizes the Base blockchain with a share-to-earn mechanism that rewards users for sharing content, enhancing community engagement.
- KIMBO—A dog-themed meme coin on the Avalanche blockchain, planning to expand into its own subnet and NFTs, with a strong community and regular feature releases.

- Pulse Inu—A Shiba Inu-inspired meme coin on the PulseChain, focusing on community-driven development without founder allocation, offering staking opportunities.
- Sponge V2—A trending Ethereum-based meme coin with play-to-earn utility and staking rewards. It has shown significant price increases and has a growing community.

Twenty-Seven Podcast Marketing, Advertising, and Ecosystem Tools

These podcast tools cover a wide range of subjects ranging from hosting and distribution to promotion, analytics, and monetization.

Hosting and Distribution

- Riverside.fm—This tool is recommended for its ease of use and quality remote recording capabilities, including video recording and automatic transcription.
- Descript—An all-in-one audio and video editing tool with AI features like Filler Word Removal and Studio Sound. It also includes a Social Post Writer to help with marketing your podcast.
- Transistor.fm—A podcast hosting and distribution tool that allows you to distribute your podcast to popular platforms like Apple Podcasts and Spotify. Known for customer service.
- Buzzsprout—User-friendly podcast hosting platform with great analytics and distribution options.
- Anchor—Host-service with a free-to-use platform for creating, distributing, and monetizing podcasts.

- Libsyn—Reliable hosting with robust analytics and monetization options.

Promotion and Marketing

- Headliner—Creates audiograms and promotional videos for social media; subscription-based model.
- Wave.video—All-in-one online video platform for creators at all levels. Like Headliner, it helps create engaging video content—editing, recording, multi-stream, and hosting.
- Canva—Design graphics, episode covers, and social media posts. Includes several professionally designed podcast templates that you can customize and share.
- Castmagic—This tool helps with creating copy assets for your podcast episodes, including show notes, YouTube descriptions, social content, emails, blog articles, and more.
- Trint—An automatic transcription tool that allows you to upload audio files and get transcripts, which can be helpful for creating show notes and timestamps.

Analytics

- Chartable—Track podcast performance and gain insights into audience behavior/attribution for publishers and advertisers.
- Podtrac—Provides detailed analytics and audience metrics. Uses industry standard measurement data.
- Google Analytics—Track website traffic driven by your podcast. There is a Google Podcasts Manager

Appendix of Additional Resources

system that allows you to know your audience and reach new listeners.

Social Media Management
- Hootsuite—Schedule and manage social media posts across platforms. Really an all-in-one tool.
- Buffer—Another option for scheduling and analyzing social media performance.

Email Marketing
- Mailchimp—Create and manage email newsletters to engage your audience.
- ConvertKit—Tailored for creators, with features for building landing pages and email sequences.

Monetization
- Patreon—Build a membership platform for exclusive content.
- Supercast—Create subscription-based premium content for listeners.

Collaboration and Project Management
- Trello—Organize podcast episodes, tasks, and collaborations. Includes podcast workflow templates.
- Asana—Manage podcast production workflow and deadlines. Also includes workflow templates.

SEO and Discovery
- Podchaser—Improve your podcast's discoverability and SEO. Considered the leading database for podcasts, with curated lists to discover new hosts and shows.

- Podpage—Create a professional podcast website that's optimized for SEO.
- Claude—An AI tool from Anthropic that can summarize podcast episodes, helping to increase productivity and make it easier to take notes.

Advertising
- Libsyn Ads—Formerly AdvertiseCast, it serves as a podcast advertising network. Connect with advertisers and monetize your podcast. (Same company mentioned above.)
- Podcorn—Marketplace for podcasters to find sponsorship opportunities.

Sixty Blockchain and Cryptocurrency Tools

These tools cover a wide range of functions necessary for development, security, asset management, analytics, explorers, DeFi, oracles, Layer-2 solutions, exchanges, NFTs, cross-chain, and trading in the blockchain and crypto space.

Please note, some tools included on this list (i.e., NFTs) are included here because they are part of this ecosystem—but please visit their specific lists when applicable for a more comprehensive and detailed summary.

- Truffle—A development environment, testing framework, and asset pipeline for Ethereum. Truffle can exchange data about blocks, transactions, balances, and other topics with both public and private blockchain networks using web3. Truly a one-of-a-kind blockchain analysis tool.
- Hardhat—A development environment to compile, deploy, test, and debug Ethereum software.

Appendix of Additional Resources

- Embark—A developer framework for Ethereum dApps—one of the top analytics tools—that enables users to develop and deploy a serverless html5 application that uses decentralized technologies.
- Solc—Solidity Compiler translates Solidity code into a more readable format for the Ethereum Virtual Machine.
- Blockchain Testnet—Enables testing of apps before going live. Arguably the best for this purpose.
- Remix IDE—An open-source web and desktop application for creating smart contracts. Very popular—has compilers which are compatible with almost all Solidity versions.
- Ganache—A personal blockchain for Ethereum development that you can use to deploy contracts, develop applications, and run tests. Of note, Ganache enables users to carry out all acts that are typically on the main chain without having to pay for them.
- Solidity—The main programming language for writing smart contracts on Ethereum. One of the most widely used blockchain dev tools. Creates contracts for voting, crowdfunding, multi-sig wallets, and blind auctions.
- Web3.js—A tool that enables connecting to Ethereum nodes; beneficial as it eliminates the need for additional infrastructure of comp languages to communicate a transaction.
- Geth—Implements an Ethereum node created with the Go programming language. One can join an existing Blockchain or start a new one with Geth.

- BaaS—Developed by Microsoft, Blockchain as a Service is an effective tool for developing decentralized applications (dApps).
- Mist—A trustworthy Ethereum wallet created by the developers of Ethereum.
- MetaMask—A Chrome browser extension and mobile app for managing Ethereum-based assets. One of the most straightforward wallets—very easy to install—that permits users to complete transactions for any Ethereum address. Does not support staking. Truly a leader in the category.
- Coinbase—Supports staking and "hot" wallet functionality. Very intuitive; easy to use.
- Gemini—A "hot" wallet that supports hundreds of cryptocurrencies and has staking capabilities.
- Ledger—A "cold" hardware wallet for storing cryptocurrencies securely. One of the best; it supports roughly 1,600 crypto assets and staking. And it's COLD!
- Trezor—Another popular hardware wallet.
- Crypto.com—Compatible with more than 700 cryptocurrencies, and supports staking.
- Trust Wallet—A mobile wallet for managing various cryptocurrencies.
- Ellipal Titan Crypto Wallet—A "cold" wallet with staking capabilities that supports more than 10,000 tokens.
- Exodus—It has been reported that the Exodus Crypto Wallet supports more than 100,000 different cryptocurrencies. It also supports staking.

Appendix of Additional Resources

- SafePal Crypto Wallet—A "cold" wallet that supports over 30,000 crypto assets and is capable of staking.
- Etherscan—A block explorer and analytics platform for Ethereum.
- Blockchain.com Explorer—A block explorer for Bitcoin and Ethereum.
- Glassnode—On-chain market intelligence and analytics platform.
- Dune Analytics—A platform for querying and visualizing Ethereum data. Really well-done—impressive team—one of my favorites, particularly with regard to lifestyle brands.
- MythX—A security analysis service for Ethereum smart contracts.
- CertiK—Blockchain security, focusing on formal verification and auditing.
- OpenZeppelin—Provides a library of secure smart contract templates and auditing services.
- Zerion—A platform for managing DeFi investments.
- Zapper—A tool for managing DeFi assets and liabilities.
- InstaDapp—A DeFi management platform for optimizing your assets.
- Chainlink—A decentralized oracle network providing reliable tamper-proof data for smart contracts. A go-to tool that plays a great role in connecting smart contracts with real world (off-chain) data.
- Pyth Network—Specializes in delivering high-fidelity, real-time market data for blockchain applications.

SOME FUTURE DAY

- Band Protocol—A cross-chain data oracle platform that aggregates and connects real-world data to smart contracts.
- Tellor—A secure and permissionless oracle providing reliable on-chain data for smart contracts.
- Universal Market Access (UMA)—An Ethereum-based protocol that acts as an oracle network and infrastructure for crypto derivatives like DeFi options and futures.
- API3—Facilitates direct integration of real-world data into smart contracts.
- Polygon—A protocol and a framework for building and connecting Ethereum-compatible blockchain networks.
- BASE—Brought to you from Coinbase, a Layer-2 protocol designed to enhance Ethereum's potential by increasing transaction speed and reducing fees.
- Arbitrum—A Layer 2 solution designed to increase Ethereum's scalability and reduce transaction fees.
- Optimism—Another Layer 2 solution for scaling Ethereum applications.
- Lightning Network—Provides the roadmap to faster, cheaper, and more accessible Bitcoin for everyone.
- Dymension—A modular blockchain ecosystem consisting of RollApps and built on a secure settlement hub.
- Coti—A Layer-2 scaling solution for Cardano—moving toward becoming a privacy-centric Layer-2 network for Ethereum (which is interesting if you take the time to research Cardano's founder's background).

Appendix of Additional Resources

- Manta Network—A privacy focused ecosystem for Ethereum, offering anonymous transactions and confidential smart contracts.
- Starknet—Uses STARK proofs, a type of zero-knowledge proof, to validate transactions off-chain, offering unmatched speed. Reduces transaction fees.
- Immutable X—L2 network designed for gaming; is scalable, affordable, and secure.
- Uniswap—A decentralized exchange protocol on Ethereum.
- SushiSwap—A decentralized exchange with additional features like yield farming.
- Binance—A centralized exchange with a wide range of cryptocurrencies.
- Coinbase—Great for beginners—extensive range of supported cryptocurrencies, robust security measures, and complex trading features; a highly intuitive/user-friendly platform.
- Crypto.com—The mobile crypto exchange app is exceptional due to its comprehensive digital asset trading and investing ecosystem, which can be conveniently accessed from your smartphone. Supports more than 350 cryptocurrencies.
- Gemini—Founded by the Winklevoss bothers, an American exchange and custodian bank. Available in all fifty US states. Insures users' funds—but charges high fees.
- Kraken—The best low-fee exchange. High liquidity; large number of supported cryptocurrencies.
- OpenSea—A marketplace for buying, selling, and discovering NFTs.
- Rarible—A decentralized NFT marketplace.

SOME FUTURE DAY

- Mintable—A platform to create, buy, and sell NFTs.
- Polkadot—A network protocol that allows arbitrary data—not just tokens—to be transferred across blockchains.
- Cosmos—An ecosystem of blockchains that can scale and interoperate with each other.

In some future day, our next generation will be using blockchain technology and cryptocurrency to run all business-to-business transactions.

**Paul Brody
Principal and Global Blockchain
Leader, Ernst & Young**

ACKNOWLEDGMENTS

Special Thanks to My Family and Very Talented Collaborators

Alice
Jude Sargent
Damaris Agathe
Hannah, Jenna, Mollye
Harvey & Janet
Naomi B.
Amy
Paco, Lauren, Nate, & Sydney

Scott Kenemore
Mark Gompertz
Sam Sohaili
Justin Metz
Tony Lyons
Caroline Russomanno
Nancy Chanin
Jon Bumhoffer

Secret Agents

Bob Dylan
Equinunk
Pablo Picasso
Jimi Hendrix
Bob Marley
James Joyce
Les Baux-de-Provence
Steve Jobs

INDEX

A
Abbeel, Pieter, 254
acceleration, 5–6, 233–248
accountability, 237–238
accounting, 139
AccuRanker, 275
ActiveCampaign, 278
Adams, Eric, 184
Adcock, Brett, 260
Advanced Web Ranking, 275
Agorapulse, 278
AI ARTA, 265–266
AIME, 240
AI Mirror, 269
Alchemy, 281
Alteryx, 273
Al Thani, Sheikh Mohammed bin Abdulrahman bin Jassim, 257
Altman, Sam, 93, 258
AMIE. *See* Articulate Medical Intelligence Explorer (AMIE)
Amodei, Daniela, 255
Amodei, Dario, 257
Amped, 278
Anchor, 285
Andrulis, Jarek, 261
animal cruelty, 154–155
API3, 292
Arbitrum, 292
archives, 38
Arkham Intelligence, 282
Arora, Nikesh, 259
Articulate Medical Intelligence Explorer (AMIE), 49
artists, 85–102
ArtMind, 268
Asana, 287
assassinations, 70–71
Attentive, 279
augmented reality, 10
authenticity, 88, 110, 112–114, 118–119
automation, 37–38, 180
autonomous vehicles, 10
autopsies, 54–55
avatars
 brand, 14
 metahuman, 34
Avedon, Richard, 16–17

B
BaaS, 290
Backlink Analysis, 274
Band Protocol, 292
Banga, Ajay, 257
banking, 123–143. *See also* cryptocurrency
Barnea, David, 258
BASE, 292
Base Dawgz, 284
Beat.ly, 265
beauty standards, 116–117
Bengio, Yoshua, 254
Benioff, Marc, 259
Bernhardsson, Erik, 257

Index

BetterHelp, 63
Bezos, Jeff, 258
bias, 24–25
Biden, Joe, 253
Binance, 279, 293
BitDegree, 281
Blackbox AI, 270
Blockchain.com, 291
blockchains, 4, 10, 15–16, 100, 110–114, 118, 132, 288–294. *See also* non-fungible tokens (NFTs)
Blockchain Testnet, 289
block explorer, 111–118, 120
Bobble AI, 271
Book of Memes, 284
Borges, Jorge Luis, 174
Bouton, Chad, 200
Boyle, Jacob, 241–242
brain hemispheres, 239
Brainly, 263
brand avatars, 14
brands, 19, 29
Breakcold, 278
Brockman, Greg, 252
Brody, Paul, 295
Brook, Yaron, 216
Buffer, 277
Bush, George W., 227
Buzzsprout, 285
BuzzSumo, 277

C

Calvin, Katherine, 251
Candy.ai, 268
Canva, 277, 286
capitalism, 22
Carlson, Tucker, 109
Casado, Martin, 255
Cashflow360, 137–138
Castmagic, 286
Catz, Safra, 256
CertiK, 291
Chainlink, 291
Character.ai, 263
Charisma AI, 102
Chartable, 286
Chat & Ask AI, 265
ChatGPT, 23, 35, 108, 138–139, 169, 213, 245, 262, 275
ChatOn, 268
ChatPDF, 270

Chen, Michael, 256
Chub.ai, 269
Civitai, 264
Claude, 264, 276, 288
climate change, 30–32
clinical trials, 52
Clipchamp, 267
clothing, 13–14, 26–27, 29
cloud computing, 10
coding, 203–204
Coinbase, 129, 290, 293
CoinCodex, 282
CoinGecko, 282
Coinglass, 283–284
collaboration, 16, 18–19, 79
community
 artists and, 102
 creators and, 43, 102
 crime and, 198
 education and, 215
 financials services and, 142
 media and, 120
 medicine and, 63
 metahumans and, 167
 sighted AI and, 177
 social media and, 231
 warfare and, 82
companionship, 161–162
Competitor Research, 274
conflict, 32–33
connectivity, 9–10
content distribution, 99–100
ConverKit, 278, 287
Copilot, 26, 270
copyright infringement, 100
CoSchedule, 277
Cosmos, 294
Coti, 292
Cox, Chris, 257
Craiyon, 270
Crawford, Kate, 260
creatives, 85–102
crime, 179–197
Crossmint, 280
CrushOn AI, 264
Crypto.com, 290, 293
cryptocurrency, 4, 100, 111–112, 127–128, 130, 181–182, 185–190, 196, 242, 281–285, 288–294. *See also* non-fungible tokens (NFTs)
CryptoSlam, 280

currency, 123–125, 127, 132–135, 141.
 See also cryptocurrency
customer service, 14–15
Cutout.Pro, 266
cybercrime, 190–194
cyberterrorism, 192–193
cyberwarfare, 77–78

D
DALL-E, 275
dangers, of artificial intelligence, 20–22, 40–42
DappRadar, 280
data analytics, 272–274
Databricks, 272
data mining, 74
data provenance, 194–195
dating, 156–161, 167
DaVinci, 262
Dawn AI, 265
death, 162–163
deaths of despair, 60
decentralization, 130, 132–133, 242–243
DeepAI, 268
DeepArt, 99
Deep Fake Detector, 121
deepfakes, 74, 107, 184, 195, 226
DefiLlama, 283
Delangue, Clement, 256
De Matteo, Drea, 178
democracy, 130–132
demographics, 29–30
Descript, 285
design, 98–99
DexScreener, 282–283
DEXTools, 282
diagnosis, medical, 46–47, 56, 59–60.
 See also imaging, medical
Dick, Philip K., 145
Digital Age, 3, 87
digital currency, 127, 134–135. See also cryptocurrency
disabled persons, 171–172
disinformation, 73–74
disruption, 16
DLC. See downloadable content (DLC)
DNA, 54–55
Dogecoin, 187
Domo, 273
downloadable content (DLC), 90–91

DreamGF, 271
driving, 170–171
drones, 10, 68–70
drug trials, 52
"dual use dilemma," 74–75
Dulin, John, 256
Dune Analytics, 283, 291
Dymension, 292

E
Earkick, 57, 63
Ebert, Roger, 88–89, 96
education, 201–215
efficiency, in healthcare, 49–50, 60–61
Eightball, 206
Eightify, 268
elderly persons, 182–183
ElevenLabs, 265
Ellipal Titan Crypto Wallet, 290
Ellison, Larry, 257
ELSA, 271
email marketing, 278
Embark, 289
emotions, 154–156
employee development, 39
employee retention, 76
employment recruiting, 33–36
Empower, 143
entertainment, 85–102
EPIK, 269
Etherscan, 281, 291
ethics, 40–42
Exodus, 290
EZ Texting, 278

F
Facebook Ads Manager, 276
Facemoji, 262
fake news, 115, 117, 120, 224
family
 art and, 102
 crime and, 198
 education and, 215
 financial services and, 142
 media and, 120
 medicine and, 63
 metahumans and, 167
 shopping and, 43
 sighted AI and, 177
 social media and, 231
 threat awareness and, 82

Index

fan platforms, 159
fashion, 13–14, 26–27, 29–30
feelings, 154–156
fiction, artificial intelligence in, 21
films, 91–96
finance, 123–143. *See also* cryptocurrency
financial planning, 139–140
Fireflies.AI.AI, 275
First Amendment, 8
Floki, 284
fog of war, 68
forecasting, 31–33
Foto Forensics, 121
Foundation, 279
Fouquet, Christophe, 260
Francis, Pope, 253
fraud, 179–197
freedom of speech, 8, 117
Frenkel, Aviv, 261
Freud, Sigmund, 149–150
Friedman, Nat, 255
friendly fire, 68
Fuld, Hillel, 250
"Funes the Memorius" (Borges), 174

G

GameStop, 187
gamification, in employment, 36
Gamma, 266
Ganache, 289
Gauff, Coco, 16
Gemini, 235, 242, 263, 290, 293
Generation Alpha, 14, 98, 192, 203
Generation X, 98
Generation Z, 14, 98, 109, 192, 203
Geth, 289
Ghodsi, Ali, 258
Gil, Elad, 252
Glassnode, 291
gold standard, 123
Gomez, Aidan, 252, 261
Goodfellow, Ian, 259
Google, 23, 49, 194
Google Ads, 276
Google Analytics, 273, 286–287
Google Glass, 165
Google Search Console (GSC), 276
Gore, Al, 227
Granberg, Brett, 256
Grok, 23
Gross, Daniel, 255
growth, 20
GSC. *See* Google Search Console (GSC)
Guo, Demi, 256
Gupta Abhinav, 252

H

hacking, 191–192, 195–196
Hamel, Alan, 162–164
Hamid, Mamoon, 255
Hao, Karen, 261
Hardhat, 288
Harry, Brian, 253
Hassabis, Demis, 259
Headliner, 286
healthcare, 45–63, 88–89, 241–242
Hernandez, Roberto, 122
Hinton, Geoffrey, 259
Hitler, Adolf, 70–71
Holz, David, 256
Hootsuite, 277, 287
hospitals, 47–48
"How to Build a Universe That Doesn't Fall Apart Two Days Later" (Dick), 145
Huang, Jensen, 258
Huang, Sonya, 256
HubSpot, 278
Huggingface, 121, 265
human element, 46, 80
humanity, 145–166, 239
Hypic, 266

I

Iconosquare, 278
Ideogram AI, 268
imagery, 17–18, 85, 110–117, 174
ImagineArt, 265
imaging, medical, 53, 59–60
Immutable X, 293
inflation, 124–125
inflection points, 13–14
Information Age, 3
innovation, 12, 245–246
InstaDapp, 291
intelligence, military, 66–67, 71–72, 79–80
interactivity, 97
Internet of Things, 10
investments, 141, 188–189
Invideo AI, 269

Iron Law of Oligarchy, 130
Isford, Grace, 255
Ittycheria, Dev, 255

J
Jaffe, Amy Myers, 64
Janitor AI, 264
job postings, 33–36
Jobs, Steve, 246
Jones Llion, 254
journalism, 105–121
JPMorgan Chase, 137–138

K
Kaplan, Jared, 255
Karpathy, Andrej, 260
KeywordInsights.Ai, 275
Khatri, Chandra, 261
KIMBO, 284
Klipfolio, 273
Kon, Martin, 252
Koons, Jeff, 86
Kraken, 293
Kress, Colette, 256
Krishna, Arvind, 259
Kurtz, George, 259
Kutylowski, Jarek, 261

L
Lacroix, Timothee, 254
Lample, Guillaume, 254
language translation, 39
Lanyard, 280
Laraki, Othman, 252
Large Language Models (LLMs), 22–26, 41, 50, 204, 237–239, 245
Later, 277
Laun, David, 260
law enforcement, 54
LeCun, Yann, 258
Ledger, 280, 290
Lee, Kai-Fu, 260
Lefkofsky, Eric, 260
Leike, Jan, 254
Lenin, Vladimir, 1
Leonardo.AI, 266
leveling effect, 2, 69
Li, Fei-Fei, 259
Liang, Wayne, 260
Libsyn, 286
Libsyn Ads, 288

licensing, in music, 88
life, 149–150
Lightning Network, 292
Liner, 263
LinkedIn Ads, 276
Li Qiang, 258
LISA AI, 270
LLMs. *See* Large Language Models (LLMs)
loneliness, 156–157, 160–161
Looker, 272
Looker Studio, 273
Loomly, 277–278
Luddites, 233–234

M
Mailchimp, 278, 287
MakersPlace, 279
Malavieille, Raphael, 168
Mangools, 274
Manifold, 279
Manta Network, 293
MARCo Health, 241–242
Marcus, Gary, 235–236
marketing
 email, 278
 SMS, 278–279
Markov, Todor, 254
matchmaking, 156–161
Mavrodi, Sergei, 188–189
MaxAI.me, 270
McGilchrist, Ian, 239–240
media, news, 105–121
medical examiners, 54–55
medicine, 45–63, 88–89, 240–242
meme coins, 187, 281–285
Mensch, Arthur, 260–261
mental health, 55–59, 63
Meta, 23
Meta Ads, 277
Meta AI, 235, 242
metahuman avatars, 34
metahumans, 145–166
MetaMask, 280, 290
Metaplex, 280
metaverse, 3–4, 10–12, 86, 89–90
meteorology, 31–32
Michels, Robert, 130–131
Microsoft, 23–24, 26
Microsoft Advertising, 276
Microsoft Edge, 262–263

Index

Microsoft Power BI, 272
Midjourney, 266
military assassinations, 70–71
military engagement, 67, 73
military intelligence, 66–67, 71–72, 79–80
military robots, 68–70
military spending, 76
military targeting, 67–68
military technology, 65–82
Mindspa, 57, 63
Mintable, 294
Mintbase, 279
misdirection, in warfare, 73–74
Mist, 290
mobile devices, 10
Mode, 272
money, 4, 127. *See also* currency; finance
Moore, Andrew, 255
Mostaque, Emad, 261
Motamedi, Saam, 255
movies, 91–96
Murati, Mira, 257
music, 87–88, 97–98, 226
Musk, Elon, 23, 227, 260
My City Business, 190–191
MythX, 291

N
Nadelha, Satya, 255
Nansen, 280
Narayen, Shantanu, 260
narrative art, 90–93
Nawabi, Wahid, 259
Nazi, George, 261
NBA Topshot, 279
Netanyahu, Benjamin, 254
network states, 128–129, 133–134
news media, 105–121
New York City, 190–191
NFT Drops Calendar, 281
NFTs. *See* non-fungible tokens (NFTs)
Ng, Andrew, 259
Nifty Gateway, 279
NightCafe, 268
Nightwatch, 275
Nixon, Richard, 123
Nonfungible.com, 280
non-fungible tokens (NFTs), 98, 100, 114, 116, 279–281

Non-Player Character (NPC), 146–148
Norvig, Peter, 257
NOVA, 264
NovelAI, 269–270
Nozzle, 274
NPCs. *See* Non-Player Character (NPC)

O
oligarchy, 130–131, 133
OnlyFans, 159
OpenAI, 93, 238, 245
OpenSea, 279–280, 293
OpenZeppelin, 291
Operation Foxley, 70–71
Optimism, 292
OpusClip, 270
Originality.Ai, 275
Otter.ai, 271
overt bias, 24–25
Oxalus, 281

P
paid social, 276–277
Pathak, Deepak, 252
patient engagement, in medicine, 45–63
Patreon, 287
Patrick, Kristin, 84
Pepe Unchained, 283
Pereyra, Gabe, 252
Perfect AI Receptionist, 167
Perkins, Melanie, 256
Perplexity, 26, 264
Peters, Gary, 253
Phantom, 280
Phind, 263
photography, 17–18, 85, 106, 110–117, 174
Photomath, 262
Photomyne, 271
PhotoRoom, 267
Pichai, Sundar, 258
Pinata, 280
PixAI, 268
PIXLR, 266–267
Planoly, 277
PlayDoge, 284
Playground AI, 269
podcasts, 285–288
Podchaser, 287
Podcorn, 288

Podpage, 288
Podtrac, 286
Poe, 263–264
Political Parties: A Sociological Study of the Oligarchical Tendencies of Modern Democracy (Michels), 130–131
politics, 107–110, 195, 223–228
Polkadot, 294
Polygon, 292
Pope Francis, 253
pornography, 158–159
"powerful triangle," 100–101
Prakash, Vipul Ved, 256
predictability, 30
Prince, Matthew, 258
privacy, 174–176
professional development, 39
proteomics, 51
psychology, 55–59, 63, 73, 154–155
Pulse Inu, 285
Pyth Network, 291

Q
Qanda, 266
Qlik Sense, 273
Question AI, 267
QuillBot, 263

R
Raji, Vijaye, 257
Ramaswamy, Sridhar, 259
Rangan, Yamini, 255
Rank Tracker, 274–275
ransomware, 191–192
Rarible, 279, 293
Rarity Sniper, 281
Razavi, Yasmin, 255
Reeves, Brandon, 255
Reface AI, 271
Remini, 265
Remix IDE, 289
Replicate, 269
research
 medical, 51–53, 61
 military, 75–76
reserve currency, 125
résumés, 36
returns, 29
Ricks, Dave, 258
RillData, 273
Riverside.fm, 285

robots
 medical, 51–52
 military, 68–70
Rocket Money, 142
Rogan, Joe, 109
romance, 156–161, 167
rumor, in warfare, 73
Runway, 267
Runway ML, 99
Russell, Stuart, 257

S
SafePal Crytpo Wallet, 291
safety, 170–171
sales, 12–15
Salvagnini, David, 251
sample testing, medical, 53–54
SAP Analytics Cloud, 273
scalability, 180, 182
scams, 179–197
Scott, Kevin, 252
search, paid, 276
search engine optimization, 274–275
Selipsky, Adam, 256
SEMrush, 273–274, 276
Sendinblue, 278
Senkut, Aydin, 255
sentiment analysis, 35–36
SEO PowerSuite, 274
Serebryany, Neil, 257
Serpple, 275
Shiba Inu, 284
shopping, 12–13, 152
sighted AI, 169–176
Sigma, 272
SimpleTexting, 278
Simplifi, 143
Sindhu, Pradeep, 253
Sisence, 273
Smola, Alex, 260
SMS marketing, 278–279
Snapchat Ads, 276
SnapEdt, 269
SocialBee, 277
social media, 10, 15, 23–24, 99–100, 114–115, 180–181, 186–189, 195–196, 217–231
 organic, 277–278
 paid, 276–277
SocialPilot, 278
Solc, 289

Index

Solidity, 289
Solscan, 283
Somers, Suzanne, 162–164
Speechify, 269
SpicyChat, 266
Sponge V2, 285
Spotfire, 273
Sprout Social, 277
SpyFu, 276
SQL, 274
Srinivas, Aravind, 257
Srinivasan, Balaji, 128–129
Stalin, Joseph, 117
Staniszewski, Mati, 257
Starknet, 293
Stata, 272
states, creation of, 128–129
Story.com, 102
storytelling, 38, 90–97
Stuxnet, 77
Suleyman, Mustafa, 252
Suno AI, 269
Supercast, 287
SuperRare, 279
Surfer, 275
SushiSwap, 293
Sutton, Willie, 190
Swab, John, 232
Sweet, Julie, 258
Swift, Taylor, 107

T

Tableau, 272
Tailwind, 277
Talkspace, 63
targeting, military, 67–68
Tarteel AI, 266
tastes, consumer, 29–30
taxes, 138–139
Tay, 23–24
telemedicine, 48
television, 92–95, 106
Tellor, 292
terms, descriptive, 34
terrorism, 192–193
TextMagic, 278
TikTok, 109, 221–222
TikTok Ads, 277
Tillis, Thom, 253
Ton-That, Hoan, 261
toys, 241–242

transformative use, 18
Transistor.fm, 285
translation, multi-language, 39
transparency, 118, 132
Travis, Randy, 88
Trello, 287
Trezor, 290
tribalism, 107–110
Trint, 286
Truffle, 288
Trump, Donald, 224–225, 253
trust, 123–143
Trust Wallet, 280, 290
Tseng, Ryan, 259
Turing, Alan, 3
Turing Test, 146
Turley, Jonathan, 8
Twilio, 278
Twitter, 227
Twitter Ads, 276

U

Ukraine, 69
UMA. *See* Universal Market Access (UMA)
Uncanny, The (Freud), 149
uncanny valley, 150
Uniswap, 293
Universal Market Access (UMA), 292
Upcoming NFT, 281

V

Valenzuela, Cristóbal, 256
Vanel, Clyde, 104
Vectorizer.AI, 271
VEED.IO, 267
video games, 90–91, 94–98, 146–148, 221
Villarrubia, James, 144
virtual realities, 3–4, 10
visual impairment, 171–172
VocalRemover, 268
voices, 88–89, 183–184
Volozh, Arkady, 261
von Neumann, John, 3
vulnerabilities, in warfare, 68

W

Waldman, Jaron, 252
Wang, Alexander, 252
Wang Chuanfu, 257

war, 32–33
warfare, 65–82
watsonX Assistant, 167
Wave.video, 286
weather events, 30–32
Web3.js, 289
Website Audit, 274
Wei, CC, 260
Weil, Kevin, 254
Weinberg, Winston, 252
White, Constance, 44
White, Sean, 259
WhiteSpark, 275
WienerAI, 283
Wincher, 275
Wonder, 270
WordStream, 276
workforce, 148
World War II, 70–71
Wu, Yuxin, 252

X
X, 23, 227
Xi Jinping, 254
Xu, Joshua, 260
Xu Li, 261

Y
Yang Zhilin, 251
Yezhov, Nikolai, 117
YoDayo, 267
You, 268
Youper, 57, 63

Z
Zadno, Reza, 258
Zapper, 282, 291
Zerion, 291
Zhou, Jiaji, 256
Zoho Analytics, 272
Zoho Social, 278
Zuckerberg, Mark, 258